A St Andrews Mystery...

The White Lady

& the Haunted Tower

"Still present in a place dreaded in the dark"

CW00553485

*An Investigation into the Chamber of Corpses
and the White Lady Apparitions of St Andrews*

Richard Falconer

Also by Richard Falconer

Ghosts of St Andrews
Incorporating 75 locations

Ghosts of Fife
Incorporating over 80 places
throughout the Kingdom

Watch out for these forthcoming titles

Golf
By 19th Century St Andrews Enthusiasts

Ghosts of St Andrews
Updated & expanded with incredible new material

More Ghosts of St Andrews
Incorporating over 100 new unpublished accounts!

The Lost Treasures of St Andrews...

Copyright © 2015 Richard Falconer
First published 2015 by Obsidian Publishing

All rights reserved. No part of this book may be reproduced, utilised in
any form or by any means, electronic, mechanical, photocopying or
recording by any information or retrieval system, without the prior
permission in writing from Obsidian Publishing.

The moral rights of the author have been asserted.

A catalogue record for this book is available from the
British Library.

ISBN: 978-0-9927538-2-5

Edited by Dr Jennifer N. Low PhD – St Andrews
Cover design, content layout & formatting by Richard Falconer
Cover photo of the Haunted Tower by Richard Falconer.
Cover photo from the Star Hotel, 1921, reproduced courtesy of
the St Andrews Preservation Trust

Photos throughout the book have either been taken by myself, are in
the public domain or are referenced with acknowledgments

Back cover and title page quotation from
'St Andrews Wonderful Old Haunted Tower'
By Dean of Guild Linskill, October 5th 1918

www.obsidianpublishing.com
enquiries@obsidianpublishing.co.uk

Dedicated to

The White Lady Saint of the Haunted Tower

*

All who sleep in the shadow of St Rule's Tower

*

Dean of Guild W. T. Linskill

&
Jan Tero
a wee boy finding his feet in a world
strange to us all

Contents

Section One...
A St Andrews Mystery

Chapter One
Preserved Corpses and a Ghost

Chapter Two
Peeping into the Chamber of Corpses -
The Early Discoveries & Initial Letters of Correspondence

Chapter Three
Post 1868 Openings of the Haunted Tower

Chapter Four

Unravelling the Telegraph Interviews of 1893
& the Involvement of those Present

Chapter Five

The Secret Hollow in Hepburn's Abbey Wall

Section Two...

Where are the Corpses?

Chapter Six

What Happened to the White Lady of the Tower?

Chapter Nine
(*Continued*)

Chapter Ten
The Clephane Family Mausoleum

Chapter Eleven
The Servants of God

Chapter Twelve
Preservation and Incorruption

Chapter Thirteen
The Reformation

Chapter Thirteen
(Continued)

Chapter Fourteen
The Aftermath

Section Four...
The Treasure

Chapter Fifteen
Hidden Away

Section Five...
The Ghosts

Chapter Sixteen
The White Lady Ghosts & Associated Experiences

Chapter Sixteen
(Continued)

Chapter Seventeen
Linskill's Stories of the White Lady

Chapter Eighteen
An Analysis of Linskill's White Lady Stories and his Mysterious Marie of the Haunted Tower

Chapter Nineteen
Further Accounts and Fictional Components

Chapter Nineteen
(Continued)

Chapter Twenty
More White Ladies of St Andrews

Chapter Twenty One
The Bride of Heaven & the Veiled Nun of St Leonards

Chapter Twenty One
(Continued)

Chapter Twenty Two
The Fair Woman

Section One...

A St Andrews Mystery

In 1987, I started writing a chapter about the White Lady and the Haunted Tower for *Ghosts of St Andrews* (2013). This was all following on from information I started gathering in the 1970s. With this, I found there was a lot more to this tower and its associated mysteries than I had previously imagined. Around 100 pages later, I realised I wasn't writing a chapter, I was writing another book.

This is the first time in over one hundred years that the wealth of material written on the subject of the White Lady and the Haunted Tower has been seen. Following in-depth research and extensive cross-referencing and analysis of the material written between 1860 and 1925, I have further developed the Victorian theories that emerged in 1894 surrounding the associated mysteries. Accordingly, the research has yielded some surprising results missed first time round.

Consequently, this is the first time since the 1890s where the opportunity has arisen for others intrigued by the tower of mystery, to draw their own conclusions based on the presented evidence.

Richard Falconer

Chapter One

Preserved Corpses and a Ghost

The Haunted Tower of Hepburn's Abbey Wall

"There is a certain soil or a certain atmosphere which preserves dead bodies from decay. It exists in Milan, and it is now known to exist nearer home. And at a certain point from St. Regulus Tower all the dead that sleep beneath its shadow are lying now as they lay on their death-bed".[i]

The Saturday Review, 1893

[i] *The Saturday Review*, November 25, 1893. Written at the end of an important epilogue about the opening of the Haunted Tower.

The Mystery of the Haunted Tower

Along Hepburn's Abbey Wall, surrounding the Cathedral and Priory Precincts, and within the shadow of the former Cathedral of St Regulus,[ii] stands a tower, known as the Haunted Tower, the Ghost Tower, the Virgin Tower or Mary's Tower. Of the original sixteen around Hepburn's Abbey Wall, thirteen towers remain today. Eleven are round and two are square. The Haunted Tower is one of the two existing square towers.

With its exposed bleak setting by the edge of the high cliffs overlooking the North Sea,[iii] this is the only tower with three chambers and an external stair within the Cathedral grounds. The stair now leads to a locked iron gate, but a wall of stone only nine inches thick once blocked its entrance, concealing within an ancient secret.

For many years, the only details to emerge of what might lie beyond the sealed entrance of this tower came through rumours spreading around the town. In November 1893, a two-part article appeared in the *Saturday Review*. This national weekly newspaper reported on the engagement of St Andrews Antiquarians looking for subterranean passages under the Cathedral and the old quarters of the town. A few other topics were touched upon to give a broader picture of their endeavours, including two almost incidental pieces tagged onto the end of each part of the article. The darker shades of human existence have always drawn on the imagination and what this article disclosed didn't disappoint the reader of the day. The first of these incidental pieces featured a letter written by a Rev. Skinner in 1860. The letter gave details about the body of a woman wearing a white dress seen in a chamber or vault somewhere in Hepburn's Wall. This was the first time anything about the existence of the body of a woman had been published in the press. The letter is reproduced on p. 29.

The second part of the *Saturday Review* article carried a remarkable story in keeping with Skinner's letter. In brief, this was the account of a few explorers, who, on desiring to see what lay beyond the sealed chamber of the Haunted Tower, apprehensively gathered in secret early one morning to open it. A Professor of the United College in North Street headed the exploration. When they went in, they were amazed at

[ii] The last remaining part of the first Cathedral is the central tower known locally as the 'Square Tower'.

[iii] Until the First World War, it was known as the German Sea.

what they found. It appears the chamber was the hiding place of up to 10 coffins dating from different centuries. There were nine males and one female. Some were wrapped head to toe in white wax cloth, including that of a slim corpse, four and a half feet long. Under the wax cloth wrappings was the corpse of a woman, young and beautiful. She wore a long white silk dress, and it was as if she had fallen asleep that very hour. Both she and the other corpses were in a perfect state of preservation. There was no obvious indication as to their identities, or why they should be entombed within the tower. Following a cursory examination, the Professor went to the Lord Advocate and told him of their discovery. He immediately ordered them to leave the bodies alone in their tomb and reseal the chamber.

The Ghost

For many years the Haunted Tower or Ghost Tower has been the lair of the elusive ghost of the 'White Lady' or 'Tower Lady' as some Victorians knew her. In the nineteenth century, any talk of this tower was enough to fill even the most robust of hearts with feelings of dread. Bound to this earth for reasons long forgotten, she is the most famous and prolific ghost in St Andrews, and has roamed this quarter for at least three centuries. Known as the 'Ladyhead', this area on the north eastern fringe of the town included Gregory Place, and Gregory Lane (formerly Dickieman's Wynd and Foundary Lane), the East Scores path, Kirkhill (Kirkheugh) to the west and down to the harbour to the east. The fisher folk were the mainstay of the residents in this area, and they certainly needed no introduction or reminder of her. Over the years, many have seen her, some have felt or heard her and instinctively many have feared her.

Accounts and descriptions of her were handed down by older generations to those eager to hear them, and when they did, they soon found themselves equally eager to dispel what their imaginations brought to life. Far from being a local folktale or story to amuse and entertain, details of the tower's wraith like resident was conveyed to the unwary with a serious tone. Children from the nearby East Infant School (Fishers School) were warned not to play there, and visitors likewise, were warned not to pass by her tomb at night. Some former pupils remember being told this as recently as the 1950s, as the school was here until 1957. In some households it maintains itself as a warning to this day and those adhering to the words they are told dare not pass

her lair once the sun dips beneath the buildings of the western skyline of St Andrews.

As the focal point of a number of mysteries, most will be able to share a tale or two about the White Lady, but nobody really knows anything about her. Despite extensive speculation commencing in the press of 1894, her identity still eludes us, although there is a theory that she was a saint, which I explore in Chapter 11, *The Servants of God*.

Inside the grounds she appears shrouded in a luminous white garment, while outside, along the pathway by the tower, she wears a long white dress contrasting with her long black hair. If she were living, she would be remarked upon for her great beauty, however, not now being of the flesh, her spontaneous appearance and disappearance is an unnerving experience for those who observe her. She was seen many times before the tower was first opened, and was last seen early 2015.

In an interview in 1893, based on the first article about the mysteries of the Haunted Tower, the Victorian, Bailie Hall, a local representative of the Woods and Forests Department in St Andrews, said, "People had been in the habit of calling the place the Haunted Tower, and when going to the harbour they ran past it".

William Linskill, a Victorian gentleman with an avid interest in the tower, wrote in 1918, "There have been many, both old and young, within the last fifty years [since 1868], who have solemnly declared that they have seen the apparition of the beautiful White Lady at that old tower, and that on a quiet night they have heard terrible sounds therein. In those days few people cared to pass that tower of mystery alone after nightfall, for it was known that there lay enshrined in it this lovely white maiden, and the attendant well-preserved skeletons or mummies which must have gone through some embalming process". [iv]

Before his death in 1929, Linskill in like manner to Hall some 36 years earlier said, "People used to run for their lives when passing this tower at night; and the older fisher folk have told me some hair-raising uncanny stories of awesome sounds and sights that had been heard and seen by many at that Tower. My tutor, Mr Robb, told me some really awful tales about this place". [v]

[iv] Excerpt from *St Andrews Wonderful Old Haunted Tower*, By Dean of Guild Linskill, October 5th 1918
[v] *The Strange Story of St Andrews Haunted Tower, Linskill*, 1925, excerpt from a short article entitled '*A Place Dreaded in the Dark*'.

William Linskill

This rare photograph on the cover was taken in 1921 in the 'Star Bar', the popular bar of the Star Hotel formerly in Market Street. It features three keen golfing friends and drinking buddies, William Linskill, Mr Ferguson, the owner of the hotel at that time, and one Captain Daniel Wilson.

William Linskill (left), Mr Ferguson (middle)
Captain Daniel Wilson (right)[vi]

Captain Daniel Wilson, known as 'Captain Dan', and based in St Andrews, was the Captain of Clipper Ships. In 1892, he sailed from Scotland to Australia and back on the maiden voyage of the ship

[vi] Image reproduced courtesy of the St Andrews Preservation Trust

Stoneleigh. It took him two years. For its second voyage, he was transferred to another boat, a fortunate occurrence; Stoneleigh sank in the Tasman Sea in 1895 with all hands lost. With a number of near misses, he was the last of the old sea faring captains in St Andrews. He died in 1926, aged 82, but not at sea. He was in a collision involving a lorry whilst riding pillion on a motorcycle in Fife.

It was Captain Dan who gave Linskill one of the earliest recorded reports we have of the physical body of the White Lady being seen in a chamber of Hepburn's Wall. Refer to p. 28.

William Thomas Linskill or W. T. Linskill as he was more formally known in his books was a town councillor and later became the Dean of Guild in St Andrews. He was founder and President of the St Andrews Antiquarian Society in 1879, and introduced the first fire service to the town. The fire engine was a steam engine and caused quite a sensation as few had ever seen such an elaborate contraption.

Linskill was greatly fascinated by the tower and the White Lady. He was one of the keenest correspondents to the newspapers about her, and wrote a couple of short stories about her for his 80 page booklet *St Andrews Ghost Stories*. Originally published in 1911, his book captured the imagination of the town, and was a local bestseller until 1978 when it went out of print. I republished his book as the last section of my own book *Ghosts of St Andrews* in 2013. I included extensive footnotes through researching his stories, so his book is now twice the length it was. I have again reproduced his stories of the White Lady in this book commencing on p. 208. This is then followed by an analysis of these stories and details of how and where he gathered his inspiration.

Linskill was certainly a character. In addition to being an author, he had a great memory and was a renowned raconteur. In many ways, there is a similarity between Linskill and the celebrated golf historian David Joy in our present age. He was well liked in the town and was sought out for his after dinner speaking abilities. Also like David, he was always spinning a yarn or two. He was likewise an actor and a keen golfer. Whilst David occasionally assumes the character of Old Tom Morris, Linskill prided himself that his golfing partner and tutor was Young Tom Morris. Both of them have also written about the game of golf. Alongside writing *St Andrews Ghost Stories,* in 1911, in 1889 Linskill wrote a book simply titled *Golf.* This was an early beginner's guide based at the Links in St Andrews, which I am republishing in 2016. With both enjoying the odd spirit, there is also another form of

spirit Linskill had an unshakable passion for. Despite saying he never experienced one, he did once hear footsteps in St Rule's Tower one Halloween night. The footsteps could have been those of the 14th Century Prior Robert De Montrose as there are many reports of him being seen in this tower over the years. Next to the ghost of the White Lady, his ghost is the most sighted in St Andrews. He was murdered by the tower in 1394 by an unruly monk by the name of Thomas Platter, whom he imprisoned for a time to chasten him for cavorting with a woman.

Linskill ended up in St Rule's Tower that Halloween night as the result of a wager by one of his fellow roommates, that one of them wouldn't spend a couple of hours alone at its top. Not that they were all looking at Linskill of course, but he was first to rise to the challenge. With his necessary supplies of brandy and cigars to see him through his impending ordeal, he boldly went to the tower. As he climbed the steep spiralling stairs, his bravado began to lack the eagerness witnessed by his friends back in the comfort of their brightly lit and warm lodgings. On reaching the top, he complied with the terms of the wager and remained there for a couple of hours. From his report, the experience terrified him! Despite there being no one else in the tower, he knew he was not alone. Whilst at the top he heard the footsteps of someone walking up the tower, he called out a few times, but no one replied and no one ever arrived at the top. When his two hours were up, and with a sigh of relief, he began making his way down the spiral stone steps. As he did so, he again heard the same footsteps, but this time they were coming from above. Something was now following him down. He stopped, but the footsteps continued and again no one arrived. When he returned to the ground, he locked the door and made his way to the Cathedral's keeper of the keys where he gladly received a stiff whisky.

Linskill would dearly loved to have seen the White Lady, although, given how terrified he was in St Rule's Tower that Halloween night, such an experience may have been the end of him.

He died peacefully in 1929, and was buried in the family grave just north of the high altar of the Cathedral. Appropriately, this is the vicinity of the "Wee Stair" mentioned later, and only yards from the Haunted Tower itself. In death, I feel sure he will have become acquainted with the deceased residents, whose ghosts he often looked out for in the precincts, including the monk of St Rule's Tower and the White Lady of the Haunted Tower whom he called his Juliet.

Chapter Two

Peeping into the Chamber of Corpses –
The Early Discoveries & Initial Letters of Correspondence

Introduction

Following the initial articles of 1893, a number of academically minded Antiquarians wrote letters to the press deliberating and speculating upon the tower and its mysteries. In this book, you will find all their letters, which make for some interesting reading. In giving it all a dust down, this is the first time some of these letters have seen the light of day since their initial release. I have correlated and cross-referenced them, and placed them in appropriate chapters. What they ultimately reveal when placed together, is a fascinating complexity of mysteries and events associated with the Haunted Tower, spanning some 92 years from around 1826 to 1918.

Having gone through all the individual newspapers in libraries across the country, sifting out the correspondence, I found the University of St Andrews Special Units Collection have a series of scrapbooks collated by Linskill from 1893 to his death in 1929 for the St Andrews Antiquarian Society. In these scrapbooks, he pasted many of these articles and letters amongst those of general Antiquarian interest from across the town and abroad.

The majority of those involved in the correspondence, and those who took part in the various openings of the tower, were members of the St Andrews Antiquarian Society. They were also members of another society, the influence of which has a direct bearing on the mysteries about to unfold.

In 1838, Sir David Brewster (1781-1868) became the Principal of the United College. Upon taking office, he, along with a few others of note, established the Literary and Philosophical Society, 16th April 1838. Known as the 'Lit and Phil's', their remit was "the study and preservation of the antiquities of St Andrews". Refer also to p. 105.

The Haunted Tower around 1905

Middle and lower chambers open, more ivy and graves starting to appear

Cathedral Grounds 1920s

This photo shows more the extent of the ivy across the Precinct wall.

The Haunted Tower 2015

Middle and lower chambers open and no ivy

An Exploration of the Mysteries

In 1925, Linskill wrote a lengthy article for the *St Andrews Citizen* about the Haunted Tower mysteries based on, and incorporating many of these letters of correspondence. The article was entitled 'The Strange Story of St Andrews Haunted Tower', which I quoted briefly in the first chapter. Following his death in 1929, this became a 31 page booklet called '*St Andrews Haunted Tower*'. The *Citizen* then reprinted a short part of this in 1938, nine years after his death as a promotional advertisement for his booklet. I have chosen not to reproduce his article or the booklet in this volume as he unfortunately edited and reworked some of the letters, and in doing so omitted important information to the investigation in hand. So I have included all the newspaper articles and letters from source, but wherever contextually relevant, I have included Linskill's own notes of reference, including his own brief commentaries regarding some of the associated correspondence from his booklet.

In commencing our exploration, it is appropriate to begin with Linskill's introduction for his 1925 article.

"Anything quite out of the beaten track or common every day rut makes a strong appeal to the minds of ordinary mortals. They love new sensations. Something very, very, very ancient like the wonderful Egyptian tombs creates great curiosity and wonderment. Historical, Antiquarian, and especially supernatural matters can fascinate most minds unless they are totally lacking in imagination. What on this earth can be more interesting than hunting for buried old ruins, concealed treasure, crypts, hypogeum's,[vii] dungeons, vaults, oubliettes or tricky winding subterranean passages, stores of deep mystery, and of many queer tricks and pitfalls? What imaginable thing can possibly be more thrilling and exciting than unravelling the mystic tangled web of the awesome wonders of haunted castles or haunted rooms and avenues, and investigating the real cause, nature, appearance, and manners of the supposed ghostly appearances? Trying to get at the real truth of these matters needs nerve, strong will, persistence, pluck, and dour determination. Such investigations are continually going on, privately, day by day all over the world, although we may hear little about them. Sometimes they are ultimately crowned with success. All honour to such intrepid explorers – whatever line of investigation they may take

[vii] Underground chambers

up. The humblest efforts sometimes reveal the unexpected in most mysterious ways, far beyond the comprehension of most folk. Miracles have never really ceased, but continue daily in our midst, often unknown, unheeded, and unsolved. We have still very much to learn".

Linskill then continues with the following...

One of the Mysteries of St Andrews

"One of the many mysteries of St Andrews is without doubt "The Haunted Tower" – that square tower beyond the Lighthouse Turret in Hepburn's great Abbey Wall. There is a deep mystery and romance about this solid, squat, square tower and its former contents: it somehow reminds one of the Capulet Vault or tomb in "Romeo and Juliet" (But the middle chamber in the Haunted Tower was never intended as a tomb), and makes one wonder who was the satin-clad Juliet who lay sleeping in this chamber, and whether there was any Romeo connected with her and her early death. That she was someone of importance – and of great importance – is certain. But what a strange resting-place she had among many others of clearly different periods!"

A Timeline of Events – Pre 1559 to Post 1913

The reports to the press from 1893 are intricate and often conflicting, not least because they involve a number of events spanning a great many years. To aid any initial confusion in what you are about to read of when events occurred, I have added the following timeline as a guide. This is the first time any have correlated, let alone published a logical sequence of events surrounding the intriguing mysteries of the Haunted Tower.

1516-1559 – Chamber was sealed. The period between which the bodies were placed in the middle chamber of the tower.

1609 – Chamber fully opened. The first opening appears to be when a memorial stone was erected on the south-facing wall of the tower. This is also the year one theory suggested the bodies themselves were interred in the tower.

1826 – Chamber fully opened. An unofficial opening of the tower's middle chamber carried out by a Professor of the United College and some academics.

***Pre 1860** – Body of a "White Lady" observed in a chamber along Hepburn's Wall.

Pre 1861 – Body of a "White Lady" observed in the tower.

***1861** – Three corpses observed in a chamber along Hepburn's Wall.

1868 – Chamber fully opened. An official opening of the tower and the White Lady corpse observed.

1868-1888 – Chamber fully opened. At least one secret opening of the tower and the White Lady removed.

1888 – Chamber fully opened. An official opening of the tower – the body of the White Lady disappears!

1891 – Chamber fully opened but not resealed. An official opening of the tower. The sealed entrance removed and an iron grating or grill put in its place.

1913-1918 – The remains of bodies given a decent burial. The former iron grating or grill replaced by an iron gate.

Despite this information being available, this is the first time the articles and letters appearing in the press between 1893 and 1925, have been pieced together to ascertain how many times the chamber had been opened. The above timeline suggests the middle chamber was fully opened and sealed at least six times, and unknown to each explorer, this accelerated the process of decay of the bodies found within.

As part of the investigative process, by correlating the finer detail in the mêlée of information you will shortly read, there appeared to be conflicting descriptions in what was found. I then had a thought, what if the disparities in some of these reports referred to another chamber? To clarify some of the confusing and seemingly conflicting testimony, on looking at it all again, I found a correlative pattern, suggesting

Hepburn's Wall has another chamber with an occupancy sharing in remarkably similar details to that found in the middle chamber of the tower. I then realised this is where some of the confusion was arising in the testimony. Accordingly, this second secret chamber has been documented at least twice up to 1861, which I have marked on the timeline with an asterisk. The accounts of this period are also suggestive of the contents of this second chamber being observed on other occasions up to this period by casual passersby peering through small holes and chinks in the wall. A further elaboration of the evidence for a second chamber commences on p. 63, but I mention it here that it will give a little perspective to some of the conflicting documented evidence we know indulge ourselves.

Pre and Post 1849

One of the early reports of a woman being seen in Hepburn's Wall is via the following contribution from Linskill's article of 1920, 'St Andrews Tales of the Past, the Strange Mystery of the Haunted Tower', where he speaks of what Captain Dan (featured earlier in the Star Bar photo) heard over the years about this haunted quarter by the harbour.

"Captain Daniel Wilson, a well-known St Andrean, informs me that many years ago his father was custodian of the turret light-house. He had several brothers and each of them had in turn to light and extinguish this lamp.[viii] In those days of long ago, Hepburn's Abbey Wall was thickly covered with the most luxurious ivy [it can still be seen in two of the photos on p. 24 and was still present in the 1920s, but may have been more extensive along the length of the perimeter wall] and it was a great bird-nesting rendezvous for the laddies of the past. There were several gaps and chinks then in the solid masonry of the mystic old Haunted Tower, and the boys enjoyed peering through these gaps and seeing with awe and wonder the form of a lovely girl robed all

[viii] The Catholics created a powerful light here by supplying it with wood and coal as a beacon for shipping. With the Reformation, the light went out and the lighthouse wasn't used again until 290 years later in 1849. This is when Captain Wilson's father and brothers maintained it, and unlike their Catholic predecessors, they powered it by gas lighting. The lighthouse, a fixed beacon, was in operation right up until the mid 1940s (probably just after the Second World War) when the Coastguard watchtower/lighthouse was created by the former eastern gable of St Mary on the Rock overlooking the harbour.

in white lying stretched out in her coffin within that tower. The lid, an early cope-shaped affair, had apparently slipped off, and lay on the chamber floor beside the coffin, exposing to view the form of the young girl who had very beautiful features to the awe-stricken gazers, who, after peering in, used to flee in terror".

I have placed the time period as being around 1849 which was the first year the turret light-house resumed operation since the Reformation of 1559, but his reference to what the boys saw in the tower could well apply to many years before this period, as well as to many occasions after.

Pre 1860

The Saturday Review Article – Part One

On November 18th, 1893, the *Saturday Review* published an article titled 'St Andrews Howkings'.[ix] It included a letter of reminiscences giving brief details about researches and observations over the years by Rev. Skinner. He was a local Antiquarian and the first priest of St Andrews Episcopal Church in Queen's Gardens (consecrated in 1869). He was also a member of the Literary and Philosophical Society mentioned earlier, and was described in the membership records as "The keenest Antiquarian in the 1860s". According to Linskill, who saw the letter, Skinner had written it to Mr T. T. Oliphant[x] of Queen Mary's in 1860 on the eve of his departure from St Andrews.

Skinner writes, "Among other reminiscences, I recall looking at some stonemasons repairing the Abbey Wall near the Lighthouse Tower, under a slab in the same wall bearing an inscription to the effect that 'A Gray of Kinfauns was buried near'.[xi] A chisel belonging to one of the workmen fell through an interstice and disappeared. I urged the men to take out some of the stones of the wall, when, lo! we found a vault in the interior, and, striking a light, we discovered a coffin with a

[ix] 'Howkings' as they were known in St Andrews, was a word given to the excavations carried out by the St Andrews Antiquarian Society.

[x] He was an active member of the church in Queen's Gardens.

[xi] I have looked for this inscription but there is nothing along this stretch. There are however a few mural slabs in the Wall along here that have completely been worn away leaving no remnants of their inscriptions.

roof-shaped lid, which had partly fallen off, and inside was the form of a female dressed in white satin, which, when touched, became dust, and on her skeleton hands and forearms she wore long white kid gauntlet gloves, with numerous buttons of gold. The wall was built up again…".

There is no specific date for when this happened, other than it was before 1860. Linskill reproduced part of Skinner's letter in his article *A Girl Mummy in a Chamber of Horrors* in 1894.

1861

Before giving details of the second *Saturday Review* article, which was the one to really capture the Victorian imagination, we move briefly to an account by John Grieve, a local stonemason who corresponded in the *Citizen* about what he saw in 1861, one year after Skinner wrote his letter.

THE HAUNTED TOWER.
(To the Editor.)

SIR, - In the year 1861, when about fifteen years of age, I assisted John Ainslie (a mason) to open this tower.

I then saw the body of a woman, with a silk napkin tied round her head. She was lying on the floor of the chamber, and the coffin was sticking about three feet above, and the bottom had fallen out. She was in a state of perfect preservation, and had long black hair[xii]; otherwise she was quite devoid of clothing.

I saw no gloves as has been stated. This statement from one engaged in the opening of the tower may be interesting. The local inspector of the Board of Works [Hall] made us build up the opening. Several other bodies were in this chamber. – I am, &c.,

John Grieve, Mason
3 Crail's Lane, St Andrews

This statement by Grieve was also reproduced near the end of Linskill's 1925 article. Headed '*Grieve, the Mason's Story*' he calls him James not John. He also omits the year when this occurred and the date of Grieve's statement in the paper. Grieve wrote the statement to the

[xii] Grieve is the only one to mention her having long black hair. Refer to p. 102

Citizen following the publication of the various articles about the tower in 1894.

I refer again to Grieve's account and these other early accounts later, as they play an integral part in unravelling the tangled web of reports appearing around that time.

1868
From the Telegraph Interviews of 1893, Incorporating the Second Part of the Saturday Review Article

Introduction

Linskill says, "This old Haunted Tower and its white girl had been almost forgotten when the embers of the old romance were once more fanned into flame by a remarkable article that appeared in a number of the "*Saturday Reviews*".

The impact of this two-part article was broadly influential. The second part entitled 'More St Andrews Howkings' published on November 25th 1893, one week after the first, carried with it an epilogue that told an incredible story. Everyone loves a good mystery and on this occasion, the *Saturday Review* did not disappoint. This was the first time details regarding the opening of the tower had found their way into the public arena, providing a real mystery to grapple with.

A day or so after its publication, based on the strength of the article, the *Telegraph* sent a reporter to St Andrews to conduct interviews, which they then published the following week.

What follows is the full *Telegraph* article. It originally included an edited version of the all-important epilogue of the second part of the *Saturday Review* article. To save repetition, rather than reproduce it separately, I have inserted the full version in its appropriate place near the beginning of the article.

This is quite a complex article so to clarify a number of points, the footnotes and everything contained within square brackets are my own. In a later chapter, I begin to unravel the article and clarify the details you are about to read...

The Telegraph Interviews
THE HAUNTED TOWER
OF ST ANDREWS

———

THE TRUE STORY OF THE
CATHEDRAL TURRET
FROM A SPECIAL REPORTER

Article dated November 1893

Articles have appeared lately in the *Saturday Review* with reference to St Andrews, and in last Saturday's issue there was a paper dealing with some of the subterraneous passages of the ancient city. At the end of the article was a "little epilogue," as it was called, in which was described with some considerable amount of circumstance and detail what was discovered when one of the towers of the Cathedral Wall was opened.

The reviewer tells how, wishing to clear up the mystery of the Haunted Tower, several gentlemen forced a hole in the wall....

[Authors note. Here is the epilogue of the second part of the *Saturday Review* article November 25th 1893. This short article wasn't only crucial to the tone of the *Telegraph* reviews, it laid the foundation for many subsequent articles emerging following its publication. What you are about to read is the first published account of the opening of the tower to include what they found within.]

[The *Saturday Review* Article – Part Two]

Discoveries within the Tower

"Not till 1826 was the litter of ages removed from the Cathedral, when the Government of the day had the grace to make an end of that crying scandal. Shortly after the place had been put to rights, a body of local Antiquarians were minded to open a certain turret that looks out on St Andrews Bay. They went to it one day, accordingly, and pulled down certain stones in the wall; and when there was room to admit the body

of a man, one of the party squeezed in his head and shoulders and all of him, in fine, but his feet. Suddenly these became quite rigid; and his friends, pulling him out, found that he had fainted. While he was being attended to, a second man peered into the black hole, in like manner; and he, too, was pulled out in a very ill way. Finally, a Professor of the United College forced his entire person into the cavity, and did not faint; but presently reappeared, with the corpse of a woman in his arms, from which the life seemed to have gone but that hour. The turret was now fully explored; and, sitting round in a circle, were found twelve bodies decked as at a feast, and all of them untouched of decay. The Professor on the instant sent off to the Lord Advocate, asking what course he should take. The answer came to close it up immediately if he would avoid prosecution.[xiii] And this was done, and the matter hushed up".

The article was evidently intended for consumption in London, where no doubt it would be highly appreciated. In St Andrews its effect was twofold. It astonished those who did not know much about the "mystery" of the Haunted Tower, and excited the risible faculties of those who did. With the view of "laying the ghost," and of eliciting all the known facts of the subject, a *Telegraph* reporter [from Dundee] visited St Andrews yesterday, and called upon certain gentlemen, whose

[xiii] The Advocate was not happy at what the Professor told him. After speaking with him of the discovery, the bodies were replaced and the tower resealed. An injunction had been issued accompanied by a threat of prosecution if this was not immediately carried out.

For many years there have been rumours of Egyptian curses, extending to a number of fictional stories written in the 1860's, where a female mummy took revenge on those who had desecrated her tomb. An impending curse would befall anybody tampering with her dwelling place of the dead. The Georgians and Victorians, being particularly prone to taking such curses seriously was reason enough for the decision by the Advocate for its rapid closure in 1826.

We know the workman of that time had no qualms when it came to discarding the bones they would frequently come across in the Cathedral grounds, but bodies in a crypt were different. They held their own importance, albeit fairly abstract. Desecration was one of wilful violation and crypts had their own bad omens to affect those who would violate their sanctity. Although those in the tower and the bones they found in great quantities in the grounds were still of the deceased, the bones in the grounds were found accidentally and held no importance. Christian corpses generally commanded respect, compared with those of Egyptian mummies but this was the mindset of the day and mirrors the difference between the general 'respect' for the dead and workmen doing their job.

names are a sufficient guarantee of the general accuracy of their statements. It will be observed that there is a substratum of truth in the *Saturday Review's* story, but the vast and gruesome superstructure, on the first inspection, melts "into air, into thin air," [this is the part which stated "sitting round in a circle, were found twelve bodies decked as at a feast"] leaving a very matter-of-fact story behind. Although some of the smaller points raised are not altogether clear, yet the main facts, which have been known to several gentlemen for some time, are explained, and the tower finally robbed of its terror. That the facts were not made sufficiently public at the time will perhaps account for the credence with which the *Saturday Review's* story was received. The tower was opened for the first time of which any record has been discovered in 1868, and subsequently in 1888, when the mystery, so far as the nature of its contents was concerned, was finally cleared up.

Mr Hall

Our reporter first called upon Mr Jesse Hall, Gas Manager, who is the local representative of the Woods and Forests Department, and on stating the object of his visit, Mr Hall laughed heartily. (Parenthetically it may be mentioned that all the gentlemen on whom our reporter waited laughed more or less when he stated his business.) I suppose, Mr Hall, you have seen the statements in the newspapers lately regarding the Haunted Tower at the Cathedral?

[Hall] Well, yes, I have heard about them.

[Reporter] Here is a cutting from the article in the *Saturday Review.*

[Hall] I don't know anything about the Professor that is mentioned. That must have been at a later time. Nor did I ever hear of the threatened prosecution.

[Reporter] I came to you because, as local representative of the Woods and Forests Department, I thought you would know something about the affair. Would you be so kind as to give the story of the opening of the tower as far as you recollect?

[Hall] I have been about the ruins since 1845, more or less, and I will tell you all I know about this tower. This tower is situated on the wall next to the Scores, a short distance from the tower with the light on it. There has been a parapet wall along the whole of the Cathedral Wall, but it is nearly all down now, and the pathway goes right through the turret in question. This turret seems to have been roofed, although none of the roofing remains. This turret, however, is the best preserved

of the lot. About the time that the first entrance into the tower was effected [1868] we had been engaged in levelling down the grounds, and had lowered the surface for a couple of feet. At the foot of this tower we found a vault which was filled with bones. It was afterwards found that a sexton, picking up more bones than he could easily get rid of, popped them all through a little hole into the vault. From time to time we had also thus engaged, the mason knocked out one of the stones in the wall of the tower. A few steps led up to what was discovered to be a door built up with thin stones. Here is an extract from a book of jottings belonging to the late Mr Smith, watchmaker [1801- 1873][xiv], purporting to give an account of what took place. Mr Smith says:-

"Square Tower on north wall of the Cathedral grounds.

This tower had often been a subject of curiosity to me, and I felt anxious to examine the interior. Old people call it the Haunted Tower. The lower part of it had been cleared out some time ago. The tower projects a considerable space from the line of the wall on both sides, and has had a stair leading up to a doorway, which is built up. I had frequently asked Mr Hall, the Inspector, to make an opening to see the interior, and on 7th September, 1868[xv] he, along with Walker, myself, and T. Carmichael, mason made an opening in the doorway sufficient to get in. We found it a square chamber, with a recess westward in the body of the wall, in which were a number of coffins containing bodies, the coffins being piled one over the other. The bodies – about 10 in number – which we examined, were in a wonderful state of preservation. They had become dried and sufficiently stiff to be lifted up and set on end. Some of them appeared to have been wrapped in linen, and must have undergone a sort of embalming. One of them – a female – had on her hands white leather gloves, very entire, a piece of which Carmichael took away as a reliquary. Some of the coffins were of oak, some had been ridge-topped, and in some were remains of

[xiv] Mr David Couper Smith, was a watch and clock maker with a shop and workshop at 95 South Street, St Andrews. Known as "Tickie Smith" he died five years after the 1868 opening in 1873, so his report couldn't have been written long after the opening. His business was succeeded by his son, also called David.

[xv] This was 42 years after the start of the initial clearing of rubble in the Cathedral precincts and the start of the speculation as to its purpose.

waxcloth. Nothing was found to indicate who they were, or when they had been laid there. There is a monumental stone inserted in the front of the projecting part, but so much worn away that I can make nothing of it".[xvi]

Mr Hall continued his story thus:- "Well, I am not sure about Carmichael, I think it must have been John Ainslie. He had been pointing the walls, and the stone gave way. He looked in and got a scare, and then told me about the hole. The hole was built up at that time without the vault being opened. Unfortunately, I did not keep a note of the dates, so that I do not know when that would be. But Mr Smith, watchmaker, and Mr Walker, the University Librarian [The University Library was the King James Library in South Street, opposite Mr Smiths clock shop], who were both antiquaries, but are now dead, pressed me frequently to allow them to open the vault. I did not care about it, as I did not like to disturb the dead; but I at last consented, and early one summer morning before six o'clock – as we did not want to make it public – the three of us, Mr Smith, Mr Walker and myself, went to the place and made a small hole, just enough to admit a man's head and shoulders. The doorway opened into a passage, and round the corner to the left was the vault proper. We all scrambled in, and by the light of a candle, which we carried, we saw two chests lying side by side. And others piled on top of each other. I cannot say how many chests there were. We did not want to disturb them any more than we could help. There would be half-a-dozen as far as I can remember. We did not turn them all up, but we saw that there were not bodies in any of them except one, in which there was the

Body of a Girl

about four feet and a half in length. The body was stiff and mummified like. It was naked, with the exception of what appeared to be a part of a glove on one of the hands [1861]. I think we lifted it up [1868]. About three years ago, [1891] General Playfair and two of his brothers[xvii] got permission from the Office of Works to open the vault, and it was done under my superintendence. At that time we got no bodies, but had all the coffins taken out, and then put them back again and we put up the

[xvi] Refer to p. 138

[xvii] Sir Robert Lambert Playfair d.1899, Lyon Playfair, d.1898, William Smoult Playfair, d.1903. Refer to p. 44

present iron grating, through which you can see into the passage, but not into the vault proper. Some of the coffins were of fir and some of oak. We found oak ones more decayed than the fir ones.

[Reporter] Where had the body of the girl gone in the interim between these two visits? [This was between 1868 and 1891. He didn't know it was also opened in 1888 until his interview with David Hay Fleming later in the day.]

[Hall] I don't know. After we went in the first time we shut up the hole, and kept the matter a profound secret, and I did not know that anyone knew of it except ourselves. People had been in the habit of calling the place the Haunted Tower, and when going to the harbour they ran past it. No one had any idea that it was a place of burial till we opened it. I do not know if there is any historical reference to it at all; nor am I aware of it being entered pervious to our visit. Mr Henry, however, may be able to give you some information as to whom it belonged.

[Reporter] How do you account for the preservation of the body?

[Hall] I cannot say. The soil is so dry there that bodies decay in about 12 years. I was once told by a Professor that if a person died under certain conditions there is no difficulty in preserving the body.

Thank you very much, Mr Hall, for your kindness.

Oh, don't mention it.

Professor Heddle[xviii]

Our reporter then made his way to the residence of Professor Heddle, and he found that gentleman busily at work in his study.

Can you give me anything about the opening of this Haunted Tower? I suppose you will have seen it mentioned in the newspapers during the last day or two.

Yes, I have seen it mentioned, but it is so long since the thing happened that I don't remember much about it now. I recollect hearing about some discoveries at the tower – it might be in 1868, but I am not

[xviii] Professor Matthew Forster Heddle (1828-1897). He was the Professor of Chemistry in St Andrews from 1862 and a noted mineralogist in his day. Based in the United College at St Salvator's he collected quite a number of the famous Dura Den fossil fish, which he gave to the College Museum. He was a prominent member of the St Andrews Literary and Philosophical Society and was also an Antiquarian.

sure – I went to it in company with the late Dr Traill.[xix] We saw a large number of skulls which had been found in the lower part of the tower. We went over the skulls – and this, I think, is more interesting than that nonsense you have come to ask me about [the White Lady]. We found that not one of those individuals ever had the toothache; their teeth were in splendid condition. Then we found that in some of them the atlas bone – that is the last bone of the vertical column was anchylosed to the skull, that is, there was a bone union instead of a cartilageous one. So that none of these poor fellows could have turned their heads without turning their bodies. Another curious thing was that in the case of about a dozen skulls the lower jaw was tied up with yellow silk banana handkerchiefs, in which there were bleaching holes. Now, there is no record of this place being used for burial purposes during the last 200 years, and it is within 200 years ago that Schwele invented the process of bleaching by chlorine, which makes the holes.

But it is said the sexton put the bones there?

Well, I only saw skulls.

What was ultimately done with them?

Some of them were laid out to be taken to the Museum, but Principal Shairp[xx] objected, and they were ordered to be put back again, although it was said they were finally thrown over the brae into the sea. A day or two after this, hearing that the upper part of the tower had been opened, I went down, and climbing the ladder, stuck my head and body into the hole. I saw at least two coffins lying east and west, and apparently others piled upon one another at right angles to these two. I examined the nearest body and found the head lying back as if it had broken off the body. The two nearest coffins had fallen to pieces. I put my hand in and felt the chest, which was exposed at the left side. It was the body of a deep-chested man.

[xix] Dr William Traill, St Andrews University. Like Heddle, he was a member of the St Andrews Literary and Philosophical Society. In the same year he visited the tower with Professor Heddle, he also became an Antiquarian. Joining the Society of Antiquaries in Scotland, 13th April 1868. He wasn't interviewed as he died 8 years before the appearance of this article in 1886.

Dr William Traill and Professor Heddle shared associations with Orkney. Heddle was born on Hoy, one of the most dramatic of the Orkney Islands, and the Traill family name was seated both in Blebo in Fife and in Orkney as far back as the 15th Century.

[xx] John C Shairp, Principal of the United College: 1868-1885. Refer to p. 57

You are sure it was not the body of a woman?

Oh, no; it was a man. The body was wholly converted into adipocere, – that is, a fatty substance.[xxi]

Do you know anything about the subsequent history of the body?

No. My impression was that the hole was built up, and that the body is there yet.

You did not bring out the body in your arms?

Oh, no; I had only my head and arms in.

Good night, sir; and thank you very much.

Good night.

Mr Henry

architect, was next visited…

[Henry isn't mentioned in any correspondence as being present at the opening but I have found there is every possibility he was, which I discuss later. David Henry, an Antiquarian and an architect in St Andrews. He studied the architecture of the tower and wrote a lengthy piece about his own theory of who the occupants of the tower were. To save unnecessary repetition I have left his somewhat involved speculative research to Chapter Ten. Titled *The Clephane Family Mausoleum,* the chapter includes details of his findings as disclosed in the press, and features correspondence for and against his theory. I continued Henry's research at some length, to see what additional material I could uncover, and whether there was anything to validate his argument for the identities of the occupants, all of which is also incorporated. Refer to p. 129]

Mr D. Hay Fleming

This was the last gentleman on whom our reporter called. After a few preliminary remarks, in the course of which Mr Fleming explained that he was just a boy in 1868, and so had no distinct recollection of the facts of the first opening of the tomb, he turned up a guide book to St Andrews which he had published, and in which the tower was briefly

[xxi] Adipocere is a greyish white or brown waxy substance formed during the decomposition of a corpse lying in a moist place of burial. Also known as corpse, grave or mortuary wax, it is created by a reaction occurring between moisture and the body's fatty acids and calcium soaps.

mentioned. I think (said Mr Fleming) It must have been Mr Carmichael, and not Mr Ainslie [as the stone mason that Mr Hall had stated earlier who had been present at the 1868 opening] because Mr Smith was a very exact man.[xxii] Besides I remember Mr Carmichael's son, who is now dead, telling me that his father had told his family about the visit to the tower.

[Reporter] Do you know anything about the second visit?

[Mr D. Hay Fleming] Well, on 21st August 1888 Mr Linskill, who had been making excavations about the town, had the tower opened. Sir Lambert Playfair was there and some others,[xxiii] and an iron grating was put up in the doorway. [The iron grating was put up in 1891]

Where did the bodies go?

I don't know. There were either one or two surreptitious visits between 1868 and 1888. Mr Linskill found the interior in great disorder – bones and fragments and coffins were all mixed up. As many as 13 skulls were counted. It is certain that the chamber was tampered with between 1868 and 1888. I see also that Mr J. Kirk, sculptor, was concerned in the first opening. From what I remember of Mr David Carmichael's[xxiv] story to me, three coffins were found, which had apparently been placed on trestles, but these had given way. In one of the coffins there was the body of a lady, which seemed to be quite fresh, and there was a glove on her hand. The vault is 8 feet high, 10 feet 8 inches in length, 6 feet 3 inches broad at the widest part, and 3 feet 3 inches at the narrowest part.

What was done with the bones, &c?

I understand they were all arranged in a corner, and are there yet.

I don't suppose you will have any idea as to whom the tomb belonged?

I have no idea. But I do not think it could have belonged to Gladstanes, who died in 1615, as he was buried in the Town Church, not far from Archbishop Sharp".

End of the *Telegraph* article

[xxii] He says this because Smith was a watchmaker.
[xxiii] Refer to p. 43
[xxiv] This is the son of T. Carmichael.

Archbishop George Gladstanes

Archbishop George Gladstanes was Archbishop of St Andrews from 1605 until his death in 1615. He succumbed to a disease at his residence in the castle and was interred in Holy Trinity Church.

He had been a candidate as one of the occupants by a few correspondents. This was because of the letter G on the now deteriorated mural on the south facing wall of the tower.

Fleming was the first in print to mention Gladstanes in connection with the tower. For him to dispel the idea of him being one of the occupants suggests there had already been talk of this as a possibility before the December 1893 interviews. Two months later, the *Scotsman*, 31st January 1894, in not seeing Fleming's comment, speaks of Archbishop Gladstanes as being a possible occupant. The *Scotsman*, said, "On one of the corners of the stone is plainly discerned the letter G. At the date of the erection of the monument Gladstanes was Archbishop of St Andrews, and it is suggested that the vault may have been the burying-place of that family".

A Note about David Hay Fleming

David Hay Fleming was possibly the greatest local historian of St Andrews. He was also an Antiquarian, and before his death in 1931, he bequeathed his collection of books to St Andrews, along with a sum of money for the founding of a town library to house his collection. Built in 1932 this was the 'Hay Fleming Reference Library'. His 13,000 strong collection of books included a great many of Scottish interest. I spent nine months in the library working my way through his collection. Written over the centuries, it includes many books about St Andrews and Fife, including his own publications on St Andrews.

Inside the library, a wooden stair on the left side of the building (opposite side to where it is now) led up to the first floor reference library room where the collection peered out from behind glass-fronted bookcases lining the walls. This room had the most wonderful air, more Victorian than Georgian in ambiance. With its creaky, dark varnished floorboards, the room had a great long heavy wooden table with matching chairs along its length, providing a quiet, aesthetic area conducive for the study of his collection.

Since the books formed his personal collection, he frequently wrote notes in the margins and footnotes in pencil. These were annotations

recording details of his historical findings since their publication, and add considerably to their historical wealth and importance. I went through all these books and recorded the notes.

David Hay Fleming
(1849-1931)

In 2000, the council moved the collection to the archives of the University and completely gutted the internal structure of the building. This so-called 'upgrading' of the building thoroughly destroyed the character, charm and historical worth of something really quite unique and valuable for the town.

A tragic testament for a man with such a passion for the history of St Andrews, and one who looked to preserve its integrity, not destroy it - and for what? Glass partitions, industrial carpeting and a few banks of computers that would have sat quite at home along either side of the long wooden table in his reference section.

Chapter Three

Post 1868 Openings of the Haunted Tower

1888

The White Lady Disappears!

At the end of the epilogue to the second part of the *Saturday Review* article, there is the following interesting piece. "within the last few years two of those present at that strange disinterment [1868] were surviving, and they told certain of the modern excavators their story, which, indeed, there was documentary evidence to support. So once again, and at night this time, the turret was secretly opened up [1888]".

The two original members were Hall and Grieve, both knew Linskill and their collaboration resulted in William Linskill heading the opening of the tower again in 1888 as Dean of Guild for St Andrews. This was a highbrow venture carried out in secret at midnight. Some very prominent members of St Andrews were in attendance, including three of the Playfair brothers. They were sons of Lieutenant Colonel Sir Hugh Lyon Playfair (1787-1861). He was a Provost of St Andrews and helped transform the town from one filled with dunghills and herring guts to one of the top leisure and study destinations in Europe.

Also present in 1888 were
William Linskill
Mr Jesse Hall (Supervising)
John Grieve (Stonemason)
Rev. Mr Skinner

It is also possible other Antiquarians were present including Professor Matthew Forster Heddle, Arthur Stanley G. Butler, Sir James Donaldson, David Henry, and Dr William Oughter Lonie, Rector of Madras College. Although there is no mention of them in any of the documents, they were all prominent Antiquarians and members of the

Literary and Philosophical Society. Heddle had been to the 1868 opening and was now Vice President of the Literary and Philosophical Society. Butler was Honorary Secretary of the St Andrews Antiquarian Society, Henry knew Hall, and along with being an Antiquarian, Lonie was one of Linskill's close aides when it came to looking for the underground passages and chambers. Born 1822 Lonie died in 1894. Refer also to foot of p. 190.

Sir Robert Lambert Playfair
1828-1899

Dr William Smoult Playfair
1836-1903

Lyon Playfair
1818-1898

Linksill corresponded with the press about his 1888 opening of the tower in a number of articles over the years. With the passage of time, his descriptions contain discrepancies in both what he saw, and the degree of preservation in what he found. There are a number of reasons for this. He wrote the reports between 1894 and his death in 1929, and his 1888 descriptions were often mixed with details of an excursion to the tower in 1891. Being also somewhat of a showman, the press was an ideal vehicle with which to showcase his flamboyant personality, and mixing or embellishing the descriptions made for better copy.

I start with his 1918 report of the 1888 opening, which appears to be reasonably accurate as a follow on from the 1868 reports 20 years earlier. Titled 'St Andrews Wonderful Old Haunted Tower', October 5th, 1918, he begins by introducing Grieve as one present at the 1868 opening of the tower. The collaboration resulting in his 1888 opening came because of Grieve's description to him of what he saw in both 1861 and 1868.

"About 1885 [this was 1888] I got hold of Grieve, the mason, who had with some others early one morning years before [1868] privately removed some masonry, and entered and examined the interior of this mysterious tower. He said he saw lots of mummified bodies, but what he would never forget was the form of a beautiful girl dressed all in white lying in a lidless coffin, with gloves on, her eyes were closed, and she just looked as if she had fallen asleep not long before".

In Linskill's article '*A Girl Mummy in a Chamber of Horrors*', 1894 he says, "Grieve, a mason in St Andrews – still alive [1894] – was the man who gave me fullest details of the place, &c. He was a boy in 1868, and helped the mason to open the turret. When Grieve told me his story I sent him to Mr Hall. Ghost tales of the usual absurd kind are numerous regarding the tower at night. I am almost certain I have seen somewhere or been told of the opening of the tower many years ago, when measurements were taken and the girl mummy seen". Linskill's last reference here appears to be from the professor's opening of the tower around 1826 although he couldn't remember his source.

Continuing his 1918 article 'St Andrews Wonderful Old Haunted Tower', he says, "My curiosity was aroused, and having got permission, one night I and several others, accompanied by Grieve, took out a few stones, and entered the chamber of mystery. The coffin was there as described, but there was no girl in it – she had vanished. As Grieve said – "Aye, there is the coffin just as I saw it years ago; but they have stolen the bonnie lady".

Who the girl can have been, and who took her away I would like to know; also whither she was taken. Besides this empty coffin there were some very well preserved skeletons, or mummies, lying about, and a lot of broken up coffins and wood and some straw. We built the opening up again..".

Later in this article he continues, "I may conclude by saying that when I entered the chamber, head first, through the small hole in the masonry, I saw nothing alarming whatever about the place, but felt a

sensation of the deepest interest and deep regret that "The White Lady" had been so ruthlessly abstracted, for it was her I wanted to see".

The following article was again part of Linskill's 'A Girl Mummy in a Chamber of Horrors'. This section was also reproduced in his Citizen article of 1925 with the following title...

The Tower Opened at Midnight

"On the 21st of August, 1888, at midnight, I opened up the tower. Among others I had with me was Grieve, who when a lad and an apprentice mason opened the Tower for Mr Hall, Mr Smith, Mr Walker, and others of whom I have spoken. When I first visited the turret and examined it, I found the whole of the interior in a most dire confusion. Wood and bits of coffins were flung about all over the place, and rather well preserved skeletons were lying here and there on the floor, and a lot of loose skulls. Strangely, I found a lot of hay and straw in the chamber or vault, and my opinion is that the often-talked of bodies, if they ever-existed, must have been packed up and removed by someone. The skeletons and fragments of coffins are now carefully stowen away round the corner out of sight. Abroad I have seen a body in a state of 'adiposia',xxv but certainly none of the remains I saw in that turret resembled that condition".

Although Linskill describes the bodies as skeletons, at the end of his piece 'A Place Dreaded in the Dark' in 1929 he says in reference to 1888, "The mummy figures I have seen and handled. The White Lady, alas! I have never set eyes on, as she must have been stolen or carried off before I entered and explored the ancient tower. I fancy these few facts will be of interest to many Antiquarians. I know they interest me vastly".

Linskill talks of seeing mummified figures, but he contradicts himself as he says in another report "the often-talked of bodies, if they ever-existed, must have been packed up and removed by someone".

Rather than being removed, some had deteriorated since Heddle's tentative examination of one of them twenty years earlier, so none now resembled the state of adiposia he had described. However, the "rather well preserved skeletons" he mentions, were the mummies seen on previous occasions.

xxv When the whole body has turned into a fatty substance.

Continuing Linskill's 1888 account (written in 1894) he says, "I can only speak of what I saw with my own eyes, but a very large number of people swear to having seen the girl, who was probably embalmed. When Grieve, the mason, came and saw the place he said – "Oh, that's all quite changed, not a bit like I saw it years ago when I helped to open it" [1868].

He showed me the corner where the bonny lassie had been resting, and told me she lay there with her long hair just as if she was taking her sleep – not a bit like death – and her dress was beautiful. It puzzled one to imagine the actual personality of this youthful and bonny Juliet laid to rest in such a strange place with such strange companions and surroundings. None of the occupants of this chamber in the tower had ever really been buried. Many persons absolutely refuse to be deposited below the soil, and there are many coffins kept above ground in strange buildings and handsome surroundings. I know of many at home and abroad. One man desired to be laid to rest on the roof of his house. He said he wanted to be up, not down.

A very rare glimpse inside the hidden chamber of the Haunted Tower in Hepburn's Wall where the coffins were found. Very few over the centuries have seen this, and this is the first time the hidden interior has been in print[xxvi]

I remember Professor Heddle telling me of putting his hand on the chest of one body. [This confirms Heddles report about his 1868 experience.] I think it was Professor Heddle who opened a tomb in St

[xxvi] Photographed by Richard Falconer, and published with kind permission of Historic Scotland, Edinburgh

Leonards Chapel, assisted by a man named Greig,[xxvii] and saw for a minute a prelate therein quite intact, but almost immediately it crumbled away to a small heap of dust".

In another article published in 1903, Linskill again speaks of the 1888 opening, and reuses some of his previous 1894 'Chamber of Horrors' article, but he changes a few words and records the date of the opening as 1866. This is a misprint, in one of the early St Andrews Antiquarian Society scrapbooks he crossed out the 66 and wrote in 86, which was also wrong! It should have been 88.

He says, "when we examined this "Haunted Tower" about 1866 [88], took down the built up door and fixed in the present iron grill [1891], we found the chamber in a state of dire confusion, coffins thrown about, and some rather well preserved skeletons lying about here and there. One of the masons employed remembers seeing the female [Grieve], but on our visit she had entirely disappeared. It is a remarkably curious place, and its former use has caused much discussion in the papers, Mr Skinner was also present at the excavations which laid bare the old chapel on the Kirk Hill". Albeit indirect, this is the only reference to Mr Skinner being present in 1888.

The following is an important newspaper article called 'The Howkings' by Linskill in 1888. Written as part of one of his on-going commentaries on the howkings around St Andrews, this is the earliest *printed* record of the tower being opened.

"On Monday a start was made at the square tower in the Abbey Wall, north-east of the St Regulus Tower, and immediately beside the Kirkhill Beacon. The tower is a square one, and rises some distance above the wall. Permission was obtained from the First Commissioner of Works [Mr Hall] to open the built-up door into the tower. While the rubble stones were being removed, several richly-moulded stones were being removed which had been employed in building up the door and are being preserved. Eight steps lead up to the door, which is about five feet from the ground, were laid bare.[xxviii] The door measured 2 ft. 3 in. In width and in height 5 ft. 9 in., and led into a chamber which measured 6 ft. 2 in from the door to the east end and 6ft in breadth from north to south. The total length from east to west was 10 ft. 8 in.

xxvii Mr George Greig, was head of the Woods and Forestry Department before Hall took office in the 1840s.

xxviii There is an importance here, which I elaborate upon on p. 174.

The chamber was shaped like the letter L. and the width of the west end was 3 ft. and the height 8 ft. The door is not to be built up again, but an iron grating is to be fixed to allow the curious to see in".

He mentions in a couple of reports about an iron grating being put up instead of the wall in 1888, here he is more specific and says an iron grating 'is to be fixed there', not that one has been fixed there. The iron grating didn't replace the stone wall until 1891, so it must have taken a while for them to either gain the necessary permissions or work out what they wanted to do with the chamber.

The article was written only a few days after the 1888 opening. It may have been noted that Linskill preserves the integrity of secrecy for the occupancy by giving no indication of what they found within. In fact, from his description, many who read this in 1888 would presume the chamber to have been empty, and his suggestion that a grating be put up to allow the curious to see in would confirm this. When he says in his chambers article of 1894, "The skeletons and fragments of coffins are now carefully stowed away round the corner out of sight," he is again referring to 1891, which is confirmed by the following.

1891

Mr Hall in his interview for the *Telegraph* article of 1894 says, "About three years ago, [1891] General Playfair and two of his brothers got permission from the Office of Works to open the vault, and it was done under my superintendence". Hall continues, "At that time we got no bodies, but had all the coffins taken out, and then put them back again and we put up the present iron grating, through which you can see into the passage, but not into the vault proper. Some of the coffins were of fir and some of oak. We found oak ones more decayed than the fir ones".

Hall could have muddled the dates of 1888 and 1891 but David Henry, who also confirmed the involvement of the Playfair's, confirmed the date when he said "some twenty-three years later [being after 1868, which again makes the year 1891] a privileged party obtained access again but they found little but the remains of the coffins".

This was the second time the Playfair's had been involved in opening the tower. They attended both times in an official capacity and were greatly interested in the chamber and its mysterious corpses.

Chapter Four

Unravelling the Telegraph Interviews of 1893
& the Involvement of those Present

The Key to the Interviews

The *Telegraph* article contains a great deal of valuable information about the opening of the tower and the contents found within. However, the testimonies are confusing in places with seemingly conflicting details never picked up or challenged at the time. This partly created, or at the least added to a whirlpool of discrepancies in subsequent articles based on these earlier reports. These include the number of times the tower was opened, the number of bodies found, their states of preservation and the individuals present.

As a brief introduction to the interviews, the *Telegraph* article says "that the facts were not made sufficiently public at the time will perhaps account for the credence with which the *Saturday Review's* story was received". By the time the *Saturday Review* report and the *Telegraph* interviews emerged, the lower chamber of the tower had been open for 25 years (since 1868), and the middle chamber 2 years (since 1891).

In the *Telegraph* article the reporter says, "I suppose, Mr Hall, you have seen the statements in the newspapers lately regarding the Haunted Tower at the Cathedral?"

[Hall] "Well, yes, I have heard about them".

[Reporter] "Here is a cutting from the article in the *Saturday Review*".

This article, which they believed was about the opening of 1868, was the central focus for the *Telegraph* interviews, but there was an important detail overlooked by the newspaper and everybody else of the time. The beginning of the *Saturday Review* report and quoted in the *Telegraph* article stated, "Not till 1826 was the litter of ages removed from the Cathedral". It then said, "Shortly after the place had been put to rights, a body of local Antiquarians were minded to open a certain turret that looks out on St Andrews Bay". The Professors report in the *Saturday Review* wasn't about 1868, it was about an earlier opening of

the tower, some 42 years earlier around 1826. Linskill eventually realised this, but it wasn't until 25 years after its publication that he acknowledges the error by saying in his 1918 article 'St Andrews Wonderful Old Haunted Tower', "This discovery was made, it said shortly after the year 1826".

This was the key to unlocking at least some of the apparent muddle and confusion in the interviews. The reporter was interviewing the wrong people. Clearly, they opened the chamber in 1868, but none were present at the 1826 opening, or were aware it had been opened then, so given the similarities between the two experiences, Hall, Heddle and the others assumed the *Saturday Review* was speaking about 1868. On looking again at the *Telegraph* article, and bearing this in mind, those interviewed thought the disparities in the report conveyed embellishments and elements of sensationalism. It is true that they did, especially the description that "sitting round in a circle, were found twelve bodies decked as at a feast". This was conveying a Victorian ideal, recalling the last supper. Amongst other reasons why this was not possible, the chamber is not large enough.

Between misunderstandings and this sensationalistic element, it explains why "On stating the object of his visit, Mr Hall laughed heartily". The *Telegraph* added, "it may be mentioned that all the gentlemen on whom our reporter waited laughed more or less when he stated his business". This also makes sense of Heddle's comment when discussing the skulls, "this, I think, is more interesting than that nonsense you have come to ask me about".

When the reporter asked Heddle, "You did not bring out the body in your arms?" He replied, "Oh, no; I had only my head and arms in". The reporter was asking the wrong Professor!

Hall knew Professor Heddle had gone to the tower. It is also possible other professors were present, but he knew no one had emerged from the chamber with a woman in their arms. This is why Hall says, "I don't know anything about the Professor that is mentioned. That must have been at a later time. Nor did I ever hear of the threatened prosecution". Hall knew the report wasn't referring to 1868 but he wasn't aware it referred to an opening taking place some 19 years before he began working in the Cathedral grounds. Unfortunately, Hall doesn't clarify Professor Heddle's 1868 involvement, and the reporter, not realising the confusion, never queried his comments.

Unravelling Hall's 1893 Statement

The *Saturday Review* articles and the *Telegraph* interviews told an incredible story. With the details they conveyed taken literally, they became the source of many subsequent debates published in the press.

Hall says, "Unfortunately, I did not keep a note of the dates". This implies that more than one opening had taken place during his time as inspector of works in the Cathedral grounds. This is what alerted me to the possibility of other times when the chamber was opened. There were brief recorded details of other openings and what he was saying was matching those of other recorded details. He wasn't just talking about 1868, it became clear he was talking about what he saw on three different occasions.

In the first part of Hall's interview, he gives valuable information about the 1861 opening of a chamber with Ainslie and Grieve.

Following 1861, his description merges two occasions when the middle chamber of the tower was fully opened, 1868 and 1891. When he started talking about Smith and Walker pressing him to allow them to open the tower, he was speaking of 1868. He then went on to discuss the 1891 opening with Playfair. After this he says, "After we went in *the first time* we shut up the hole, and kept the matter a profound secret, and I did not know that anyone knew of it except ourselves". This could refer to either 1861 or 1868.

There was one opening Hall didn't speak about, even though he was present. This was the 1888 opening with Linskill, for whatever reason, this is only mentioned in the *Telegraph* by Fleming.

Mr A. H. Millar corresponding in 1895 says, "The mystery of the so-called "Haunted Tower" in the Priory Wall was brought into notice by some of the London periodicals in March, 1894. It appears that in 1868, this tower had been accidentally found to contain several embalmed bodies, covered with waxen cloth (cerements), and these were in a fair state of preservation. Unfortunately, a thorough examination of the place was not made, and the search was hastily abandoned. As the wall was built by Prior John Hepburn early in the sixteenth century, it was concluded that the tower had been used as a mausoleum".[1] This is another indication that the 1868 opening was being confused with 1826. As it was the 1826 opening which had been "hastily abandoned" under a threat of prosecution by the Lord Advocate if the chamber wasn't immediately resealed.

Also, from the report of around 1826, it is evident this was not the first time the tower had been opened. Whilst the bodies were intact at that time, the lid of the coffin of the White Lady had already been partially moved, exposing to view her shrouded corpse lying within. This either happened when she was originally placed there, or in 1609 when a memorial stone was placed on the south-facing wall of the tower. It could be, the coped lid of the coffin was moved for the curious to see what lay within, the corpse gave them a scare and they left without replacing it. Alternatively and probably more in-keeping, whoever removed the lid did so to see if there were any treasure hidden about the body and only partially replaced it before resealing the entrance.

The Stonemasons

Hall, Smith and Fleming each gave conflicting information about which stonemason was present in 1868. When Hall said, "I think it must have been John Ainslie" he was talking about 1861. Grieve confirms this in his statement about 1861 when he says, "I assisted John Ainslie (a mason) to open this tower".

Fleming says, "It must have been Mr Carmichael and not Mr Ainslie because Mr Smith was a very exact man". Carmichael was certainly present however, the *Scotsman* article dated 31st January 1894, on mentioning those present in 1868, says Mr T. Carmichael was a builder. When we look at Smith's article more closely, he says of those present "Walker, myself, and T. Carmichael, *mason made an opening* in the doorway sufficient to get in". Linskill initially got this wrong, but in one of his personal scrapbook's he corrects the mistake by writing Grieve's name above the word *mason* in his personal copy of the newspaper cutting. This confirms the mason was Grieve not Carmichael.

The Association of Jesse Hall and David Henry

"Jesse Hall was born in 1820 at Bowden, Roxburghshire and apprenticed to his brother Robert, a building contractor in Galashiels in 1835. He met William Nixon in the course of business there and became his clerk of works first in Edinburgh and then in St Andrews.

Bailie
Jesse Hall
(1820-1906)

He returned to Edinburgh in 1849, but in 1850 came back to St Andrews as manager to the local gas company and set up an architectural practice at 138 Market Street, [part of which is now Tesco supermarket], an appointment which he combined with supervision of the University buildings and the ancient monuments which were in government care".[2] The word 'care' is not one I would readily associate with their involvement when it came to the ancient monuments of the Cathedral and Castle they were in charge of.[xxix]

"In 1862, Hall took on an assistant at his architectural practice – David Henry. "Henry was born in Carnoustie in 1835 and had previously been apprenticed as a cabinetmaker. After a period of gaining wider experience in Edinburgh, Henry became a partner in 1874. But Hall withdrew from the partnership in 1884 to concentrate solely on his responsibilities as Superintendent of Buildings for the government and from 1890 onwards for the University Court. Hall was also the local Gas Manager [he was known locally as "Gassie Hall"].

[xxix] Refer also to Chapter Fourteen, *The Aftermath*, p. 176.

He retired in 1905 and died in December 1906. Henry continued the practice and moved it to Church Square. [This is now the Doll's House Restaurant and the starting point of my Ghost and History Tours of the town.] He ran the practice until his own death in February 1914".[3]

He was a man of standing, and had a major influence in Victorian and Edwardian St Andrews. One of Henry's first projects was a new billiard room for the Royal and Ancient Club House on the Scores in 1872. Amongst his other many other architectural achievements was the construction of the Rusack's Marine Hotel on the Links in 1896, the St Andrews Masonic Lodge No.25 in 1897 and the town's Western Cemetery and buildings in 1901.

Due to the connection between Jesse Hall and David Henry, it is very likely Henry gained his initial interest for the Haunted Tower through Hall. Henry was a member of the St Andrews Antiquarian Society and was one of the main correspondents to the press. He, along with others, propounded about the theory of the tower being a family mausoleum, for which he wrote extensively.

Having been in Hall's employment for 6 years, and with an avid interest in the mysteries surrounding the tower it is reasonable to imagine he would receive an invitation to attend a number of its openings.

The College Museum

Part of the remit of the Literary and Philosophical Society was the establishment of a museum at the University. Created in 1838, the same year as the founding of the society, the Literary and Philosophical Society Museum of Scotland was housed in the Upper Hall of the United College, St Salvator's, in North Street.

By the 1870s, the museum was generally known as the College Museum. Its upkeep was a joint venture between the society and the University, with the society being the driving force behind its success. The society had amongst its membership, University Professors, Doctors and, Principals. One of its most distinguished members was Charles Darwin. Another member was Professor Heddle who headed the Society for a number of years.[xxx]

[xxx] Refer also to p. 93

Professor Heddle's 1868 Involvement

Regarding Professor Heddle's involvement following the opening of the lower chamber, Heddle says, "A day or two after this, hearing that the

upper part of the tower had been opened, I went down". This is a valuable comment, as he is the only one who mentions their being a delay between the opening of the lower and middle chambers.

Professor Matthew Forster Heddle
(1828-1897)

Opening the middle chamber before 6am gave Smith and Walker a few hours of relative peace before the arrival of invited guests and potential stray visitors. For Heddle to know when each chamber was being opened he must been one of these invited guests. In speaking of the second occasion when he went to the tower he said, "I went down, and climbing the ladder, stuck my head and body into the hole". All he could do was give a cursory examination of what he found. Specifically, this was whatever he happened to find within arm's reach of the entrance. He didn't see the young woman, as she was located round the corner in the long L leg of the chamber.

A Chamber of Skulls

Professor Heddle's account of his involvement is invaluable. He says, "I recollect hearing about some discoveries at the tower". He then went to the tower with his newly inaugurated Antiquarian friend Dr Traill and on arriving with Dr Traill, Heddle said he "saw a large number of skulls which had been found in the lower part of the tower, in the case of about a dozen skulls the lower jaw was tied up with yellow silk banana handkerchiefs". This is reminiscent of the description Grieve gave of

the White Lady he saw seven years earlier when he said she had "a silk napkin tied round her head".[xxxi]

Principal John Campbell Shairp (1819-1885)

Because of their unusual nature, I believe the skulls he spoke of were the ones he wanted the Museum to have, but Principal Shairp objected, and ordered them to be returned to the chamber. It is likely these were in the lower chamber before they levelled down the grounds in this area. It was at that time when they filled the chamber with bones. Hall says, "a sexton, picking up more bones than he could easily get rid of, popped them all through a little hole into the vault. From time to time we had also thus engaged..". The lower chamber had become a repository for bones. In all probability, with there being a hole large enough for them to be dropped through into the lower chamber, many would have peered through and seen them over the years. For Heddle to just see skulls, suggests workmen had already discarded all the other bones before his arrival. In referring to what happened to the skulls, Heddle remarks, "It was said they were finally thrown over the brae into the sea".[xxxii]

In one of Linskill's reports of the 1888 opening, he says they found "a lot of loose skulls," and Fleming, on speaking of Linskill's 1888 opening believed "as many as 13 skulls were counted". This agrees with Heddle talking about a dozen skulls. Although Linskill doesn't mention

[xxxi] Refer to, p. 30
[xxxii] Refer to foot of p. 177

the handkerchiefs, it is likely these were the same ones. It also explains why there was no mention of any skulls in the middle chamber during the 1826 opening, nor when they opened the chamber in 1868. In 1868, these 12 or 13 skulls were not discarded as Heddle had suggested, they were put back into the tower as ordered by Shairp, but this time into the middle chamber. It was all the other bones from the lower chamber that were thrown over the brae into the sea before his arrival.[xxxiii] For the skulls to have been left the workmen must have deemed them as being more important. When they were moved to the middle chamber and with the other bones gone, nothing now remained in the lower chamber so there was no point in resealing it. As a result, everyone now had access into the lower chamber and saw it was empty. With the middle chamber being resealed, details of the occupants within still remained a relative secret.

From Heddle's description of the skulls, he was certainly a reliable witness to the contents of the middle chamber, although it is curious he didn't take the opportunity to go all the way in and conduct a more thorough survey. The reason may have been one of time. Unlike the opening around 1826, there was no threat of prosecution on this occasion, but in not wanting to make it public, Hall would not have wanted it left open for any longer than was necessary. Heddle arrived on the scene later than the others, no doubt shortly before they were going to reseal it again, so he would only have had enough time to take a brief look through the entrance hole and 'examine' the first body he could reach, which evidently either had no coffin lid, or they never replaced it.

The 1868 excursion into the tower had been in order to satisfy the curiosity of Smith and Walker as to what lay within the tower, rather than as a formal investigation of the contents. Heddle was the most qualified amongst them and did his best given the little time he had there, but given the potential importance of what they found it was not enough.

Like the skulls and bones of the lower chamber, the occupants of the middle chamber were not afforded much dignity and would have suffered a degree of deterioration from being handled again. Although it appears they did leave everything in this chamber more or less as it was before they entered, the skulls with the yellow ties were added and it

[xxxiii] Refer also to p. 176

would appear Carmichael took a piece of one of the white leather gloves from the White Lady.

How Many Corpses were in the Tower?

Aside the *Saturday Review* article stating there were twelve bodies plus the White Lady, in referring to the 1868 opening, Hall said – "There would be half-a-dozen as far as I can remember. We did not turn them all up, but we saw that there were not bodies in any of them except one, in which there was the body of a girl about four feet and a half in length. The body was stiff and mummified like". He didn't see all the occupants, as he says, "we did not turn them all up" and alongside poor reporting, his statements may refer to different time periods and quite possibly to different locations, which I referred to earlier and speak about in the next chapter.

A. H. Millar in 1895 says, 'in 1868 this tower had been accidentally found to contain several embalmed bodies, covered with waxen cloth (cerements), and these were in a fair state of preservation".

Albeit brief, the most accurate description is Smith's account, quoted by a number of correspondents. "The bodies – about 10 in number – which we examined were in a wonderful state of preservation".

David Henry[xxxiv] stated, "There were ten or eleven half mummified bodies partly in grave clothes and in coffins more or less decayed. The coffins were in the long leg of the L — laid two in the width — and apparently had been piled up to about five or more in the height".[4] His description is similar to Smith's account, so he could have taken his lead from Smith but he is very thorough in what he writes. This doesn't have the hallmarks of a quote, if his words were from Smith he would have quoted him. Following my earlier suggestion, it points more to himself being present at the opening of 1868, which would then further qualify Smith's statement as to the number of bodies within.

[xxxiv] Refer to *THE HAUNTED TOWER* by David Henry F.S.A. Scot, 1912, p. 136

Who was Present at the 1868 Opening?

The only ones specifically named in the *Telegraph*, as being present at the 1868 event, were the ones involved in an official capacity of one sort or another. Grieve is only mentioned as "mason". Fleming mentions a Mr J. Kirk, a sculptor as being present. I have been unable to find any details about Kirk, or why he would be present. From what I can gather, this is the only mention of him in any report about the tower.

Smith, Walker, Hall, T. Carmichael and Grieve had gone all the way into the middle chamber. We have brief reports from Smith and Hall of what they found, and we have Professor Heddle's account shortly before it was resealed. We also have reports from Grieve to Linskill of what he saw, and in knowing Henry's involvement with Hall, it is likely he too was present. The avid Antiquarian Rev. Mr Skinner, who was present in 1888, was also likely to have been present in 1868.

Secrecy

Undoubtedly, others would also have been there whom we may never know about. It is likely the presence of each was under the proviso of secrecy about the proceedings, as Hall confidently states, "After we went in the first time we shut up the hole, and kept the matter a profound secret, and I did not know that anyone knew of it except ourselves". Although as I mentioned earlier, this could apply just as easily to 1861 as 1868, we do have something from David Henry on this. As brief as it is, in his article '*The Haunted Tower*' he says, "vowing eternal secrecy". This could be why Henry never mentions anything of his involvement and it is probably the reason why no details of the opening reached the press of the time.

The earlier opening of 1826 was also kept secret, and although being unaware of 1826, Hall for his part continued this tradition. Moving this forward, Mr A. Hutcheson, an architect from Broughty Ferry and a keen correspondent about the tower, picked up Hall's comment and wrote in 1894 that it was a "secret vault".[5] This was in keeping with Hall's words, however Linskill, in a note to this remarked "it was not secret – just the opposite". Whilst Linskill and Hutcheson were both referring to the tower, they were both writing in 1894 and were both correct. Hutcheson was referring to before 1888 and Linskill to after.

They were talking at cross-purposes. Times were changing, and after 1888, although no details made their way to the press until the appearance of the *Saturday Review* article in 1893, more had an idea of what the tower contained than those involved supposed.

The area had been avoided after nightfall for many years, and along with her ghost being seen, a number of people had seen the physical body of a preserved woman, either in the chamber, or in another vault along the wall. Certainly enough had viewed her to promote and sustain rumours about her. Reverend Skinner, a number of groundsmen at the Cathedral, stonemasons, a Presbyterian minister and a gamekeeper (who feature in the next chapter), had all seen the corpse of a young woman sometime after 1849. Local boys and passersby also saw her before this time through narrow chinks in the wall. Grieve with Ainslie saw her in 1861, and there were enough Antiquarians, stonemasons and general ground staff present in 1868 to promote lively discussions within local lay, professional and antiquarian circles.

In 1947, A. B. Paterson (Alec Paterson) wrote and staged a play at the Byre Theatre involving the White Lady and the Haunted Tower. It was called *The Witching Women of St Andrews*.[xxxv] His play is a fictional piece based on some of the fascinating facts surrounding the White Lady. Set in 1881, one of the characters speaks of a night when her late husband was drinking in the Bell Rock Tavern down at the harbour and was told by John Grieve the stonemason of their 1868 discovery. This was probably not far off the mark, but Grieve may also have had a secret he would keep to his grave concerning the disappearance of the White Lady corpse, mentioned on p. 79.

Linskill avidly sought out the legends about the Haunted Tower. Keeping his ear to the ground, he knew how widespread talk of the White Lady was, and along with the Bell Rock Tavern, his local haunt the 'Star Bar', in the centre of town would have been one of the hubs for rumours to spread of the contents of the tower. In the next chapter, there is a newspaper article (foot of p. 64) where Linskill says, "Since I can first remember St Andrews there have always been the most absurd and fantastic tales told about the square turret in Prior Hepburn's Wall, now called the Haunted Tower".

Over the years, all kinds of fanciful tales were told and these would have been especially pronounced in 1868 when the lower chamber of

[xxxv] Refer to p. 85

the tower was exposed and left open for all to see within. The same happened in 1891 when the wall blocking the entrance of the middle chamber was taken down, and again in 1893 with the release of the two-part *Saturday Review* article.

Chapter Five

The Secret Hollow in Hepburn's Abbey Wall

By piecing together the articles appearing in the press between 1893 and 1925, there appears to be another chamber in Hepburn's Wall between the Lighthouse Turret (Round Tower) and the Haunted Tower. This secret chamber was opened at least twice up to 1861, and its contents quite probably observed on numerous occasions up to that time. Further to this, it is quite possible this other chamber still contains two or three preserved corpses, including that of a woman also fitting the description of the White Lady.

Grieve - 1861/1868 Revisited

In the story of the towers numerous openings, Grieve is one of the most prominent and important witnesses we have, yet he hardly features in the reports. Hall and Grieve were the only ones to have seen corpses on at least four occasions. The first time was in 1861, when an apprentice stonemason for Ainslie, he subsequently saw corpses in 1868, as a stonemason for Smith, and twice as Linskill's stonemason in 1888 and 1891.

When Grieve spoke of his 1861 involvement, he described certain features tallying with the 1868 opening, so in like manner to the mix up in the *Telegraph* interviews, Linskill and everyone else again assumed it was 1868 he was referring too. They took 1861 to be a misprint. In Linskill's 1894 article, '*A Girl Mummy in a Chamber of Horrors*' he inadvertently confirms this misunderstanding by saying of Grieve, "He was a boy in 1868, and helped the mason to open the turret". In another of Linskill's articles about the 1888 opening he says "Among others I had with me was Grieve, who when a lad and an apprentice mason opened the Tower for Mr Hall, Mr Smith, Mr Walker, and others of whom I have spoken".

In Grieve's statement he says, "In the year 1861, when about fifteen years of age". If this were correct, it would mean he wasn't a boy in 1868 as Linskill had stated. So to find out his age, my research led to

the location of the Grieve family plot situated east of the Holy Well (Healing Well) in the Eastern Cemetery of the Cathedral precincts. Amongst the names is one John Grieve 1846-1905. He was the son of John and Elizabeth, his is the fourth name down on the gravestone.

From this, it is clear he was 15 years of age in 1861, confirming both the date in his statement, and the year he first saw the body of a woman. This also confirms he was an apprentice stonemason in 1861 and at the opening of 1868, he was 22, so by then he was a qualified stonemason.

I believe these misunderstandings led Grieve to submit his statement following the general letters to the press about the openings.

Although we have details from himself, and through Linskill of what he saw in 1868 and 1888, they both unfortunately lack detail. This was a commonality shared by all involved. Nobody was very thorough in relaying experiences to the press, either that or the press were adept at editing the detail. We also have Linskill's flamboyance to contend with, although his artistic licence is relatively low key regarding his letters about the Haunted Tower and its occupants. His characteristic flair is far more apparent in his fictional writing reproduced in the fifth section of this book.

In 1910, some 16 years after Grieve's statement, Linskill published a series of articles entitled '*The Haunted Tower*'. At the foot of one of these articles, he finally acknowledges the 1861 opening as concerning a different time to 1868, although he still merges some of the details with the latter. He says, "At the time when the tower was opened a letter appeared in the newspaper from a mason [the letter was written three

years after the 1891 opening in 1894, he was good friends with Grieve, so it is odd he never mentioned him by name], who stated that in 1861 he and another mason named Ainslie were made to open the Tower. [They were not made to open the tower as he suggested, a stone had simply given way when they were repairing a section of Hepburn's Wall. Linskill mixes it up with the following from Grieve's 1861 account, "The local inspector of the Board of Works [Hall] made us build up the opening.]. He [Grieve] then saw the body of a woman on the floor – she was in a perfect state of preservation, and had very long black hair".

The body on the floor is at odds with other descriptions which state she was in her coffin. This was thought provoking. I went back and re-read some of the articles. I started looking at the conflicting descriptions not as discrepancies but as a potential new location. This is what I found...

Another White Lady Corpse!

In Linskill's 1894 article, '*A Girl Mummy in a Chamber of Horrors*' he mentions something from a gamekeeper that neither he nor anyone else picked up. At no time does he dwell in any of his writing on what you are about to read.

In referring to the Haunted Tower he says, "I can't help thinking the place must have been opened up several times since 1868. A Presbyterian minister, now dead, told me about seeing the girl. An old St Andrews man – now, I believe a gamekeeper at Wellfield – told me some years ago of another hollow in the Abbey Wall, wherein he saw what he termed two or three mummies. No doubt this was the tower, yet when I took him there he said it was not".

Unfortunately, Linskill gives us no further clue as to the location of the "hollow in the Abbey Wall," or any descriptions of the three corpses seen by the gamekeeper.

David Hay Fleming's 1893 interview corroborates there being three coffins, he says, "From what I remember of Mr David Carmichael's story to me, three coffins were found, which had apparently been placed on trestles, but these had given way. In one of the coffins there was the body of a lady, which seemed to be quite fresh, and there was a glove on her hand".

David Carmichael relayed what his father told him about what he had seen, and this was taken to refer to the tower chamber, but the

description again points to this other chamber. So along with the gamekeeper mentioning two or three mummies being present, Carmichael mentions the same. As does another source. Cook's *Excursionists Guide to St Andrews,* 1896, says, "There were found three coffins containing bodies. These were so fresh in appearance as to startle those who saw them". [1]

Grieve says, "I then saw the body of a woman, with a silk napkin tied round her head. She was lying on the floor of the chamber, and the coffin was sticking about three feet above, and the bottom had fallen out. She was in a state of perfect preservation, and had long black hair". This again is referring to the naked corpse of 1861.

"Dean" of Tyasaoga, a correspondent to the press in 1894 is compliant with Grieve's statement when he says, "The body lay on the ground under a coffin resting on trestles; and the supposition was that the bottom of the coffin had given way, allowing it to fall to the ground, and so it was left". [xxxvi]

Along with three corpses, Carmichael, Grieve and Tyasaoga all mention trestles. There are commonalities here not compliant with the tower reports. I have not been able to ascertain who "Dean" of Tyasaoga was. He was no doubt an Antiquarian and was corresponding from Dundee. There is no indication as to his profession and the only reference I can find to anything closely resembling the spelling of his name is to one Tiyo Soga.

Soga studied at the University of Glasgow and died in 1871. Perhaps he adopted his name as an alias in respect of his remarkable achievements, as he was the first black South African to be ordained as a minister there.

Tyasaoga 's knowledge of what was found in both chambers is fairly accurate, he speaks in the first person and adds information not published by others. Could he have been present at the openings, and also saw into this other chamber through a gap in the stone?

There is no indication of where the minister saw the "girl," but a newspaper article of the time has the following, which may or may not pertain to the same witness, but its relevancy holds interest nonetheless, "The interest aroused by the tales of gruesome discoveries in the Haunted Tower of St Andrews Cathedral has by no means abated. Mr W. T. Linskill, Cambridge, sends us the following communication on

[xxxvi] Refer to his first letter p.121 and his second p. 125

the subject:- "Since I can first remember St Andrews there have always been the most absurd and fantastic tales told about the square turret in Prior Hepburn's Wall, now called the Haunted Tower. I could cover sheets of foolscap with the nonsense I have heard from time to time – [the majority of this will have been local pub banter, as a master of exaggeration, if it was as extensive as he suggests, I have no doubt he would have published it – he didn't.] gross exaggerations of facts, &c. The first tale I heard (from a tutor of mine) when a boy was that there were a lot of girls found in the turret, in riding dresses and gloves, with no appearance of decay about them. Later on a most pious and worthy man told me gravely that "within that tower reposed the incorruptible body of a beautiful girl saint"."

The tutor was probably Mr Robb quoted in the first chapter and of whom Linskill says he, "told me some really awful tales about this place". It makes sense in this context for the word "awful" to mean nonsense rather than gruesome. The pious man may have been the minister, placing his sighting of her in the tower, and as I explore later, calling her "a beautiful girl saint" may not be far off the mark.

Grieve stated the 1861 location was the Haunted Tower, but he also says, "she was quite devoid of clothing... Several other bodies were in this chamber". He also mentions Hall as the local inspector, but gives no mention of whether Hall saw within the chamber himself on that occasion. From the following, it is clear he did. Taken again from Hall's 1893 interview, he says, "It was naked, with the exception of what appeared to be a part of a glove on one of the hands [1861]. I think we lifted it up". [Lifting it up could be referring to the hand in 1861, or to the body, which they lifted up in 1868, my personal judgement would be to the body in 1868].

In his lengthy article to the *Citizen* in 1925, Linskill records Skinner's letter of 1860 but his version omits a few interesting details. Namely "when touched, became dust, and on her skeleton hands and forearms," and the "numerous buttons of gold" on her gauntlet gloves. Linskill did see Skinner's original letter, so why did he leave out these details? It could be they were not in his letter and the *Saturday Review* added them as embellishments for their readership? Alternatively, Linskill left these details out, as they did not fit with what he had been told, but the description easily refers to the attire of a different corpse in a different location, and crucially, Skinner doesn't mention the Haunted Tower in his letter.

So everything points to there being two different chambers along this stretch of Hepburn's Wall, one is the middle chamber of the Haunted Tower, the other somewhere between this tower and the Lighthouse Turret. Each contained a female corpse with very similar descriptions. In this second chamber, there were or are, three coffins resting on trestles. One of the coffins had a roof-shaped lid partly falling off, and inside, the form of a female with a silk napkin tied round her head. Dressed in white satin, she had long black hair and wore long white kid gauntlet gloves with numerous buttons of gold, and when the dress was touched, it turned to dust leaving her naked. When the body was next seen the base of the coffin had fallen through and her corpse was lying on the chamber floor.

Calf Skin Leather Gloves

Skinner says there were two gloves. Hall says he saw "part of a glove on one of the hands," Carmichael also mentions one glove being present. For those in Skinner's report to see her skeletal hands and for him to see two gloves, means they removed at least one of her gloves to know the hand(s) were skeletal, and unlike the dress, the gloves hadn't deteriorated. It would seem from this, that someone then took one of the gloves as a souvenir. Both Carmichael and Grieve are reputed to have taken one, which opens its own possibilities. A glove disappeared in 1861, and another in 1868. When Grieve said, "I saw no gloves as has been stated," he is referring to 1861. The glove taken in this second chamber in 1861 would have been the one closer to the hole made in the wall. If Grieve only saw the gloveless hand nearest to him, it would suggest Carmichael took the glove sometime after Skinner's experience (where he saw two), and before Grieve saw into the chamber himself (where he saw none). Bearing in mind Grieve was young and as an apprentice stonemason at the time, he would have been one of the last to see within the vault. If this were the case, Grieve may have taken a glove from the corpse in the middle chamber during the 1868 opening as Smith recalls seeing her long white kidskin leather gloves.

In another article to the *Citizen* in 1925, Linskill says, "I have seen a piece cut out of one of these gloves".[xxxvii] He knew Grieve had taken a glove, so in all probability he showed Linskill part of what remained.

xxxvii Howkings. Rummaging up old papers", *Citizen*, April 11, 1925

1868 and a Different Description

By the time of the 1861 opening, the coffin had deteriorated and the bottom had given way. The dress had also disintegrated, so when Ainslie, Grieve and Hall saw her, she was lying naked on the floor.

When we look at the 1868 opening of the tower chamber, the descriptions are very different. There were up to ten corpses, including a woman still wearing a long white silk dress and she was still in possession of both of her gloves. In Captain Dan's early report to Linskill, he says there was the "form of a lovely girl robed all in white lying stretched out in her coffin within that tower". So she was still in her coped lidded oak coffin and not on the floor, and there is no mention in any of the reports of trestles being present in the middle chamber of the tower.

Linskill said of Grieve in 1888 "He showed me the corner where the bonny lassie had been resting [1868], and told me she lay there with her long hair just as if she was taking her sleep – not a bit like death – and her dress was beautiful". Grieve also said to Linskill "Aye, there is the coffin just as I saw it years ago; but they have stolen the bonnie lady".

From Grieve's descriptions both females had long black hair but there is no mention of the corpse in the Haunted Tower chamber having a silk napkin tied round her head. She was also in a better state of preservation, but her white leather gloves were not as ornate as the ones in the other chamber. With this, it would seem the corpse in the second chamber with the "buttons of gold" held even greater importance, and given her general state of deterioration, and that her dress disintegrated, she appears to be from an earlier age than the one in the tower.

Since 1826, there is no mention of either corpse being wrapped in white wax cloth. Although in reference to the corpses in the tower chamber, Smith does say there were remains of white wax cloth in some of the coffins. This suggests the cloth the professor described in 1826 was still present, but with the bodies being handled, the cloth had deteriorated and fallen off the bodies. The cloth may also have protected the white silk dress of the corpse in the tower from deteriorating.

Where is this other Chamber?

The descriptions from the earlier half of the 1800s suggest that through chinks in the wall, the casual passerby could view the corpse of the White Lady lying in her chamber. This always puzzled me. How could a casual passerby observe the corpse of a woman if it were in the middle chamber of the tower? It was too high from the pavement side for any to see in. They could only do so from within the grounds, and this is at odds with those casually passing by peering in. The answer is in Skinner's letter. He says, "under a slab in the same wall bearing an inscription to the effect that 'A Gray of Kinfauns was buried near'. A chisel belonging to one of the workmen fell through an interstice and disappeared".

There is no description anywhere along Hepburn's Wall fitting Skinner's description, but there are two memorials on the wall between the Lighthouse Tower and the Haunted Tower that have lost all trace of their description and dedication. One is by the Haunted Tower, the other by the Lighthouse Tower. The first is the large memorial slab standing in the wall just a little to the left of the Haunted Tower. The second is immediately to the right of the Lighthouse Tower. Although space would have been at a premium, it seems unusual this is the only memorial on the section of wall between the Lighthouse Tower and the gun loophole.

There is also something curious about the sections of wall beside these two towers. The gun loopholes give this stretch of wall a feel that it is all a uniform three to four feet thick. Not thick enough to house a crypt, but it would appear, the gun loopholes have created an illusion. When looking at the walls, although it is subtle, the section at both memorials appears to be thicker than at the gun loopholes. It is not inconceivable to think if the Hepburns widened the wall at these points, it would strengthen both the towers and the wall. Importantly, given the illusion cast, and in the same way as the design and functionality of Priest holes, it would also given them the perfect opportunity to create hollows for the concealment of something of great value.

The crypt was said to be below a memorial stone. This places it quite considerably lower than the middle chamber of the Haunted Tower, so a chink between stones revealing something within would have been observable from outside the precinct wall.

The ground within the precinct is higher along this part of the wall, at least four feet higher than the outside. The crypt could easily extend under the ground on the precinct side and be deeper than the path side. Again, this would make sense of the passerby being able to observe her without any more effort than a casual curiosity. Wherever this other "hollow", "crypt" or "vault" is, it is quite possible there are corpses, and maybe other artefacts hidden amongst them, including a long white kid gauntlet glove, with its numerous buttons of gold!

The Incidental Involvement of Grieve & Smith

Until relatively recently, other than a passing interest in ghosts and a fascination for the Haunted Tower, the majority of the towns people held varying degrees of indifference for the Cathedral and its precinct ruins. Walker and Smith who had pressed Hall into allowing them to open the vault in 1868 were exceptions, but they had died by the time the *Telegraph* interviews took place.

I discovered something that linked Grieve and Smith and added an additional, and potentially very important, factor to their involvement with the tower – they both lived in Crail's Lane in St Andrews. This lane runs between South Street and Market Street and once belonged to the church in Crail. The lane is a thoroughfare between St Mary's College of the University and Market Street through to St Salvator's. Grieve lived at number 3 and Smith at number 2, so they were neighbours. Given their unique association, and the mutual connection they had with the tower, this was too great to be coincidental. If Grieve had found bodies in another hidden chamber in Hepburn's Wall, what curiosities could the tower hold? For a watchmaker to have an interest in a tower that had not been previously publicised I am sure came through his relationship with Grieve. It is almost certain they conversed about the corpses following Grieve's 1861 experience, and it is more than likely the account of what he had seen was the reason why Smith pressed Hall to open the tower in 1868. Smith had approached Hall on a number of occasions to have it opened. Hall took some persuading, but as he said in his 1893 interview, "I at last consented".

The apparition of the White Lady and thoughts of evil spirits were never far from the minds of many when in the vicinity of the Cathedral grounds. Some would have preferred that the chambers were left sealed than display any Antiquarian interest. The Lord Advocate around 1826, and Hall, during the later openings, were both of the mind to respect

the dead and allow them to rest in peace than to tamper with them. Hall stated, "I did not care about it, as I did not like to disturb the dead".

Along with his involvement with Smith, Grieve was it seems the catalyst behind the 1888 opening of the tower. Grieve went to see Hall about reopening the middle chamber after he gave his description of the woman to a very enthusiastic Linskill, which I explore more thoroughly in the next chapter.

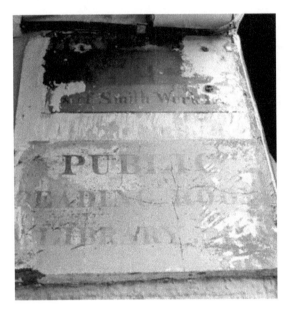

These very rare signs sitting on the right hand wall at the entrance to Crail's Lane off South Street have been overlooked by most. The top sign is advertising Smiths watch and clock making workshop. The entrance would have been down Crail's Lane, to the back of his shop at 95 South Street, now Zest Café.

The lower sign is for the Public Reading Room of a Library that stood at 99 South Street, next door to Smiths shop. Like Smiths workshop, the reading room would have been accessed off Crail's Lane, along a lane a few yards down to the left. The library building, which may have been called the 'Circulating Library', was eventually demolished. The current building dates from around 1874 and is now occupied by the popular Criterion Bar (the Cri) and their world famous 'Cri pies'!

Section Two...

Where are the Corpses?

Chapter Six

What Happened to the White Lady of the Tower?

Introduction

There is a web of intrigue and layers of mystery here. As elusive as many facets appear to be, there are sufficient facts to put together a credible sequence of events surrounding the disappearance of the White Lady from the tower. There may even be evidence as to where she ended up and clues as to who may have taken her and why.

From the reports, we know she existed and that she was in the tower. She had been preserved as in life. She was young, very beautiful and slim. She wore a white silk dress, was wrapped in waxed white linen and lay in a very ancient, coped lidded, oak coffin. We know the tower had been opened a number of times since 1826, and can identify at least some of the main players involved. We also know sometime between 1868 and 1888 the tower was secretly opened, her body removed, and the chamber resealed with sufficient skill, nobody noticed it had been tampered with.

Based on presented information, this chapter is an analytical investigation into her disappearance. This is followed by an intriguing tale by William Linskill's granddaughter concerning her removal from the tower. With elements of a yarn worthy of a Linskill story, there are compelling aspects partially verified by an unusual piece of physical evidence, and an obscure article, hurriedly making its way into the Edinburgh and St Andrews press on 31st January 1894.

The Resurrection Men

The mummified body of the White Lady was 'officially' last seen in 1868, lying in the darkest quarter of the Cathedral grounds, before the entrance to the middle chamber was re-sealed by the stonemason John Grieve. When he reopened the middle chamber for Linskill some 20 years later in 1888, her body had gone.

Historically grave robbing was a means of medical fraternities obtaining bodies for experimentation. With St Andrews being a University town, it is easy to imagine her disappearance as the work of

opportunistic grave robbers supplying bodies for enthusiastic medical students.

In 1903 a series of fascinating correspondence appeared in the *Scotsman* newspaper about grave robbing in the Cathedral grounds.

CURIOUS DISCOVERY AT ST ANDREWS
St Andrews November 9, 1903
SIR, - A curious thing was found here recently by Mr Mackie, custodian of the Cathedral ruins. He found in an old coffin a skeleton with a half-hoop iron band, about an inch wide, round its neck. It was fastened to the sole of the coffin with square screw nuts, and the ends turned over. Mr C. H. Read of the British Museum, writes me that he knows of no ancient practice of the sort.

Can it have been to preclude the possibility of body-snatching in the Burke and Hare days? [or could it have been to stop the dead rising from the grave!]

Has anything of the kind been dug up anywhere before in Edinburgh or elsewhere? – I am, &c.

W. T. Linskill.,
President of the St Andrews Antiquarian Society.

Martyn Gorman of the University of Aberdeen has a fascinating webpage called 'An introduction to grave robbing in Scotland'. His site "deals with some of the ingenious ways by which the people of Scotland tried to prevent their loved ones from falling into the arms of the anatomists based in the University towns".[1]

The grave robbers were known as 'Resurrection men' and their practices were particularly prevalent in the early 19th Century.

CURIOUS DISCOVERY AT ST ANDREWS
November 11, 1903
SIR, - In a letter in to-day's "Scotsman," W. T. Linskill writes that a body has been found in the churchyard with an iron hoop round the neck, fastened to the floor of the coffin. This has perplexed the Antiquarians of the ancient City.

Many years ago I was told by the late Dr Thomas Traill, Professor of Medical Jurisprudence, that the resurrection men, in order to escape the labour and loss of time of uncovering the whole coffin, used to dig down to the head, when, fastening a noose round the neck, they

forcibly hauled the body up. This seems to confirm Mr Linskill's surmise that the iron hoop described was intended to prevent the body being lifted by these active purveyors of subjects for dissection. – I am, &c.

William W. Ireland

CURIOUS DISCOVERY AT ST ANDREWS
Broughty Ferry, November 12, 1903
SIR, – I read with much interest Mr W. T. Linskill's letter giving an account of the recent discovery in the Cathedral burying-ground of a half hoop iron band enclosing the neck of a skeleton and secured to the sole of a wooden coffin with square screw nuts and the ends turned over.

Mr Linskill does not seem to be aware that over eight years ago a similar iron hoop secured in like fashion was discovered in the same burying-ground to the south of the Church of St Regulus. There would appear, therefore, to have been a practice of using such in St Andrews, since two specimens, apparently closely resembling each other, have been found there.

I find on reference to a note-book that I saw, the first one was on 20th May 1895. Its description and dimensions, noted at the time, were as follows: – The band was of malleable iron, rectangular in section, one inch thick and one-eighth in breadth by half an-inch thick. It took the form of a stilted semi-circle, measuring seven and a half inches in width by seven inches in height. The band, where it touched on the wooden sole, was finished at either extremity with a square shoulder which rested on the wood and was prolonged downwards in the form of two circular rods or prongs screwed in close proximity to the aforesaid shoulder to receive a nut, and split at the points in the manner of a gun spike.

When intended to be fixed in position, two holes would be pierced at proper distance apart in the wood sole of the coffin. The band would then be pressed downwards, the prongs passing through the two holes until the shoulders on the band reached the wood work, when the nuts would be put on from below and screwed hard up, and the split points of the prongs being opened up and turned over, would effectively prevent the removal of the nuts.

It seems probable that to give greater security a stout bar was provided in the bottom of the coffin for fixing the band, since a portion

of such a bar, apparently of elm-wood, and one and a half inch in thickness, was still attached to the specimen got in 1895.

The "Resurrection" theory put forth by Mr Linskill is not new. The suggestion was made by Dr Hay Fleming, St Andrews, to explain the former discovery, and I remember was discussed at the time.

It is to be hoped the publicity now given to the matter may lead to more information being forthcoming on a subject, which still seems to require elucidation. – I am, &c.

A. Hutcheson

The following letter appeared in the *Citizen* in 1903.

THE HOWKERS AND THE MYSTERIOUS IRON COLLAR.
"The ghastly resurrectionist stories that have reached us of late from both America and Australia recall to me a gruesome dinner-party of my youth. Among the guests was an aged doctor, the most genial of men, who recalled and described a body-snatching expedition in which he himself had taken part as a medical student. What struck me most in the gruesome narrative – next to the nonchalance of its narrator – was the deftness by which a body might be exhumed by an expert, sometimes within a quarter of an hour. The earth was cleared from the head only of the coffin and by its head the body was withdrawn and stripped of its grave clothes, which, by the way, were never carried off. Why? Because, though there is no property according to English law in a corpse, the theft of a shroud is larceny!"

The widespread practice of grave robbing continued until 1832 when a new Anatomy Bill was passed regulating the licensed teachers. Gorman says, "The Act, provided for the need of physicians, surgeons and students by giving them legal access to corpses that were unclaimed after death, in particular those who died in prison or the workhouse. Further, a person could donate their next of kin's corpse in exchange for burial at the expense of the donee.

The act was effective and largely ended the scourge of the Resurrection Men".[2]

The first opening of the Haunted Tower around 1826 was anything up to six years before the Act came into being. Grave robbers may have suspected bodies lay in the tower, but they were looking for fresh corpses, digging them up as soon after burial as possible. However, had

they known there were *preserved* corpses in the tower they would almost certainly have entered, as the fascination for mummified corpses at this time created its own chain of supply and demand. There was a profusion of mummies making their way across the western world from Egypt.

The fact they didn't enter the chamber is a testament to how well they kept the contents of the tower secret, and this would have been one of a number of reasons why they did so.

By 1868, opportunistic grave robbing had all but ceased, and had someone entered and stolen the body of the White Lady it is doubtful they would have resealed the entrance. With this in mind, it doesn't appear likely she was taken by an opportunistic grave robber.

Why was the Middle Chamber Resealed?

So why would anyone bother to reseal the chamber? Surely, the more time spent there, the greater the risk of being caught? This may be a crucial factor, and one not considered in 1888 or in the press of 1893 and beyond. If it had been left open, Hall would have soon found out, and having been present in 1868, on inspection he would have seen she was missing. Whoever took her knew a public outcry was doubtful, since the initial discovery of her corpse had been kept secret. Therefore, the most likely reason for resealing the chamber was to prevent Hall from knowing and calling for an internal enquiry. In so doing, it would have come under the scrutiny of local academic circles involving professional and Antiquarian bodies. Thus resealing the chamber was the only way of avoiding such attention.

Motive

Along with the mystery surrounding who she was in life and why she and the others were hidden in the tower, her preserved corpse stood apart from Egyptian mummies making their way to the shores of Scotland. Being able to study such a unique find, especially a curio originating on the doorstep would surely be an irresistible opportunity.

Having said this, it is doubtful someone would have incurred the expense, not to mention the risk of having the tower opened based on local lore alone. Whoever it was needed something more substantial than rumour before undertaking such a task. Given the level of secrecy, it is likely, and in-keeping with "Dean" of Tyasaoga's involvement, that

they either saw her in the tower themselves, or they had been reliably informed by someone who had, someone they trusted; a close friend?

It is clear whoever took her had foresight. They were able to move beyond the realms of desecration expressed by the popular mindset and encapsulated by the Lord Advocate of 1826. Whoever took her was able to recognise her potential historical importance, and they did so for reasons of preservation, to avoid potential desecration by the unscrupulous and from further deterioration and decay.

The Stonemason and the Contract

Linskill said "There is no old tower that I know of that has been so much drawn, painted, photographed, and studied by artists and Antiquarians and lovers of the mystic".[xxxviii] Its reputation was equal to that of Crail Harbour today and I am sure in Linskill's day this was the same. So the tower was a well observed location, yet during the intervening period between the tower being secretly opened and the 1888 opening, the entrance looked sufficiently untouched that no one realised it had been tampered with. Grieve resealed the chamber in 1868, so if any were to notice it had been opened, it would surely have been him. This brings up an interesting question. Would he not have recognised if his work had been tampered with?

Those involved in extracting the White Lady had enough time to open the chamber, remove the body and reseal it. If we discount her disappearance as being the work of opportunistic thieves, it had to be the work of professionals. For no one to notice the entrance had been tampered with points to the involvement of a stonemason, who I believe was contracted by someone with enough motive to go to all the trouble and risk in having her removed.

In trying to identify who took her, there is potentially an interesting twist. What if the entrance of the chamber hadn't been tampered with between 1868 and 1888? It would certainly explain why no one noticed. For Grieve not to "notice" could mean he was involved in her disappearance himself. Being caught opening and closing the chamber was the last thing anyone would have wanted, so the job had to be both professionally done and hastily carried out. He had already opened the chamber in 1868, so he knew what he was doing. For none to notice,

[xxxviii] *St Andrews Wonderful Old Haunted Tower* By Dean of Guild Linskill, October 5th 1918

he would have to remove any evidence of external tampering. This could only be achieved if he were to "officially" reopen the chamber as soon as possible after he had secretly resealed it.

I have mentioned the possibility of Grieve being the catalyst for Smith to press Hall in opening the tower in 1868. It is also possible Grieve gave the same suggestion to Linskill in 1888. Grieve then went directly to see Hall about opening the chamber in 1888 on his own suggestion, or at least after planting the seed for Linskill to suggest this is what Grieve should do at all speed. Grieve knew how enthusiastic Linskill would have been to go in and see her, Linskill said, "My curiosity was aroused, and having got permission, one night I and several others, accompanied by Grieve, took out a few stones, and entered the chamber of mystery".[3]

In 1868, they went in at dawn. On this occasion, they went in at midnight. This could have been suggested by Grieve, as Hall was also present in 1868, and being head of the Cathedral grounds, he would have surely noticed himself before this time if it had been tampered with. Opening the tower at short notice, and in the dark, would prevent anyone, including Hall, from being able to scrutinise the entrance in any great detail. Not being stonemasons, as long as the work didn't look too fresh and was professionally done, no one would have known.

On entering the chamber, the coffin was there as described, but there was no girl in it – she had vanished. Other than disappointment, there was no suggestion or intimation of anyone looking for her. It was assumed she had been removed years earlier, and Grieve's comment to Linskill in the chamber, reinforced this, "Aye, there is the coffin just as I saw it years ago; but they have stolen the bonnie lady".[4]

Linskill said, "Who the girl can have been, and who took her away I would like to know; also whither she was taken".[5] No one conceived the possibility of her disappearing just prior to the official opening of 1888. They would have thought it occurred a number of years previously.

If this were true, a contract would have been agreed with Grieve and a healthy fee paid to him for doing the job and keeping quiet about it. All that had to be done was to make a hole in the blocked up entrance similar to that made in 1868. A coffin filled with hay and straw could then be taken in through the hole into the chamber, her body placed within, and the hay and straw packed around her to protect her body in transit. This would account for the hay and straw Linskill described

seeing strewn around the floor of the chamber in 1888. Once out of the chamber, Grieve resealed the entrance again.

It is almost certain that whoever ended up with her was one present at Linskill's 1888 opening. They would have gone there to see the reaction.

A St Andrews Tale...Linskill and the White Lady Corpse!

I move now to a fascinating tale that will sound like an amusing tall story of St Andrews, albeit a dark one, but then that is how we like them. Somewhat surprisingly, there are elements of truth buried within the narrative that I am about to relate. The following directly involves a prominent member of the St Andrews Antiquarian Society, the President himself – William Linskill.

In early 2014, I was conducting research in the Preservation Trust Museum in North Street. One afternoon, Sam the Curator and Anne, one of the trustees, introduced me to three elderly ladies as the "Ghost Man" and author of local historical/ghost books. Excitedly, they began chatting enthusiastically and thinking our meeting was going to be brief, I didn't get out my notebook and pen. An hour or two later however, having been regaled with the most remarkable ghostly accounts and stories, I went to the nearby North Point Café and recorded everything in my notebook.

One of those present was Jillian Falconer. She gave me a number of accounts of a paranormal nature from around the town. Jillian knew the granddaughter of William Linskill. It was she who told her the following absorbing and curious story involving her grandfather and the disappearance of the White Lady.

After William Linskill's death in 1929, the granddaughter and grandmother (Linskill's wife Jessie), were sorting out one of the cupboards in their house at 17 Murray Park. The granddaughter came across an old biscuit tin in the cupboard. On taking it out her grandmother went pale and abruptly told her to put it back into the cupboard, never to go near it or touch it, and certainly never to open it. Somewhat startled by this reaction, she did as she was told, but her grandmother's words were also enough to arouse her curiosity. We know William Linskill had a curious nature and perhaps the youngster inherited the trait!

Over the next few days, the biscuit tin was increasingly playing on the girl's mind. One afternoon after her grandmother left the house to

get the messages (shopping) she now had her chance. The tin had become an irresistible temptation, so she went to the cupboard to see what was inside. On her return, Jessie could tell by her granddaughter's face that she had opened the tin. Her grandmother was then obliged to explain the contents of the tin.

The following is Jessie Linskill's account to her granddaughter as retold by Jillian Falconer.

One night Jessie Linskill, following the late return of her husband, heard a commotion and went into the parlour. She was horrified when she saw propped against the table the slim corpse of a woman. She was in a perfect state of preservation. The skin still covering her bones was dark brown in colour and leathery. She had long black hair and wore an old white dress.

Linskill enjoyed port, fine dining and the company of fellow Antiquarians alongside that of golfers and academics. On this particular night, after having a few drinks in the Star Hotel in Market Street, he and a few academics ventured down to the Haunted Tower. Linskill climbed up the wall of the tower and being of heavy stature he fell through the roof. Finding himself in the middle chamber, he saw the body of a young woman – the White Lady. She was as stiff as a board and, with the help of others he removed her from the tower. After obtaining a sheet and covering her up, he put her over his shoulder and carried her back to his house.

Linskill propped her up against the table in the parlour just as the maid entered the room to greet him. On seeing the corpse, she was horrified and threatened to give notice. This was the commotion that caused Jessie to come downstairs and see what was going on. On seeing the corpse, she said words to the effect of "My God, I don't know where you got that from, but get rid of it!!" The time was around 1am. Being somewhat worse for wear, he couldn't decide what to do with her. He picked her up, took her into the garden and hid her in the toilet. The next morning the gardener saw her in there and he too threatened to give notice.

What ultimately happened to the body the grandmother didn't say, that was all she told her granddaughter, apart from to add that while he was carrying her around, one of her preserved hands had fallen off. When the granddaughter opened the biscuit tin, it was the preserved hand she was looking at!

Whilst Jillian was reminiscing about Linskill's alleged exploits, and how a preserved hand ended up in a biscuit tin, I could see Anne pondering on what had just been relayed to us all. She then said, "Do you know Richard. We have a photo of that hand upstairs!" whereupon she disappeared up the creaky old stairs of the museum, and we reflected on what Jillian had told us, and on what Anne was about to show us. She came back presently with a copy of a newspaper article.

This was the press release for the newspapers[xxxix]

Sure enough, there in the photo was the hand.

From the first photo it looks like the hand is sitting propped up in the biscuit tin. Described as being perfectly preserved, it had long slim fingers and dark leathery skin covering the bones. It was a dark chestnut colour, and given the descriptions, it reflected the preserved state the rest of the body would be in, if it still existed, and of course it could be found.

The hand hadn't deteriorated after being exposed to the air, so maybe the rest of the body also survived?

[xxxix] Image reproduced courtesy of the St Andrews Preservation Trust.

This is the original photo taken for the press[xl]

This second photo gives a far clearer image, and what it is actually propped up against.

In 2014, I met a wonderful elderly lady called Nan. She is a gold mine of information about generations of the town's residents. She told me how A. B. Paterson (Alec), co-founder of the Byre Theatre in 1933, knew two elderly ladies who stayed in a large house in Hepburn Gardens, not far from Kinburn House. Alec knew they were in possession of the hand and asked if he could borrow it to take a promotional photo to advertise a play he had written. Their consent resulted in the photo being taken for the press.

Following the photo being taken, Alec wanted to use the hand as a prop in the play. He was talked out of this as it was deemed "inappropriate," as Nan put it. So he had Ronnie Todd of the Byre Theatre's props department make a plaster cast of the hand which was then used in the play. During the play, the hand is separated from the body and is briefly revealed for the audience to see. Alec told Nan the hand played considerably on the minds of the two ladies who had the real hand. They called it the "black hand" and were worried about the

[xl] Image reproduced courtesy of the St Andrews Preservation Trust. Photo by Andrew Cowie.

amount of publicity it was now courting throughout the town. Fearing unnecessary intrusion into their privacy, with Linskill dying 18 years earlier, and it being a particularly morbid curio or relic to keep hold of, Nan believes they ended up destroying it by throwing it into the fire at their home and burning it.

The caption at the bottom of the photo from the newspaper read, "Margaret Watson, an Anstruther teacher, who plays a leading role in A. B. Paterson's "*The Witching Women of St Andrews*" at the Byre Theatre, St Andrews and Elliott Playfair, the producer, examine the mummified hand of the "White Lady" whose stealing from the town's haunted tower is the subject of the play".

The word Byre is a Scots word meaning shed or barn. At that time the theatre was a converted cowshed and was noted as being one of the smallest in Britain for many years.

The following is a short synopsis of the play.

The Witching Women of St Andrews
A Student Play in Three Acts

By A. B. Paterson

It took a while to track down a copy of the play, I began thinking all was lost, then, in September 2015, I finally found a bound carbon copy in the Special Collections Unit of the National Library for Scotland in Edinburgh. The first producer of the play was Charles Marford, actor and co-founder of the theatre in 1933. The play is set in the living room of a bunkhouse, (boarding house) along the Scores, near the Haunted Tower. The lodgers are students and the play covers three days in March 1881. As a cultural and historical backdrop, the play incorporates the Kate Kennedy Parade and the floundering in the bay, during a great storm, of two ships, one of which was 'the Merlin'. As a subplot, there is also a budding romance between a third year medical student and a local lassie. The relevance for us however, is in its main plot. Beginning with a sighting of the White Lady ghost by the Haunted Tower, the story soon leads to the removal of her corpse from the tower. As a variation on the tale involving Linskill, she is taken from the tower by medical students, and ultimately is taken aboard a boat and is never seen again.

Amongst the archives of the Preservation Trust Museum, North Street, St Andrews, are photo albums from many plays the theatre has staged over the years, including this play. Photographic records exist for each year it was performed at the Byre, being 1947, 1948, 1950, 1952 and finally 1959. I have included two remarkable photos from rehearsals of its first performance in 1947, which to my knowledge have never before been published. I am gratefully indebted to Samantha Bannerman, the Curator of the Museum, for her work in tracking down the photos in the archives for me and for permission to use them.

A scene from the play in 1947[xli]

CHARACTERS

Duncan Flockhart A third year medical student from Buckhind

Mary MacAndrew An 18 year old dressmaker

Anthony Robbins A second year arts student

Mrs MacAndrew St Andrews "bunkwife" or student landlady

[xli] Image reproduced courtesy of the St Andrews Preservation Trust. Photo by Andrew Cowie.

Charles Blue	A second year arts student
Captain Burns	Skipper of a coaster

LOCATION

As a lead into the play, Paterson says, "The entire action of the play takes place in the sitting room of the "bunk" of Mrs MacAndrew. All the characters are fictional, although many of the incidents are historical". The acts are as follows:

Another scene from the play in 1947[xlii]

ACTS

ACT I	Friday evening 4th March 1881
ACT II	Saturday 5th March 1881 – Kate Kennedy's Day
ACT III	Tuesday 8th March 1881

[xlii] Image reproduced courtesy of the St Andrews Preservation Trust. Photo by Andrew Cowie.

My intention is to have the play staged once again at the Byre Theatre as a St Andrews historical production.

The Antiquarian, a few Medical Students & a Skipper...

If it were not for some compelling elements in Jessie's story to her granddaughter of how they came to be in possession of the hand, it would remain a tall story passed on and embellished through generations of retelling. Intriguingly, not only did the hand exist, it appears Linskill was in possession of it.

A few weeks after hearing this story of Linskill and the White Lady, I found a hastily published article in the *Edinburgh Evening Dispatch* dated 31st January 1894. The article also appeared in the *Citizen* a few days later. The *Dispatch* article was published the same day as the short *Scotsman* article briefly quoting the *Saturday Review* report about the opening of the tower. It included the wayward speculation as to the identity of one of the occupants quoted on p. 41. Although the *Dispatch* article gives no dates, it was written as a clarification to this *Scotsman/Saturday Review* article, and is uncannily similar in a number of ways to what Jessie told her granddaughter. It is also reminiscent of Paterson's play, and is where he may have gathered some of his inspiration. I then realised it had also been republished in Linskill's long 1925 article in the *Citizen*. I had read it before, but with there being so much speculation in various articles from different angles about the tower and the White Lady in general, I gave it the same credence as Linskill gave to his own introductory heading to the piece, calling it 'A Skipper's Yarn'.

This is the first article offering new information since the *Saturday Review* article of November 1893 and the *Telegraph* interviews a few days later and ran as follows...

ANOTHER STRANGE STORY OF ST ANDREWS

[TO THE EDITOR OF THE "EVENING DISPATCH"]
January 31, 1894.

SIR, -While on board a yacht on the Clyde two summers ago which had just been bought and brought there from St Andrews, the skipper,

who was a native of that city, told me a story which I did not credit at the time, but since seeing your issue of Monday and to-day's *Scotsman* I think there may be some truth in it. I give you it for what it is worth.

On a certain evening an antiquary and a few medical students called on this man and asked him to assist in the exhuming of a female body from St Regulus Tower, [the author of this piece has muddled St Regulus Tower with the Haunted Tower. When Linskill reproduced this piece in his article he gets round this by changing it to 'an old tower'] which body was in a state of complete preservation. There was not much difficulty in finding it, so the body with a cloth over it was carried shoulder high through the streets to the antiquary's house, where it was propped up on the dining-room table with decanters and empty bottles. The body was that of a young, good-looking girl, with perfectly preserved black hair.

Ultimately, the body was locked up in the cellar. A rival antiquary got wind of this "find," and bribed the skipper to steal it, which was duly done. After this the body was lost sight of, and the skipper of the yacht firmly believes it is now in the Edinburgh Museum (?). – I am, &c.

INTERESTED READER

Linskill doesn't include this last piece about the skipper taking her to an Edinburgh Museum, after quoting the above piece he continued his article with his own reply to the letter.

"Personally, I cannot say I believe one word of this skipper's mythical tale, but without doubt between 1868 (when Mr Hall and his friends explored the Haunted Tower) and 1888 (when my friends and I examined the place) some folks had paid a visit or visits to its interior and played havoc therein, smashed up the coffins, and removed any means of identification".

He suitably exaggerates here as nothing had been smashed up. Whilst the contents had indeed been disturbed and damage done, it was not from vandals in the conventional sense. From his earlier descriptions of 1888, other than the White Lady disappearing and hay and straw lying about the floor, what he found wasn't overly dissimilar to the reports of how Antiquarians had left the chamber in 1868.

On the surface, it is plausible Linskill took her, and on taking her to his house, he eventually moved her into the cellar and employed a skipper, a fisherman he could trust to take her away. This could have

been Mr John Chisholm, described as 'an old seafarer'. He was in charge of the digs Linskill conducted when looking for underground passages and chambers around the Cathedral grounds. A fanciful notion, but could Linskill have paid him so much money for taking her to Edinburgh that Chisholm bought a yacht with the proceeds and moved to Glasgow? On making enquiries, I followed up the story of the skipper and contacted the museums in Edinburgh. There is no record of her being taken to any of them, or of them having anything fitting her description.

With the letter appearing in the newspaper on the same day as the *Scotsman* article, it could have been written in haste as a red herring to divert attention away from St Andrews. Since my initial enquiries in Edinburgh, I have found this may have been the case and she may well have remained in town. Could Linskill have known this, which is why he omits this detail when he quoted the article?

In print, he deplored the extraction of her from the tower, yet despite him having appearing to have a hand purporting to belong to her, neither he nor anyone else furthered the speculation. The story is certainly in keeping with Linskill's mischievous character as the dark humour blends with what appears to be elements of truth, mixed with seemingly obvious fiction.

To investigate the details of the story further that Jillian Falconer relayed to us, one of the things I needed to do was to go inside the chambers of the Haunted Tower and take a look around. The iron gates on the chamber entrances are locked to the public, so I sought permission from Historic Scotland's head office for the gates to be opened for me and an appointment was made.

Entering the Chambers

One sunny, crisp morning in October 2014, I went to the tower. It was an odd feeling walking through the grounds. The tower was so familiar to me. Having conducted so much research into this tower over the years, and taking tour parties there on a daily basis, being able to go inside felt almost like a pilgrimage. It certainly formed one of the last connections I needed for this book. On meeting Alison Sullivan, the Monument Manager of Historic Scotland in St Andrews, and with the help of Historic Scotland workmen, the gates of the middle and lower chambers were opened. This isn't a place visitors have access to so this was indeed a rare and wonderful privilege. Birds get into the lower

chamber through the gun loop holes so workmen go in once or twice a year and sweep out.

When I entered the middle chamber, I could immediately see the roof comprised of large heavy stone slabs, integral to the structure and former parapet walkway above. As interesting a notion as the story of Linskill, or indeed one of the academics falling through the roof of the chamber had been, there is no sign of a cave in, nor indeed the repairs of one. The slabs forming the roof of the chamber are very solid and firmly fixed which rules out that possibility. Whoever went in did so by either going through the southern side of Hepburn's Wall above the stair, or through the sealed entrance at the top of the stair, and certainly needed a stonemason.

The truth behind her disappearance may lie somewhere between the grandmothers' tale, Paterson's play and the newspaper article. With this, the story of Linskill's involvement is more likely an elaboration of the hastily published 1894 *Evening Dispatch* article. Personally, I don't believe he took her, but as mentioned, it appears he did have the hand. Another explanation of how he came by the hand is hidden in something Smith said in his 1893 interview; "One of them – a female – had on her hands white leather gloves, very entire, a piece of which Carmichael took away as a reliquary".

This is a fairly cryptic sentence, "very entire" could refer to the corpse or to the glove. A reliquary is a container for bones, and in using this term, is it possible Carmichael took the leather glove in 1868 with her hand still inside? Linskill could then have received the hand from Carmichael. Linskill knew all the Antiquarians of the day, and if he didn't get the hand from Carmichael, perhaps he obtained it from the College Museum following its demise.[xliii]

I wonder what Linskill would have made of the story? After all, he wasn't immune to a little exaggeration and enjoyed a little poetic licence. Maybe in his inimitable style he would have said something along the lines of, "Odd's fish, Sir! A St Andrews tail indeed!"

A Few Candidates

Only a few before the 1893 article knew for sure of her existence. In considering the profile of whoever had the remains of the White Lady removed from the chamber, aside Linskill and medical students, there is

[xliii] Refer to foot of p. 107

enough evidence to suggest the following:- They were someone resident in the town, someone of means, someone with an Antiquarian interest, a person connected in some way with science or the medical profession. Could it have been someone of note within the University, someone holding a prominent position, a professor or doctor perhaps?

As mentioned earlier, an internal enquiry would have been likely, and these conclusions would have been drawn at the time. The University would have been one of the first called upon. This would have stirred things up and they would have applied their own internal pressure, pressure someone really didn't want either for themselves, or for whichever body, department or society they were involved in or associated with.

Removing her corpse must have been worth the risk it surely involved and explains why the chamber had to be professionally resealed. Despite so many avoiding this area after dark, every minute down there was increasing the chances of being caught.

The Antiquarians were the forerunners of the archaeologists we have today, and they were curious rather than careful. The foundations of archaeological methodology we employ today were not introduced until the 1920s. Before then, historical curiosities were collected but little or nothing was done on a site in terms of recording excavations, or in understanding the value of the position and location of what was being discovered. Neither were the methods employed to excavate a site geared towards preserving locations as well as artefacts.

Speculation as to who had her inevitably focuses on those prominent members of the University who were also Antiquarians at the time. The period I have looked at is 1888, of these, there are three possible candidates fitting the profile at the University in St Andrews.

The first is - Sir James Donaldson, Principal of the United College in 1888. Taking office in 1886, he was a Scottish classical scholar and theologian. Recipient of many awards, in 1907 he was awarded an honorary Doctor of Divinity by the University of Aberdeen in recognition of his work on Church history. He wrote a number of books, including one titled '*Woman; her position and influence in ancient Greece and Rome, and among the early Christians*'. In his memoirs, he reputedly describes how he went into Bishop Kennedy's crypt in St Salvator's Chapel with his wife and their beagle dog and fondled his skull!

Sir James Donaldson
Principal of the United
College in 1888
(1831-1915)

As Principal of the United College he was certainly more amenable to procuring and exhibiting historical artefacts than his predecessor Principal Shairp, and would have been more likely to have appreciated the historical importance and value of the White Lady's corpse.

Another candidate is the Honorary Secretary of the St Andrews Antiquarian Society, Professor Arthur Stanley G. Butler, Professor of Natural Philosophy at the University from 1880 until 1922. A convert to the Catholic faith, he came from an established line of prominent academics based predominantly in Cambridge.

Arthur Stanley G. Butler and Sir James Donaldson were both prominent Antiquarians and had a very keen interest in St Andrews. Although there is no mention of them being present in 1868 or in 1888, it is probable they were, given their avid interest in the town and its historical curios.

Of those we know who were definitely present at the 1868 opening, Professor Matthew Forster Heddle is the one who stands out the most as a possible candidate for wanting to preserve the integrity of the remains of the lady. Although his specialist and favourite subject was mineralogy, he took the chair in St Andrews as Professor of Chemistry at the United College. He was an Antiquarian, and by now, he was the Vice President of the Literary and Philosophical Society. A position he held from 1884 to 1893. With this, he would have been involved heavily in the College Museum, although by now the museum was suffering from a lacking of volunteers to maintain it. Importantly, he was also a Medical Doctor in Edinburgh for five years before coming to

St Andrews, and being noted as a highly intelligent man, he could turn his mind to any subject.

He was the only one who made the suggestion in 1868 to move the unusual skulls found in the lower chamber to the museum but this was before he took office there. Given his background, he was probably the most knowledgeable and appreciative member of the group about what they discovered during the 1868 opening. Although he never went fully into the tower, the discovery of the White Lady would have been the focus of everyone's conversation that day, so he will certainly have been aware of her. He knew Grieve and lived in the former buildings of St Leonards College, so a mutual bargain could easily have been reached to have her removed. With him living by the Cathedral precincts, she could have been taken south through the burial grounds, up the short distance of the Pends into the buildings at the end of the Nun's Walk.

Professor Heddle, Sir James Donaldson and Professor Butler each fit the profile of one who could have paid to have her corpse removed for reasons of preservation. History and historical artefacts were very important to each of them, and as pioneers in their own fields, if the bodies were discovered today, archaeologists would have no hesitation in removing them and carrying out more research. If they were not responsible for her disappearance, they were very likely moving in the same circles as whoever was.

Chapter Seven

The Body of the White Lady
& an Egyptian Mummy

A Preserved Foot ('the Black Foot')

Along with the photo of the hand and the strange story of its provenance, there is also something else – a delicate foot, purporting to be from the White Lady. The foot ended up on display in the College Museum at St Salvator's shortly after the 1888 expedition into the tower. With the legend on the glass cabinet under which it was exhibited, officially stating it to be the 'The Delicate Foot of the White Lady', the credence of its provenance also lends the possibility of someone connected with the University having removed her from her hiding place.

The fact, it was because it was given this provenance that it was very important. In an article headed 'Mr Andrew Lang on St Andrews Vandalism', published in *Longmans Magazine* in the 1890s, he says, "In the College Museum is a beautiful foot of a woman, an exquisite thing, far lovelier than Trilby's. It is reported to have come out of the Haunted Tower, but nobody can really know the truth".

Trilby is a novel by George du Maurier. Published in 1899 the book is about the left foot of a young woman in Paris called 'Trilby'. The book sold a million copies in its day and is worth quoting a short piece here.

""That's my foot," she said, kicking off her big slipper and stretching out the limb. "It's the handsomest foot in all Paris. There's only one in all Paris to match it, and here it is," she laughed heartily (like a merry peal of bells), and stuck out the other.

Poor Trilby!

The shape of those lovely slender feet (that were neither large nor small), facsimiled in dusty, pale plaster of Paris, survives on the shelves and walls of many a studio throughout the world, and many a sculptor

yet unborn has yet to marvel at their strange perfection, in studious despair.

For when Dame Nature takes it into her head to do her very best, and bestow her minutest attention on a mere detail, as happens now and then—once in a blue moon, perhaps—she makes it uphill work for poor human art to keep pace with her.

It is a wondrous thing, the human foot—like the human hand; even more so, perhaps; but, unlike the hand, with which we are so familiar, it is seldom a thing of beauty in civilized adults who go about in leather boots or shoes...

It was Trilby's foot, and nobody else's, nor could have been".[1]

The foot still exists and resides in the University Medical Building. I had a meeting at the end of October 2014 with Susan Whiten MA PhD, Senior Lecturer in Anatomy at the School of Medicine at the University. I met with her to look at the foot and find out what information they had about it.

'The delicate foot of the White Lady'

When I saw it, I recognised it immediately from a rare photograph I had seen of it displayed under the small glass case in the College Museum in the 1890s. This is her left foot; the very one Lang had

associated with "Trilby". The preservation is complete with a full complement of toenails. Noting its colour, I realised why the two elderly ladies called the hand the 'black hand'. It wasn't through any sinister connotation as I had initially thought when Nan mentioned that term to me. The foot is mainly black with hints of very dark golden brown, the colour of honey. Its appearance is strikingly similar in both its delicate appearance and colouration to the hand, so we could easily call this the 'black foot'. Susan said, alcohol with formalin is now used for preservation, but bodies were once preserved using salt and honey. The foot is not on display, and it is in a very good state of preservation.

I was somewhat surprised when Susan told me the University has no provenance for the foot and she was unaware it had once been on display in the College Museum. She was also unaware in the 1890s it was used by lecturers for teaching purposes. This delighted her, as without knowing she is carrying on a tradition spanning well over a hundred years. She uses it to demonstrate the movement of the talus bone, joining the leg and the foot. On this example, the talus bone comes apart from the rest of the foot. Maybe this is the reason why it has not been lost or consigned to the obscure, or simply assigned a number and forgotten amidst the University's extensive archives over the years.

Appealing to the imagination of all who saw it in the museum, a poem was even written about it. The poem was published anonymously in December 1894, and was printed onto a sheet of thick cream paper folded in half. Linskill, with his customary sleight of hand when it came to detail, gives no name for its author, simply stating the poem was put together by "a local man". With the passing of 26 years since the poem's publication, Linskill discloses his name in his 1920 article '*the Strange Mystery of the Haunted Tower*'. He writes, "The late Colonel Thomson wrote a poem about her with a picture of the outside of the Haunted Tower".

The following is the poem he published. At the end of the poem is an interesting note Colonel Thomson wrote about the foot. The poem is introduced with the following words...

"Reflections of a visitor on seeing the foot of a girl embalmed. Or otherwise well preserved, exposed to view in a glass case in the College Museum".

A Poem in Memory of the Unknown Lady

Whence came this dainty little foot?
A gruesome thing, it doth repel me,
Curator knoweth not, is mute,
And Janitor he cannot tell me.
An object grim, yet it begets
Strange thoughts and eerie speculation,
Queer brooding fancies, vain regrets,
With wonder at its preservation.

For many lustres it has lain
In mouldy grave or mausoleum,
And now it sees the light again
Encased in glass in our Museum.

It once was pink and white as down,
Of sunny peach or ripening cherry;
But now its tint is ruddy brown
As hazel nut or autumn berry.

Some sixteen summers it has seen
Of creeping, toddling, running, dancing;
Has romped and skipped upon the green
The fairy feet like sunbeams glancing.
Oft it has roamed the yellow sands,
And bathed and paddled in the "briny",
While breakers thundered on the strand,
And wavelets kissed the toes so tiny.

In spring, where blooms the primrose sweet,
It sought thy sunny nooks, Kinkell;
When o'er the rocks the little feet
Sprung lightly like a young gazelle.
Its owner's name – Ah! Who can tell?
'Twas surely musical and pretty.
Like Mary, Maud, or Isobel;
Perhaps they called her Lady Betty.
The child of gentle blood, I ween,

Of gallant knight or baron bold;
Her pedigree it might have been
As ancient as the ruins of old.

A bright embodiment of grace,
Displayed in every motion,
Love, candour, beaming in a face
Oft glowing with emotion.

A maiden, winsome, sweet, and sprightly,
With dancing limb and laughing eye –
One who could tread a measure lightly,
And sullen care and grief defy.

Who to the Links would sometimes stray,
With other maids, in summer weather,
To watch the eager golfers play,
'Mid golden gorse and blooming heather.

Or to the ancient butts she'd hie[xliv]
To see the noble archers shoot,
And 'mong her college friends espy
Some honoured names of high repute:
Bright sons of men of learning,
Bold scions of war and strife,
Blithe lads from the braes of Angus,
Young bonnet Lairds of Fife.

She may have known the gallant Graeme,
Montrose, that flower of chivalrie;
Or later still, of tragic fame,
The brave, the beautiful Dundee.

Her life was one long summer's day,
And she the darling of the hour;
A rosebud in a garden gay –
Alas! it never lived to flower.

[xliv] Go quickly

Poor little foot! there's none can tell
Its owner's sad and simple story –
The cruel fate, the blow that fell
To waft her to the realm of glory.

Note, - "There is every reason to believe that the foot in question belonged to the mysterious and interesting collection of human remains discovered some thirty years ago [he is speaking of the 1868 opening] entombed and immured in the upper chamber of the quadrilateral tower situated east of the turret light. This tower now vulgarly known as the 'Haunted Tower' which formed part of the wall embracing the Cathedral and other Church property was built by Priors John and Patrick Hepburn early in the 16th Century. How it came to be used for such a purpose as above described and by whom is still shrouded in mystery; but this we know that the objects discovered were of a singularly interesting character. They consisted of coffins of pine and oak of antique shape, containing skeletons; also other coffins of more recent date, enclosing the remains of bodies in various stages of decay – some of them in a state of partial preservation.

Notably of the latter class was one – the corpse of a young female attired in costly grave clothing which appeared to have been embalmed with remarkable success. To this body belonged, I am convinced, the little foot now exposed to view in the College Museum. Since the original discovery by certain inquisitive citizens of St Andrews, the chamber has been repeatedly entered, and so thoroughly and unscrupulously plundered of its contents that at the present time nothing remains to be seen but a few bones and fragments of coffin boards".

Linskill in one of the St Andrews Antiquarian Scrapbooks spanning the 1890s has one of the sections of the poem marked with a cross. He knew this had significance as it perfectly describes the tone of her skin...

"It once was pink and white as down,
Of sunny peach or ripening cherry;
But now its tint is ruddy brown
As hazel nut or autumn berry".

The hand was a mix of this and black and the foot is almost entirely black. The colouration also describes something else matching this description.

The Preserved Head

Along with the delicate foot, which I was delighted to find still existed and is still being used as an anatomical teaching aid, there was a surprise in store on my visit that morning to the University Medical Building. Grieve said to Linskill "her eyes were closed, and she just looked as if she had fallen asleep not long before".

In 1826, the Professor had said the same thing. When Susan arrived in the room with a box containing the foot, something else also arrived. A porter appeared behind her carrying another box covered by a white sheet. Following introductions, when the sheet was removed I found myself looking face to face with something only a few have known exists and even fewer have ever seen. This is the wonderfully preserved head of a young woman, now sealed under a clear Perspex box fashioned possibly by a porter at the University in the 1970s. Inscribed on the base is the date 2/6/76 and the initials PBS.

As far as I am aware, this is the first time details of the existence of the head have emerged in print. I doubt Linskill was aware it existed. So it would seem only a select and privileged few in the University have known of it over the years.

As with the foot, there is no provenance for the head, which has been cleanly severed at the neck. It is female, young, with high cheekbones, she would have been very striking when alive, and her eyes closed follow the description of her in the tower.

The Black Hair

The head is bald, the skin leathery, very smooth and shiny. Rather than her hair falling out over the years, this suggests she had no hair when preserved. However, Grieve mentions seeing her hair in both his 1861 and his 1868 accounts to Linskill. Interestingly, of the original witness reports, he is the only one to give any mention to her hair. It is apparent Grieve had parts of the 1861 and the 1868 reports muddled, so it is possible only the corpse in the second chamber had hair. From this it is also possible the head is from the White Lady in the tower and her head was shaved before she was preserved. The skipper and Linskill's granddaughter also mention hair and this could ultimately have come from either Grieve's description or the description of her ghost rather than her corpse.

What Happened to the Rest of Her Body?

So what happened to the rest of the body if it ended up in the United College Museum? The majority of the body of the White Lady, like the other preserved occupants of the tower suffered greatly after being handled by the Antiquarians. With them moving the bodies around, and the chamber being opened on numerous occasions, they accelerated the process of decay. If the head, foot and hand are from her, then attempts were made to preserve the integrity of the intact parts. Interestingly, along with the head, it is the left hand and left foot that survived. If she were from the tower, being entombed facing east, her left side would have been more protected from the draughts and the elements coming in through any chinks in the south wall that were re-pointed.

There is another possibility for the preserved body parts. In 1781, an Egyptian Mummy was presented to the University. It was kept in a glass case and displayed in the King James Library overlooking South Street and St Mary's Quad. The library was the forerunner of the College Museum and is where some of the University curiosities were housed.

George Alexander Cooke in 1805 wrote a short piece about it, "The College library, where there are several curiosities preserved, such as an Egyptian mummy, &c. is well kept, and is considered one of the best in the kingdom".[2] James Grierson writing three years later in his *Delineations of St Andrews* in 1807 says "among the curiosities shewn to strangers who visit this library, is an Egyptian mummy, but in a bad state of preservation".[3] Grierson saying it was in a bad state seems to be in contradiction to Cooke saying it was "well kept". To try and find out more about this curious Egyptian mummy and if the existent remains were from the White Lady or the mummy, I contacted Dr Helen C. Rawson, Co-Director of the Museum Collections Unit (Collections and Exhibitions) at the University of St Andrews. She kindly replied with valuable information that at least cleared up the above discrepancy regarding the state of the mummy. Her reply is as follows.

20th November 2014

Dear Mr Falconer,

I have always assumed that the extant head and foot are from the original mummy, which must have been unwrapped at some point, though I have never discovered any documentation that firmly establishes this. However, there is no evidence that the University has ever held more than one mummy, so I think this is the most likely scenario.

The mummy was presented by a Mr Galloway in 1781 - it is recorded in the Senate Minutes of 17 July 1781 as having been presented with 'some Eastern curiosities'. There is no indication of the gender. The Senate ordered that a display case be made for it, and two keys obtained, one to be kept by the Quaestor and one the Librarian.

It was displayed in the University Library on South Street (now known as the King James Library).

In 1784, Bartélemy Faujas de Saint Fond wrote that:

There is ... shown as an object of curiosity, an Egyptian mummy in very bad condition, without even its ancient case, and appearing to me to be one of those which the Arabs fabricate out of patches and fragments, for the purpose of selling them to such as are unable to detect the imposition.[4]

So it always seems to have been in a fairly poor state. I think Cooke may have been describing the Library, rather than the mummy, as one of the best in the kingdom. The Library was generally admired in this period.

The mummy was transferred from the University Library to the new joint Museum of the University and Literary and Philosophical Society in St Andrews in 1838, which was in Upper College Hall, off St Salvator's Quad. I don't know at what point it came off display. In the 1838 list it is described as 'Egyptian mummy in case', presumably the case commissioned by the Senate in 1781 rather than a sarcophagus. Hope this is of some help

Kind regards
Helen

When it came to the remains of the deceased, there was a difference between the respect afforded to them in the public eye, and the indifference suffered by many behind the scenes. Gorman, on speaking of human Egyptian mummies, says, "In Victorian times Christians felt no qualms in desecrating mummies. There seemed to be such a great supply of them that "mummies were exported to the US for use in the papermaking industry... Mark Twain reported they were also burnt as railroad fuel". It has been said the latter is an urban myth, so I leave it to you and your own research to decide if burning them as railroad fuel actually occurred.

Alongside humans, around 70 million animals were also mummified in Egypt to be buried with their owners and a great many were sold to pilgrims who would then offer them to the appropriate Gods. The demand was so great it outstripped the supply, and some species, such as the baboon, became extinct in Egypt. With this, they started breeding animals specifically for the purpose, but it still wasn't enough. Thousands of mummified cats made their way to Britain from Egypt, and by all accounts, a great many were processed and used as fertiliser. Scans conducted in 2015 by Manchester University and Manchester

Museum on over 800 mummified animals, found that despite having all the characteristics of a particular animal, one third contained no skeletal remains.

The Lit and Phil Society and the Museum

Despite the popularity of the College Museum, it had a chequered history. As Helen pointed out, it was created as a joint venture between the University and the 'Lit and Phil' Society, but "there were occasional tensions between the University and the Society. By the 1850s there was increasing pressure to open the museum to the public. In April 1855, it was agreed to open for two hours every Saturday afternoon during the summer. This was repeated the following summer, but not in 1857 for lack of money to pay a custodian. In 1858, in response to public pressure, the Society decided to open the museum from 10 to 4 during term time and 10 to 6 during the summer, with charges for non-members. But this arrangement did not last".[5]

Despite its popularity when it was open to the public, the running of the museum was causing diplomatic tensions between the University and the Society. The records show, "the Society was in decline in the 1870s".[6] In 1879 when underground passageways were accidentally discovered by a workman at the Archbishop's Palace. He vanished, dropping 15 feet into a tunnel with a wheelbarrow full of heavy rubble!

Linskill believed this to be an underground passage extending between the Palace and the Cathedral. The Saturday Review wrote in this regard that, "Mr Linskill's theory became respectable".[7]

Following the excitement of its discovery, Linskill was convinced there was a network of tunnels and chambers under the old quarters of St Andrews, especially under the Cathedral precincts. Amongst other purposes, he believed these chambers were used as hiding places for valuables in times of trouble. He and many in the town believed that before the Reformation, the Catholics had enough time to hide what they could underground. Refer also to Section Four, 'The Treasure', p. 181.

With this in mind, he formed the St Andrews Antiquarian Society. Its purpose was to look for the lost treasures of the Cathedral. Members of the 'Lit and Phil's' soon began switching to his new society, and in diverting their attention away from the museum, this was the beginning of the end for both the 'Lit and Phil's' as a society, and the museum itself. The society "was revived slightly, [between 1879 and 1889] then in 1889 members [possibly headed by Professor Heddle] had a serious debate as to whether to continue or not".[8]

Unable to sustain the museum, the University took complete control in 1904. A skeletal form of the society managed to limp on until half way through the First World War when it finally folded in 1916. Sadly, when the University took complete control of the museum, the collection was broken up and distributed to different buildings. Unfortunately, during this period, some the collection just disappeared. The diplomatic line of the time simply stated that some of the artefacts "cannot now be traced". If the hand had been part of the museum archives, this may add another explanation of how Linksill came to be in possession of it.

The White Lady or the Egyptian Mummy?

There are certainly arguments on both sides as to the provenance of the body parts in the medical building. Is it too outlandish a notion to think they could be of the White Lady, or does this possibility carry the most plausibility?

The Lit and Phil officials could have given the association of the foot to the White Lady rather than to the Mummy because of the fascination for her. By the late 1800s, she was more of a draw for a flagging museum, and it is certainly true the foot attracted many to the

museum as a result, as almost everyone knew of the possibility of her existence before the articles about her corpse appeared in the press of 1893. Although, having said this, it is unlikely the Lit and Phil's would have been prepared to deliberately mislead the public. This is a University, the museum was part of the University, and presenting the facts is what they strive to do. The dilemma in knowing this is where the crux of the matter resides. The museum was looking to increase the number of visitors, but they wouldn't have compromised their credibility or that of the University with a side show at a time when many of the members of the Lit and Phils had already left. The conclusion from this lends credibility to the provenance of the artefact as being that of the foot of the White Lady. This also supports the view that whoever took her wanted to ensure her preservation, or at least to care for whatever was left of her.

However logical this appears to be, if this were true, why secretly remove her? Why not go through official channels and have her moved to somewhere safe? The fact she was removed is undeniable, but I believe this option wasn't entertained because they knew they would be refused. They were not interested and the desecration card would once more have been played. Professor Heddle, who saw the skulls in 1868 with the yellow silk tied around their heads, had already asked the museum if they wanted them. Principal Shairp had only been presented with the Principalship of the United College a few months prior to the opening of the tower in 1868, and automatically objected to the idea. He had been in St Andrews for 11 years, but like the Lord Advocate, many years before him, he had no interest in their discoveries. Officials in 1826 saw the opening of the chamber as an act of desecration rather than as an important discovery. This would not only have been because grave robbing was still rife at the time, but also from them being oblivious to the potential archaeological importance of the find.

Shairp held the chair until 1885, three years before the next official opening of the chamber. By then, Linskill's enthusiasm for the history and preservation of the town matched that of Hugh Lyon Playfair and the Lit and Phil's, who had all done so much for the town. It was now all extending to Playfair's sons, who, along with Linskill, were prominent officials of the town. Enjoying similar interests and good company, the Playfair brothers were behind Linskill in his endeavours and attended both the secret openings of 1888 and 1891. Finally, a

movement of positive interest was apparent about the chamber's occupants not evidenced before.

A Hushed Up Affair

The formal disclosure of the existence of the White Lady, the mystery surrounding her disappearance and the letters of correspondence to the press came six years after it was found she had disappeared. On going through the mêlée of letters, it appears every aspect of the mysteries connected with the tower were covered, barring one, the nature of her disappearance. There was the occasional public expression of disgruntlement and anger, but there was never a serious inquiry or debate into the matter. For something really quite major I found this unusual, as there was a mystery here and a corpse carrying its own importance and enigma had disappeared.

Could it be that nobody was willing to broach the subject of who took her in public because of potential libel? Any formal speculation in the press would have included names, or planted seeds in the direction of a name or organisation. Even though it was six years after her disappearance that letters started appearing in the press it was still too recent. In private circles, it would have been a different matter and Linskill certainly pondered on this mystery, but in print, he too refrains from delivering his thoughts too deeply. He just poses the simple questions "...how, when, and where she went?"[xlv] He must have had his own theories. Knowing everyone who may have had a qualified interest in her, it is more than likely he suspected he knew the identity of the person or persons who took her, especially after a foot appeared in the museum purporting to be from her. Alongside libel, this exhibit and its publicised provenance had both narrowed the field of suspects and potentially answered the question of where she finally ended up. The appearance in the museum of the foot diluted their willingness to speculate about how it now came to be in their possession. Maybe this is why Linskill's remark a few years later about the hay and straw he found in the chamber of 1888 was never furthered by any in the press.

When the Antiquarians saw the foot in the glass case, for them, this was the foot of the White Lady and that was all that mattered. It was a prized piece to them and the town, and all who saw it were mesmerized

[xlv] Linskill. 'The Strange Story of St Andrews Haunted Tower', *St Andrews Citizen,* 1925. Paragraph headed 'The Mystery Remains a Mystery'.

by it. This was more than a preserved curio, with the heading of the exhibit directly associating the foot with the White Lady this was something captivating, something almost magical, which struck those who saw it with a childlike awe. They would peer through the small glass case at close quarters, steaming it up with their every gasp. The town had been absorbed in the mysteries of the tower for many years, and the foot appeared in the museum around the same time the wall of the middle chamber was removed and replaced with an iron grill. In the museum, the public were now being given access to what they believed was at least part of her. Perhaps appropriately, it was now being venerated as a relic from a saint, with a poem even being written about it. Yet while it enthralled them, it also scared them, as they believed the spirit of the woman the foot was purporting to have come from was still active only a few hundred yards east of the museum.

Summing up

The head, the foot and from what can be seen in the promotional photo of the hand and its description, do all seem to be from the same person. They share the same skin tone and level of preservation. They also share commonalities with the description of the White Lady, barring the hair, but then, as I mentioned, it is possible she never had any hair when she was preserved. It is also the case that aside the preservation fitting with that of an Egyptian mummy, they don't appear to fit with Grierson's brief description of the Egyptian Mummy presented to the University, as he said it was in a "bad state of preservation". Of course, this could have been superficial and its outward appearance was simply due to the wrappings.

Through investigating this aspect of the mystery, with every thought arising in one particular direction as to their provenance, a counter thought appears. University academics in the late 1800s were aware an Egyptian mummy had been a feature of the University, and that it was moved to the College Museum from the King James Library. Despite this, they still gave provenance of the foot to the White Lady and not to the mummy. This is significant, as there is an opinion that the last part of the mummy to remain was its head, as the body itself was believed to have been discarded, which would be in keeping with Grierson's 1807 appraisal. At a later point, and still covered in ancient bandages, the head was also thought to have been destroyed.

If we took the scenario that some of the mummy survived and the foot was from the mummy, there would have been an obvious line of provenance, but, however compelling the provenance was for it coming from the mummy, as we know it was given to the White Lady and was accepted without dispute. Added to this, the hand has also been directly attributed to her on a number of occasions. With the closure of the museum, and the removal of the foot from its case, the passage of time has nearly erased this potential.

Although the mummy was special in its own right, and certainly a curio for the University and town, there was a particular mystique surrounding the White Lady in the late 19th Century. There are no witness descriptions mentioning the tone of her skin when seen in the chamber, but she and the other corpses have been described as being mummified. If they are from the Cathedral, then they are from the corpse in the Haunted Tower and not the second chamber, as that corpse was described as being in a worse condition.

The current resting place for the foot and head also fits with both theories, so for the present, it is all in the balance. Based on the information at hand, it is left for your own discretion as to who you think they belonged to.

Chapter Eight

The Haunted Tower Corpses

What Happened to the other Occupants of the Tower?

Aside Linskill describing the secret opening of the tower and that the body of the White Lady had disappeared, in his report referring to the 1888 opening he states, "The skeletons and fragments of coffins are now carefully stowed away round the corner out of sight".

In another article referring to this opening he says, "There were some very well preserved skeletons, or mummies, lying about, and a lot of broken up coffins and wood and some straw. We built the opening up again".

In his 1893 statement, Hall, in referring to the last opening of 1891, says, "we got no bodies". He was referring to preserved bodies, not to skeletal remains, as it appears at least some of the mummified bodies of 1868 had turned to "rather well preserved skeletons", so from the descriptions, by 1888 and certainly, by 1891, the process of decay was very much apparent.

David Henry in his involved article *The Haunted Tower* written in 1912, and reproduced in full on p. 136 says, "some twenty-three years later [after 1868 in 1891] a privileged party obtained access again but they found little but the remains of the coffins; probably the admission of light and air at the first opening had hastened the natural decay of the bodies for they had literally returned to the dust from which man came. At that time the coffin remains were gathered together and put, where they still are, at the extreme leftward end of the vault out of view from the door opening and a grill – the predecessor of the present gate – put on". Hall also says in his 1894 statement, "About three years ago, [1891] … we put up the present iron grating, through which you can see into the passage, but not into the vault proper".

In 1891, the coffins were taken out then replaced in the tower. They could have temporarily removed them for a closer inspection, but more than likely, they cleaned out the interior preparing for the public to see into the short L of the chamber, then replaced them, as Henry says "at the extreme leftward end of the vault out of view from the door

opening". Henry says, "they found little but the remains of the coffins". Clearly things had deteriorated, but there were still remains. If there weren't, they wouldn't have replaced the remains of coffin in the tower, they would have discarded them. In fact, according to Henry in another article, the remains were still present in 1912. They were eventually taken out and buried sometime after 1913 and before 1918, so during the First World War. Linskill says, "once the fragments of coffins were finally cleared away and the last of the bodies were removed and given a decent burial the iron-gate [the present gate, replacing the iron grill of 1891] was put up and gardener's then used the middle chamber as a tool shed".

The removal of the last of the bodies was confirmed on October 5th 1918, only 37 days before the end of the First World War, when the committee of the St Andrews Antiquarian Society gave a report about its activities around the town since its inception in 1879. The article includes a short piece about the Haunted Tower as follows. "Another interesting piece of work was the opening up of the masonry of the much-talked-of Haunted Tower in the Abbey Wall, when an L shaped chamber was found containing well preserved mummified bodies and skeletons, which ultimately were taken away and buried. It was clear that this chamber had been previously entered, and the well-preserved body of a young female which had been seen there removed. About this time the ground plan of the Cathedral and the pillars were marked out in the turf as now shown. This particular work was done at the expense of the Board of Works".

Linskill was one of those present when this was done, and he says the remnants of the coffins themselves were discarded. I have not thus far found any record of where the remains were buried. It will have been in the Cathedral grounds, but few records exist from that time, and they were far from meticulous in what they recorded. Added to this, there was no identification for them, so it isn't possible to look through the record of burials held by Historic Scotland at the Cathedral by name. The search for them continues and if they are found they will, I am sure, still prove invaluable to our understanding about who they were. Unfortunately, the chances of the coffins ever being found are even more remote, but there may be fragments with the remains that could give further clues.

Unfortunately, the methods employed during the various forays into the tower were primitive. The chamber had been repeatedly entered,

and the deterioration of what they found through subsequent visits was clear, but unknown to each successive expedition into the tower. The chamber had been fully opened at least six times, five of which cover a period of 65 years, between 1826 and 1891. There wasn't any wanton vandalism by any, but they were unaware how curiosity, even with the best of intentions can do the same. By them touching, briefly examining, moving, standing on end and prodding the bodies over the years, they had all inadvertently accelerated the process of decay.

In the present day, a find of this nature would be an archaeologists and a forensic archaeologists dream. By 1891, the only significance a pile of bones and fragments of coffins held for the Antiquarians was to ponder on their identities, to wonder why they were there, and to express disappointment that they were no longer in the same state as earlier reports suggested.

Examination

The contents of the tower had been one of the finds of the century in St Andrews, yet they were regarded more as curiosities than as relics of potential historical, if not national significance. Nothing was ever taken away for further examination, storage or preservation, barring possibly the body of the White Lady. At no time did it occur to anyone to take some of the fragments of coffins, clearly dating from an early age to the museum. After all, for them they were just bits of decaying oak and fur.

Linskill never explored the possibility of the bodies being those of saints, and this is despite being open to Hutcheson's suggestion some seven years earlier. Surely even the mere intimation would have carried enough weight for further examination and research to take place, yet despite Andrew Lang, "Dean" of Tyasaoga and others putting forward suggestions in this direction, an examination was never carried out. There has to be a reason for this, especially when we consider that throughout this whole period of discussion, debate and speculation they were still present in the tower. Instead of speculating and debating, any one of them could easily have just gone down and looked. The sealed entrance had been removed some three years before the speculation started and the bodies, with the exception of the female corpse, were, as we know, still present until sometime during the First World War.

The Antiquarians had completely overlooked the potential historical worth of the bodies. Through a lack of understanding, they didn't have the ability to appreciate the potential value. Current methods of

shedding light on the historic past carries no compensation for the destruction by the curious and the methods they employed. The information gathered from what was being discovered pre and post 1920s are worlds apart, and the technology we have today is worlds apart from the 1920s. If the location of their burial can be found, and the remains exhumed, we could find out a great deal more about them. With DNA profiling, a pile of rotting remains partially covered in wax cloth is all that is needed to determine their age, sex, diet, hair colour, eye colour, country of origin, if they had any diseases, when and how they were embalmed and the surgery required to do so etc. Add in possible facial reconstruction from the skulls and the value of these remains easily hold far greater worth than the Victorians could ever have imagined them to have.

Section Three...

Who was the White Lady
& who were the other Occupants... Will we ever know?

At the end of Linskill's piece '*A Place Dreaded in the Dark*' he says, "My only wonder is – who was the satin-clad White Lady? When was she placed there and for what possible purpose? ...She must have been someone of distinction and why on earth was she laid in state in such an isolated turret?"

In Linskill's booklet there is a paragraph headed 'The Mystery remains a Mystery' where he says "The whole affair is most remarkable, and no record or history whatsoever can be found to give the faintest clue as to who these elaborately interred persons may have been or when they were placed in this peculiar chamber – and why? Will we ever get to know who the handsomely dressed young Juliet was... All that we do know is that the shade of this beautiful White Lady is still supposed to hover around her sepulchre in the old Haunted Tower of Hepburn's Abbey Wall, and has been seen by many".

This next section includes all the written correspondence surrounding the speculation regarding the identity of the White Lady, including an extension of Hutcheson's theory based on many years of researching the presented information.

Chapter Nine

Further Letters to the Press
1894

Speculation

The *Saturday Review* articles and the *Telegraph* interviews generated a great deal of intrigue and excitement. Following the release of the *Scotsman* article in January 1894, Linskill says, "The article called forth a tremendous lot of letters in various papers, and many prominent citizens in St Andrews were interviewed".[xlvi] Antiquarians, academics, professionals and laypersons alike were soon submitting further articles and correspondence in trying to make sense of what they had read.

These contained a great deal of speculation as to the purpose of the tower, alongside a number of theories for the identities of its mysterious occupants, and thoughts as to why or how they came to be placed there. A few of these theories run to some length and become quite involved, especially Henry's theory that the tower became a family mausoleum. There was also talk of saints, royalty and the Virgin Mary herself, along with details about the ghostly White Lady famed for appearing by the tower she occupied for so long in death.

When these letters appeared in the press, the White Lady had disappeared at least six years before, but the other bodies and coffins were still within the tower. The following is the first of these letters, appearing just over two months later as a response to the *Saturday Review* article of 1893. Linskill quoted parts of it in his Haunted Tower article to the *Citizen* giving it the title '*The Great Age of the Bodies found in the Tower*'.

[xlvi] From Linskill's article headed "*The True Story of the Cathedral Turret*". He is referring here to the second *Saturday Review* article. The letters started appearing after the *Telegraph* and *Scotsman* articles.

THE HAUNTED TOWER
ST ANDREWS
WHO WERE ITS OCCUPANTS?

Alexander Hutcheson
Broughty-Ferry, 8[h] February 1894

The various accounts of discoveries made from time to time in this Tower, which have recently appeared in the public prints, when divested of those elements of superstition and mystery which tradition and popular fancy delight in, will leave yet a residuum of fact upon which to found a fair amount of theory as to the occupants of the Haunted Tower.

There is no room for doubt that this Tower was explored in 1868, and that at that time several coffins containing bodies in a fair state of preservation and presenting other peculiar features of interest were seen by the explorers. From these revelations very interesting questions are raised as to the age of the interments.

The Abbey Wall is stated by Mr Hay Fleming in his *Guide to St Andrews* to have been erected by Prior John Hepburn early in the 16th Century. I presume there is undoubted evidence of this statement. Corroborative proof that it cannot claim in the upper part at least a greater, if indeed so great, an antiquary, is to be found in the niches with which its many towers are ornamented. The upper part of the tower where the bodies were found was built at a much later date than the lower portion, since there were niches, capitals of pillars, and other fragments of masonry used indiscriminately in its construction. The stones which compose some of these niches have done previous service in some ecclesiastical building, and they have been so utilised by masons who either did not know or did not study the component parts of a niche, since some of the stones have been inverted and capitals of pillars have been made to do duty as corbels. The two niches in the north wall of the Haunted Tower itself furnish the best illustration of this, and between these two niches, there is a row of mullions inserted as common rubble. If, then, the Abbey Wall cannot claim to be older than the beginning of the 16th Century, I think there are good grounds for believing the interments to be far older than the vault in which they were found in 1868.

I base this conclusion on several considerations. These are derived from features brought out in the information which has been published. These are, first, that "some of the coffins were of oak, and some of them had been ridge-topped;" second, the evidence of embalming; and third, the appearance of "wax cloth". In order that the significance of these features may be realised in a question affecting the age of the interments, it may be well to review the evidences afforded by history. Examples of ridge-topped coffins in stone have been ascribed to the fifth century. The earliest forms were probably those curious mound-shaped examples, something like a boat laid keel uppermost, of which class there are late examples at Meigle and Brechin. This shape was probably an imitation of the primitive monumental cairn, as doubtless the still more modern grassy mound, so common yet in some country churchyards, is a survival of the same fashion. By-and-bye the mound or boat form gave way to the roof or ridge-topped form, and there is reason for believing that even inside of churches coffin-lids to stand above the floor and mounds of earth were common in very early times. In Cutts' Manual, p. 16, it is stated that in one of the laws made in the reign of King AEthelred, A.D.994, to regulate burials in churches, it is provided "where mounds appear let them either be buried deeper in the ground… or let them be brought to a level with the pavement of the church, so that no mounds appear there". The coped coffin-lid, however, held its own against all law, and in the 13th Century was very common. It was now highly ornamented, and by the 14th Century was frequently elevated on a base, and so led up to the magnificent altar-tombs of a later age. About the Reformation, and probably before this the ridged stone coffin had disappeared, but the fashion had continued in the ridged monumental slab made in the form of the ridged coffin lid, which until well on in the seventeenth century held its own in our burying grounds. The wood coffin has a different history. Coffins of oak are as old as the Bronze age in Britain; but the ridged or coped oaken lid doubtless came in when stone coffins were placed on or near to the surface, so that the lid would be above the ground, that when the bodies of saints were embalmed their relic might be seen. The difficulty of lifting a stone lid would doubtless suggest the employment of a less weighty material, and oak, which from its durability would be almost as lasting as stone, offered a ready and lighter substitute. Richly carved, and ornamented with the precious metals and jewels, such a lid formed a fitting covering, easily removed

to exhibit to the faithful the precious relics enshrined within. When the Reformation led to a change in the reverence for relics, this use of coped lids for wood coffins would cease; moreover, it was frequently only after the lapse of years from the death of a beautified or canonised person that their relics were enshrined. It is therefore unlikely that the first half of the sixteenth century would add many examples of such shrines.

The evidence of embalming seem indubitable. The bodies, it is said, could be lifted up and "set on end". They presented more or less the appearance of mummies. The process of embalming in Christian times was usually performed on the bodies of saints, that their relics might be exhibited. It was in these times seldom performed on any but the most exalted in rank or piety.

Another indication of age is the "waxcloth" which Mr Smith stated was seen in some of the coffins. This was doubtless the "cere-cloth," a cloth prepared with wax, and used as a winding-sheet. It is of great antiquity, and seems to have been almost universally used by civilised nations in ancient times. It was occasionally used in the century which preceded the Reformation, and at least one instance of it is known in the 16th Century, that of Archbishop Dunbar, who died in 1547, and was buried in the chancel of Glasgow–Cathedral.

All of these peculiarities of interment are indicative of ancient modes of burial, which, although occasionally represented in rare instances in the 16th Century, render it unlikely that so many instances of these different practices would be brought together in one set of interments. Moreover, we have the evidence as to the condition of the oak coffins, which are said to have been more decayed than the fur ones, thus pointing to a great age.

A consideration of these circumstances seems to render it impossible to attribute the interments to any part of the 16th Century – that to account for the aggregation of so many bodies exhibiting the age peculiarities referred to above, some other explanation must be forthcoming than the supposition of ordinary interment, and an interment, be it remembered, in the second storey of a tower! These circumstances raise a problem incapable of solution on the supposition of a 16th Century interment.

The explanation I venture to give – and which, I submit, meets all the difficulties – is that these bodies were those of saints preserved in the Cathedral of St Andrews, and possibly in other ecclesiastical edifices in the city, which relics were hurriedly removed and secretly moved to

this Tower as at once the nearest and safest repository when the sack of the churches took place in 1559. Who shall say what sacred relics may have been enclosed in this secret vault (*Linskill's note: it was not secret – just the opposite*) so rudely broken in upon and so sacrilegiously handled – perhaps those of the Patron Saint of Scotland, perhaps of the Pictish Princess, Muren, the first according to the legend of St Andrew to be buried at Kilrymont? [xlvii] and perhaps of the early founders of the Christian settlement there?

The removal would probably leak out in some fashion, possibly when the mural monument of 1609 was inserted, and so account for the reputation of the tower being haunted – a reputation which existed long before the interments were known of by the present generation. I would suggest that a careful examination be now made by experts of what remains of the coffins, &c., to see how far this theory is supported thereby.

A. Hutcheson,
Broughty Ferry, 8th February 1894

Hutcheson made some interesting observations. His letter was an irresistible invitation that laid the ground for subsequent correspondents to join in and deliberate about the findings in the tower. Following Hutcheson's letter Andrew Lang gave his reply as follows...

THE HAUNTED TOWER
(*To the Editor*)
Andrew Lang February 1894

SIR, - Mr Hutcheson's theory of the Haunted Tower is picturesque and attractive. Surely it would be possible to have the coffins reverently examined. It is, I think, unlikely that St Andrews ever produced many local saints, nor would a whole saint be readily parted with by other churches. Persons of rank are more probably the inmates of the Haunted Tower. The relics of the Apostle would, I presume, be kept in

[xlvii] Kilrymonth or Kilrymont was an early name for St Andrews. There are a few variations for its meaning including 'Church on the King's Hill or Mount', or 'End of the Kings Hill'.

a reliquary of precious metal, which doubtless did not escape the zeal of the Reformers. Still, the relics may conceivably have been hidden among the bodies. – I am, &c., Andrews Lang

Andrew Lang wrote another article called 'Andrew Lang and Saints' which was a repartition of the above letter so I haven't reproduced it here.

Linskill in his booklet says "Two very long letters appeared by one who signed himself "Dean of Tyasaoga"." He only quoted one paragraph from the first letter saying the bodies "are not those of any of the Scottish Saints". "Dean" of Tyasaoga's first letter ran as follows...

THE HAUNTED TOWER
(*To the Editor*)
"Dean" of Tyasaoga
3rd March 1894

SIR, - While agreeing for the most part with the contents of the excellent letter of your correspondent, Mr Hutcheson, on the "haunted" tower in the Abbey Wall, which appeared in your issue, I must take exception to the supposition that the bodies found in it are those of saints or founders of the Cathedral.

One of the greatest rarities, not only in the times immediately preceding the Reformation, but for centuries before, was an entire and authentic body of any saint or holy man.

The really pious in the first ages of the Church had the disagreeable habit of dividing up the bodies of their saints and distributing the *disjecta membra* through dozens of churches. Considering the cures these relics were supposed to effect, to have and retain an entire saint, or, at least, his body, all to oneself or Church, was an abomination of desolation to these devout people.

Hence, while we have arms, leg-bones, toenails, and fingers of these so-called saints in abundance, nowhere do we find an entire body.

Now, the bodies in the tower, as described by those who saw them, were whole and have evidence of being embalmed. When the Commissioners of Woods and Forests were putting the ruins of the Cathedral in repair, it was reported that they had the tomb of

Archbishop James Stewart, the natural son of King James, who was killed at Flodden, opened, but found it empty.

No traces of any human remains could be discovered in it. This was considered to be extraordinary, and the only explanation suggested for such a state of matters was that it was another "pious fraud" by the men of the time, for which there was no accounting.

Now, it is much more reasonable and more in accordance with facts, to look on these bodies as perhaps his and one or two others of exalted rank, which had been removed from their proper resting places and hidden in the tower to escape the desecration of the lawless. I think you will find it to be an historical fact that Holyrood Chapel was abused by the mob before the full fury of the Reformation broke out, and that the ashes of the Scottish Kings were scandalously treated by them.

Foreseeing a similar fate for those interred in the Cathedral at St Andrews, they had been removed with the intention of being re-interred when the troubles of the times had abated.

As this never did occur, we have a sufficient explanation for the leaving of them where they have been found on the part of those who knew the place of their concealment.

The strong presumption, therefore, is that these bodies in the tower are not those of any Scottish saints, such as St Mungo, St Fillan, and others who lived in times when embalming was a difficult and expensive process, but are the bodies of men of a later age, whose position in life was well known to their contemporaries – members of a kingly stock, among whom there was money and influence enough to have their bodies after death treated in this way for preservation.

While differing from your correspondent, Mr Hutcheson, so far, I agree with him very fully in the sensible suggestion that these bodies should not be allowed to moulder away in silence to their parent dust, but that an opportunity should be given to competent authorities to examine them and fix definitely, if possible, their character.

In the act of writing, I am reminded of the discovery in recent years of the bodies of the Pharaoh of the oppression, of Annuleis his queen, and mummies or other royal personages, in the caves of Upper Egypt, to which they had been removed and hidden to escape the desecration of the vulgar and the robbers of the dead.

There were no bodies of mythical persons mixed up with these remains, while the cartouches on the cases gave a sufficient indication as to whom the embalmed remains belonged. A searching examination

with the microscope by experts gave some curious results – as, for instance, that one of these Pharaohs had been killed by a spear passing through his cheek and into the neck, giving him intense pain and causing him to bite through his tongue in his agony; as also another fact that he had only been shaved immediately before the battle in which he has been killed.

If a similarly careful and minute examination were made of the mummified remains still hidden away in the tower on the Abbey Wall, sufficient ground might be found to lead to their identification, and with this knowledge to save them from being disturbed in after times, - I am, &c.,

"Dean" of Tyasaoga

THE HAUNTED TOWER
(To the Editor)
Alexander Hutcheson, Broughty-Ferry, 6th March 1894

SIR, - Will you permit me to reply to one or two points in the courteous letters of your correspondents who have referred to my communication on the Haunted Tower.

Through some laxity of expression I find I have allowed it to be gathered that I meant the bodies seen in the Tower may have been those of noted Scottish saints. I did not mean this. I knew that in the case of the apostle and patron saint of Scotland only one or two bones at most are supposed to have been brought to St Andrews. Mr Andrew Lang "hit the mark" when he supposes the relics of the apostle would be kept in a reliquary of precious metal, which may (or may not) have fallen a prey to stupidity at the Reformation; but, as Mr Lang continues, the relics of the apostle may have been hidden amongst the bodies in the Tower. I would suggest that without being amongst the bodies, the sacred relics of the apostle, as being more precious may have been buried or otherwise secreted by themselves in the walls or basement of the Tower.

As to the suggestion of a correspondent that the bodies may more probably have been those of men of exalted rank, I think my remarks will bear that interpretation so far; but I would urge in support of my former contention that the principle of sub-division and distribution of the bodies of such eminent Scottish saints as those instanced by your

correspondent – viz, St Mungo, St Fillans, &c. –would not apply to the bodies of the Princess Muren, and early founders of Christian settlements in St Andrews, since these personages would have little or no distinction beyond the limits of St Andrews; and there would consequently have been no such inducement to divide their bodies as existed in the case of the better-known Scottish saints, whose relics could command a national or more than national reverence.

Permit me, further, to observe that your correspondent, "Dean" of Tyasaoga, was in error in stating that the son of King James who was killed at Flodden was Archbishop James Stewart. It was Archbishop Alexander Stewart who was there slain. Further, I do not know the sources of your correspondent's information in stating that when the ruins of the Cathedral were being put in order by the Commissioners of Woods and Forests, the tomb of this Archbishop was opened and found to be empty. So far as I can learn, it is not known where Archbishop Alexander Stewart is buried. A tomb near the high altar was opened, but it was not empty. It contained a skeleton, the skull of which was found to be cleft; and it was conjectured that this might be the tomb and the skeleton of this youthful prelate, who "had been Archbishop of St Andrews and Chancellor of Scotland for more than three years before he fell a Flodden at the age of twenty, or less".

Finally, I am glad that your correspondents agree in expressing the sensibility of having the remains now carefully and reverently examined.
– I am, &.,

Alexander Hutcheson

Despite there being a general agreement of Hutcheson's suggestion to have the remains examined, little care was ever afforded to them and incredibly, an examination never took place.

A. H. Millar, who also recorded Hutcheson's words in his *Fife – Pictorial and Historical* Vol. 1, 1895, p. 322, in concluding Hutcheson's article says: "It is easy to imagine the process whereby this tower – the last refuge of these venerated relics, if such they be, – should acquire the reputation of being haunted".

"Dean" of Tyasaoga's second letter...

THE HAUNTED TOWER
(*To the Editor*)
"Dean" of Tyasaoga
March 1894

SIR, - I am obliged to Mr Hutcheson for his kindness in correcting my mistake concerning Archbishop Alexander Stewart. At the time of writing, I had no means of verifying my statement. I am glad he has done so for me.

My informant for the condition of the tomb supposed to be his was one who was present at the time. In answer to my enquiries and in conversation he more than once declared it was empty; but a gentleman, a friend of mine, who is more conversant with the modes of thought among St Andrews "folk," acutely remarked that my informant's statement might be construed to mean that no treasure or valuables were found in it.

This suggestion is not improbable. The impression conveyed to me from my informant's words clearly conveyed the idea that the tomb was empty. There are, no doubt, notes taken at the time, or written records of a more reliable kind than word-of-mouth statements in existence to fall back upon for the settlement of the point.

I have been informed that the Tower was opened about thirty years ago, and then the bodies were almost entire, and so fresh in appearance as to be startling to those who saw them. One was apparently that of a lady. The body lay on the ground under a coffin resting on trestles; and the supposition was that the bottom of the coffin had given way, allowing it to fall to the ground, and so it was left. Another was that of a man of "gigantic" stature – over seven feet, according to the account given me – and so dried and hard as to allow one of the workman present to lift it, and place it on its feet at the end of the chamber against the wall.

Some little fiction may have mingled with fact in these accounts, which I give for what they are worth, and in the hope that any of those living in St Andrews who were present might give such information as they possess.

I find nothing in Mr Hutcheson's or Mr Linskill's letters to impair the inherent probability of what I conjectured these bodies to be –

people of standing and position in the world – who lived in the times of the Reformation or shortly before it. It is a most remarkable fact that there is no traditionary tales or history to give even a clue to their identity – nothing to connect them with the families of the great in these times; and yet the form of their burial shows that they were people of high standing.

The modes of life and habits of the higher clergy just before the Reformation were those of the nobility.

What might be excused in a man of rank not in orders in the Church looked very black indeed in a prelate who was.

I have no intention of weaving a little romance out of the exceedingly slender materials these relics of the past in the Haunted Tower supply. And yet, we know that after Cardinal Beaton was slain, and his body exposed at a window in the Castle, it was put in salt in the Bottle Dungeon, I think, and left there till the Castle was surrendered, after which it was given up to be buried according to the rites of the Roman Church. Here it may be observed that in *all* cases in which individuals have met violent deaths, resulting in the draining of the body of the blood, its power to resist decay is extraordinary.

The coffin of Charles the First was opened early in the century to verify its contents before the removal, and the face was quite recognisable.

Now, was Cardinal Beaton a man of unusual stature? If the body in the Tower is his, would not its extraordinary condition of preservation, as described by this eye-witness, be the result of his death and the salting it afterwards received?

In the excited state of feeling in these Reformation times, he was the most famous of all the public characters surrounding him for the part he took in these troubles. To the one party he was almost, if not quite, a saint, to the other a sinner of the deepest dye, and that other party was steadily rising in power and influence. If the scenes which had occurred in Edinburgh were to be re-enacted in St Andrews, he, of all men, would be the one whose mortal remains would most likely be ill-treated by a lawless mob burning with recollections of former injuries, of which he was the author, in their estimation, and desiring to wreak their vengeance in some way or another on him.

Claypots Castle, near Broughty-Ferry, was a residence of the Cardinal's, and there a Lady Ogilvy, his mistress, lived for some time as well.

An old ecclesiastical ring, a veritable relic in its way – now, I understand, in the Antiquarian Museum in Edinburgh – was found a few years ago in its vicinity.

Would it not be the very irony of fate to find, if such were within the limits of possibility, that these two bodies were his and that of his mistress, hidden there with others to save them from maltreatment, and yet in the end leading to it at last – to nameless forgetfulness – objects to be poked at with sticks and turned over as that of strangers to the place and people in the midst of whose forefathers they lived? – I am, &c.,

"DEAN" OF TYASAOGA.

Dundee, March 1894.

Other Theories for the Identity of the Occupants

The main suggestions for the occupancy above are shared between Henry's suggestion of the tower becoming a family mausoleum and Hutcheson's for it becoming the hiding place of local saints. In the next two chapters, I explore both of these possibilities, but firstly it is worth looking at a few of the other suggestions put forward around the time of the debate.

Princess Muren or Mirren

Hutcheson briefly mentions Princess Muren in his first letter of correspondence of 8th February 1894. Linskill picks up on this in some of his correspondence. "Princess Muren, the daughter of King Constantine, who resigned his crown to become Abbot of the Culdee Church on the Kirkhill, was very probably embalmed and kept in that early church; but why on earth after all those years should she be the mysterious girl enshrined in the Haunted Tower?"

He didn't believe it was her entombed in the tower, but it didn't stop him giving her this association in his booklet *St Andrews Ghost Stories*. In his fictional story '*The Beckoning Monk*', he mentions, "Out of a side passage I saw a female figure glide quickly along. She was dressed as a bride for a wedding; then she disappeared.

'Fear not', said the monk, 'that is Mirren of Hepburn's Tower, the White Lady. She can materialise herself and appear when she chooses, but she is not re-incarnate as I am'".

Queen Mary's Maid of Honour

The following is an excerpt from '*St Andrews Wonderful Old Haunted Tower*', By Linskill, October 5th 1918. "After the article in The *Saturday Review*, articles appeared in a number of newspapers, among others, the Dundee papers – all of which I cut out and have carefully preserved, but no solution of the mystery was arrived at. Some correspondents imagined the female to be Marion Ogilvie, the wife of Cardinal Beaton, others maintained it was Princess Muren, daughter of King Constantine, and yet others thought it might be the embalmed body of one of the four Maries – Queen Mary's maids of Honour. Many of the leading citizens in St Andrews were interviewed, and I have kept all these accounts, but the mystery has never been solved, and I suppose never will be".

He developed the suggestion that it was one of Queen Mary's maids of Honour at some length in two of his fictional stories about the White Lady, where she becomes the central theme, and which I explore in Chapter 18, p. 215.

Chapter Ten

The Clephane Family Mausoleum

Letters - The Clephane Connection

THE HAUNTED TOWER
(To the Editor)
Mr David Henry, *Citizen*, 14th March, 1894[xlviii]

SIR, - Not being able to agree with your correspondents as to how the human remains now in the Tower come to be there, may I offer a solution that must surely be obvious to anyone not in search of the marvellous? It is really too much to ask us to believe that these remains are those of distinguished persons interred within the Cathedral, whose graves had been rifled by Knox's "rascal multitude," and that they were thus hidden by friends of the Old Church till better times should come again. Hidden, too, be it observed, at the top of a flight of steps which – as Mr Linskill truly says – would be sure to attract attention, and built in by a wall only nine inches thick, which any able-bodied member of the aforesaid multitude could easily put his shoulder through.

It appears to me that the most obvious solution is the right one – viz., that some family of consideration in the city or neighbourhood had taken possession of the Tower as a family mausoleum, and adapted it to their purpose. The front wall appears to have been partially thinned to enlarge the chamber. The left-hand door jamb has a rybat[xlix] head wrought on to form a check for the hinged side of a wooden door, and an ordinary giblet check is cut on the return of the front wall for the other side to shut into. The lower half of these door checks is cut and splayed away, plainly to allow of these coffins being carried in and

[xlviii] David Henry further elaborated his theory as the chapter of a book called *The Haunted Tower*, published in 1912. Refer to p.136.
[xlix] A stone forming part of a door opening.

turned before being placed where they were to lie. When the monument on the south face of the Tower was erected in 1609, the wall was quite cut through to receive it, making a hole about *seven* feet by *four*. The monument, after being set in place, was backed up from the inside and built round, showing that the builders had access thereto for themselves and their materials at that date – 285 years ago. Part of the thin backing appears to have fallen out, as the cornice and pediment are now visible from the inside. Is it credible that these remains were there then, and that they were left practically intact? It is much more probable that the owners of the monument took possession, and made these slight changes for the reception of their dead, using the wooden door for access, till probably the last of the race was laid to rest, and the door built up. In a generation or two the exact circumstances would be forgotten, only a confused memory surviving of dead people lying there which in its turn would be merged in the still more vague designation of the Haunted Tower. It was a common mode of disposing of the dead. Private mausoleums exist all over the country in churchyards and in woods and valleys. Within my own knowledge, the chief heritor in a remote parish, not more than half a century ago left instructions in his will that when he – the last of his race and name – was laid within the family mausoleum, the door should be built up. Built up it was, and the whole structure is now going to ruin. Many such cases must occur to those interested in such matters.

Whether the owners of the monument on the Haunted Tower will ever be identified is doubtful, as the inscription is hopelessly defaced. Still the arms and the K.G. on either side, and the similarity in design and materials to the Traill-Myrton Monument a little to the East, and which is of the same date – viz, 1609 – may yet afford a clue. It may be that I am unromantic; but I cannot imagine any other history for the poor remains of these ancient tenants of this gloomy chamber than that above indicated. – I am, &c.,

THE HAUNTED TOWER
(*To the Editor*)
W. T. Linskill, University Golf Club, Cambridge,
March 17th, 1894

SIR, - A few ideas in regard to Mr Henry's more interesting letter in the *Citizen* of March 17th.

May not the wooden door he mentions be the original door of the old Tower, not one temporarily put up for a *comparatively* modern vault?

Again, if some important family had taken possession of the Tower as a mausoleum 285 years ago, would not the dead have been buried in *lead?* With wooden coffins inside, frequent openings must have been attended with unpleasant results.

One last point – (I have alone, for the present, the statements regarding white gauntlet gloves, white satin dresses, and silk handkerchief(s) – how did nearly all the bodies get into such a well-preserved or semi-mummified condition: One or two of them are stated by *several witnesses* to have been quite fresh – I am, &c.,

THE HAUNTED TOWER
(*To the Editor*)
Mr A. Hutcheson, 20th March, 1894

SIR, - The solution advanced by Mr Henry is, on close examination, not so obvious as he claims it to be.

It is wholly based on the assumption that the family who caused the monument to be inserted in the Tower Wall used the apartment inside as their family mausoleum. As well as argue that the owners of the "Traill-Myrton Monument, a little to the east, and which is of the same date," buried their dead in the heart of the wall behind it.

The monumental slab in the south wall of the Tower doubtless represented, as did all the other slabs on the Abbey Wall, that those whom it commemorated were interred in the ground immediately in front. As for the wall having been broken through, and the chamber entered in 1609, when the monument was inserted, it does not follow that the bodies – granting they were then there – would be desecrated by the masons. The bodies could scarcely, under any circumstances,

have been subjected to rougher treatment than by those who "set them up on end" in 1868, and since.

With all deference, I cannot see that Mr Henry's "solution" accounts for the following particulars of interment.

(1st.) The coped oak coffins – very much decayed.

Can Mr Henry point to the use of coped oak coffins in the 17th Century? Then as to the decay and its suggestiveness. Oak is very well-known to be a very lasting wood. Coffins of oak attributable to the Bronze Age have been discovered in England, Germany, and Denmark. Many of these are in a fair state of preservation, not "very much decayed". Sir John Evans places the beginning of the bronze period, on the shortest computation, at 1200 to 1400 B.C., and concludes that by the second or third century B.C., the employment of bronze for cutting instruments had practically ceased in Britain. (Ancient Bronze Implements of Great Britain, p. 472-3) This would assign to the coffins of that period, an age of probably not less than 2500 years. Then there is the evidence of the enduring nature of oak furnished by the canoes which have come down to us from the same, if not from a more remote period.

The age claimed for the coffins in the Tower is not on a parallel with these; but a fair inference may be drawn from them in favour of the belief that coffins of oak, dating no further back than the beginning of the 17th Century, could scarcely have been "very much decayed" in 1868.

(2nd.) The evidence of vestments, embalming, and cere cloth.

I take it these features are established beyond question. Can Mr Henry cite any instances in Scotland attributable to the 17th Century?

I have not referred to the gloves which covered the hands of one of the embalmed bodies. This, I consider, is a strong point in favour of my contention. Gloves were usually put on that the faithful might kiss the hands of the canonised person.

As the fact, then, of embalming cannot be overlooked, it follows that Mr Henry's theory supposes one of two assumptions equally untenable. Either there was here a catastrophe resulting in the simultaneous deaths of a dozen of persons of one family, whose bodies were embalmed and enclosed in this vault, or they died natural deaths extending over a period of years, and each was in turn embalmed. Probably those whom Mr Henry charitably supposes to be "in search of

the marvellous" would find their object in considering these two deductions. – I am, &c.,

THE HAUNTED TOWER
(To the Editor)
David Henry, St Andrews, March 31ˢᵗ, 1894

The majority of this letter correctly disputes the suggestions of Cardinal David Beaton as being one of the occupants. He then refers to Hutcheson's letter above.

"...I am not able to answer the questions 1 and 2, which Mr Hutcheson puts to me, from personal knowledge, but I am given to understand by one eminently qualified to judge, that coped coffins and cerecloth (fine linen and wax) existed not only in the 17ᵗʰ Century, but far into the 18ᵗʰ. – I am, &c.,"

The following was David Henry's last letter to the *Citizen*.

THE HAUNTED TOWER
(To the Editor)
David Henry, St Andrews, March 20ᵗʰ, 1894.

SIR, - This Tower is believed to have been built about – or a little before – 1560, and by John Hepburn, prior of the Metropolitan Church of St Andrews – the greatest of the many great builders who have left their impress upon the Ancient City. Its purpose appears to have been that of a summer or garden-house. It has a stair of access, a door, and it doubtless had a window to the south where the monument now is. Sheltered from the north and east, and open only to the south and west, it would be a pleasant enough place in which to spend a quiet hour on a summer evening, and the old Prior may have frequently resorted thither to meditate upon his latter end, which was then not far off. It is even conceivable that Reverend Ecclesiastic, his nephew and successor, Patrick Hepburn, may in like circumstances have enjoyed the occasional society of some of those agreeable nymphs who amongst them helped him to realise those ten bastards whose letters of legitimation are preserved for us in the Register of the Great Seal...

Henry's letter continues after the following introduction.

The Ancient Clephane Family of Fife
& their Connection with the Haunted Tower

On the south-facing wall of the Haunted Tower is the monument Henry was referring to. There are actually two memorials here, one of marble above one of sandstone. The marble memorial was the focus of Henry's work, while the lower sandstone memorial was neglected and finds itself being omitted from his research. Being prominently placed on the wall of the tower it doesn't take much persuasion to believe these memorial plaques have an association with those found interred within. Architect David Henry believed this and spent some considerable amount of time researching this possibility. There are many memorial plaques along this stretch of wall and it would be equally valid to suppose the families the memorials referred to, were buried in front of the tower, not within it.

<p align="center">THE HAUNTED TOWER
(To the Editor)
David Henry, St Andrews, March 20th, 1894.
(Continued)</p>

I suspect John Hepburn's old summer-house has a more likely and lively history as a haunt of living sinners than as a hiding place of dead saints.[1] At the beginning of the 17th Century, people of rank – county lairds and Professors – appear to have been deserting the parish burying-ground in the centre of the town and choosing for themselves "lairs" along the side of this northern wall, and erecting monuments on which they recorded the names and virtues of their dead. The monument on the Tower - as has already been mentioned – is of the same character, materials and date as the Traill-Myrton one, and they are the oldest but one now on this wall. The others are all of stone (but not all local), and have the large *raised* letter inscriptions characteristic of the period. These two have marble panels, and have had small incised letter inscriptions, suggesting a foreign origin... Marble does not stand

[1] This appears to be an inference to the Clephane's. Refer to 2nd paragraph p.147

<p align="center">~ 134 ~</p>

our northern climate very long, and these inscriptions are hopelessly defaced, while many of the stone ones can still be read. Why Menteith does not give the "Tower" inscription in his *Theatre* of Mortality (1702), while he gives its "twin," is not easy to say, unless it had become un readable even before his time. The identification of this family who thus appropriated the old Prior's summer-house as a mausoleum at the beginning of the 17th Century, and caused such ingenious speculation amongst the learned antiquaries of the latter half of the 19th, is not quite hopeless. – I am, &c.,

David Henry eventually put forward an involved proposal that this memorial had been erected to one Katherine Clephane of Carslogie and the tower became the family mausoleum for the Clephane and Martine families in 1609. He doesn't ever mention the White Lady in his correspondence, but in presenting his ideas of the tower being a mausoleum, her identity has often been attributed to Katherine Clephane. It seemed to be a logical proposition and as his theory spread throughout the town, it gained its own ground of acceptance. For many this marked an end to the mystery of who she was. Passing through successive generations we find the same in our own time. It certainly keeps things neat and tidy to suppose it was Katherine, but having continued Henry's line of research, I have found information that puts pay to this theory.

David Henry published an article in the *Citizen* Saturday 31st December 1910 entitled '*The Haunted Tower*'. In 1912, he republished this as the last chapter of a rare and curious booklet he wrote entitled *The Knights of St. John with other Mediaeval Institutions and their Buildings in St Andrews*. Having read his booklet, I found it curious he would devote the entire last chapter to a subject almost completely out of context with the rest of his booklet.

He spent no little time in research, developing the ideas he formulated for his contributions to the press back in 1894. This tower and its occupants intrigued him. His level of interest and enthusiasm is revealed throughout by the degree of detail he captured. Written with an architectural eye, it contains a great deal of material about the structure of the tower he never expressed in his press correspondence, and his theory about the occupants develops into a fairly involved family tree.

I have reproduced this rare chapter below and added a few illustrations, together with my own annotations and footnotes, as it becomes quite a complex task to keep up with the various family names he mentions.

Henry died in 1914 aged 79, only two years after the release of his publication. I continued Henry's research to find if his suggestions were plausible and if my own research would uncover any new leads. I can say that it did, and I have included my findings after Henry's chapter.

During my research, I found a few discrepancies in his booklet concerning the family names he mentions which I have noted and duly corrected.

THE HAUNTED TOWER
by David Henry F.S.A. Scot, 1912

The Tower is unique amongst the many towers on the wall, being rectangular, while the others, with unimportant exceptions, are half circles or half cylinders set on end. It is, however, a "hollow fraud," for while it stands fair and foursquare to all outward seeming, not one of its walls exceeds seventeen inches in thickness – less by a fourth than the commonest wall of the commonest house of our own time.

It is two storeys in height – almost three – and the under floor has the usual gun-holes for raking the faces of the wall; [if you dare to place your a hand within the central gun hole the White Lady is said to grab it] otherwise its shape and size have been determined by the room above, which it carries. This room is reached by an outside stair so inserted in the west corner as to be altogether outside and yet within the main lines of the building which is corbelled over it. One result of that arrangement is that the lower and upper rooms are the shape of the letter L; their greatest length is about 10 feet 8 inches; their greatest width 6 feet 3 inches and the narrowest 3 feet 3 inches. As the outside dimensions are 13 feet 6 inches by about 9 feet 1 inch it will be seen that only about 17 inches is left for each of the external walls. [The height is 8 feet] There may have been – very probably there was – a window in the southern wall where the monument now is. [Facing the former Cathedral Gardens I have seen this wall from the inside. There is the indication of a window arrangement filled in with many small stones rather than the larger stones making up the main body of the tower.

Another area of the south facing wall within the hidden chamber also comprises of these small stones. This is above the first few stone steps about 9 or 10 feet from the ground where stonemasons have made repairs to the wall.]

This room never can have fulfilled any exalted function, it might be dignified by the name of an oratory but more probably it was a summer lounge and watchtower overlooking the Monastery gardens for the prevention of "Slothful brethren" amongst the Canons giving themselves to that "idleness or foolish talk" which their rule forbade.

The great interest manifested in its purposes in recent years is due to the fact that it contained certain coffined but unburied human bodies. Apparently, from the time of their consignment to this gloomy vault a tradition had lingered on from one generation to another that such bodies were there — the precise circumstances would be forgotten – but people continued to call it the "Haunted Tower" and in earlier times ran past it on their way to and from the shore if it were dark.

Previous to the year 1868 the stair led up to the blank wall of what was apparently a built-up door. In that year a few adventurous spirits, greatly daring, met on a summer's morning, very early, and breaking a hole in the wall crept in and saw by the light of their candles about ten or eleven half-mummified bodies partly in grave clothes and in coffins more or less decayed. The coffins were in the long leg of the L — laid two in the width — and apparently had been piled up to about five or more in the height. After a brief examination and some mental notes made they came out again a little "skeered" by their adventure, and vowing eternal secrecy had the hole built up again and all before the sleeping town knew what was being done.

Some twenty-three years later [1891] a privileged party obtained access again but they found little but the remains of the coffins; probably the admission of light and air at the first opening had hastened the natural decay of the bodies for they had literally returned to the dust from which man came. At that time the coffin remains were gathered together and put, where they still are, at the extreme leftward end of the vault out of view from the door opening and a grill – the predecessor of the present gate – put on.

The mural monument on the southern face of the Tower has also excited interest as probably being connected with the bodies within.

The result of much "howking", sifting and comparing has led to the following conclusions:

1. The room was constructed for some purpose connected with the Monastery gardens – which it overlooked – espionage probably. [Looking out for "foolish talk"]

2. The now indecipherable monument was erected to the memory of Katherine Clephane, wife of John Martine of Denbrae.

3. The bodies were those of these two and of their children, some of whom are known to have died of the plague in 1605.

The first conclusion hardly needs further remark, but the second may require justification. Of the many families who have enjoyed extensive respect and esteem in St Andrews none are more outstanding than the Martine's. From Thomas Martine, who sold his house and garden in the Butts Wynd to Bishop Kennedy, when he was acquiring the land on which he built his College of St. Salvator before 1450, down to George Martine of Clermont, the author of the "Reliquiae Divi Andreae" who died in 1712, [he was Archbishop Sharpe's Secretary[li]]

[li] Born in 1635 George Martine of Clermont was a historian. Most notably he is best known to subsequent historians as Archbishop James Sharpe's Secretary. He was also the family historian of the Martines and the Clephane's. Along with Clermont, he had a dwelling at the southeastern end of South Street at

they filled all kinds of offices, both in Church and State. They were lairds, parsons, professors, lawyers, and merchants, to say nothing of being Elders and Bailies – one was even Provost, [of St Andrews] George Martine in 1456. [This is the grandfather of Sharpe's Secretary George Martine mentioned above,[lii] but he was Provost of St Andrews from 1620 – 1645. The date 1456 actually refers to the time when Bishop Kennedy ran St. Salvator's which has no bearing here.]

They were apparently always on the growing hand, and their historian [George Martine – Sharpe's secretary] has not failed to tell the whole tale of all their power and greatness; discreetly veiling, however, some severe lapses from virtue that are recorded in the Kirk Session Register against certain members of the Clan – notably a Mr. James of Lathones.

One of the numerous John Martine's was in the sixteenth century, he was Laird of Denbrae, and had married in 1567 Katherine Clephane of Carslogie – an estate near Cupar, held by that very ancient family for twenty generations from father to son till the male line failed in 1803.[liii]

George Clephane, the lady's brother [he was her father Alexander's brother, so he was her uncle] was one of those unquiet spirits who keep a whole countryside in turmoil. Several of his adventures brought him within the wind of the law as recorded in the Register of the Privy Council. The special nature of the quarrel or quarrels between him [George Clephane] and his brother-in-law [this was actually his Uncle-in-law John Martine - husband of Katherine Clephane of Carslogie] is

No.38. I have quoted him on a number of occasions in my book *Ghosts of St Andrews* 2013, in connection with the brief insights he gives of the Castle, the Cathedral and one of Sharpe's residences - the 'haunted' New Inn down the Pend's Road. He was the eldest son of James Martine a minister, who himself was born 1614 and died in 1684.

[lii] It does get confusing because in the records, George 'Martine' of Clermont's grandfather and grandson were both known as Dr George Martine.

[liii] This is Carslogie House. The last of the eldest branch of the family, Major-general William Maclean Douglas Clephane, who died in 1804, was the twenty-first laird in the direct male line, without the intervention of a female or the succession of a younger branch [some 600 years]. He sold the remaining portion of the barony, and it is a singular coincidence that when the property went entirely from the family, the eldest male line became extinct. The general married the daughter of Mr. Maclean of Torloisk, Mull, and after his death, Sir Walter Scott was chosen by his daughters to be their guardian.

immaterial, but the result to John Martine was that he had to sell his estate of Denbrae to pay the expenses of George Clephane's many law suits. It is satisfactory, however, to know that his son, [this is John Martine and Katherine's son] George Martine [who was the aforementioned Provost of St Andrews from 1620 – 1645 and grandfather of Sharpe's Secretary], was able to buy back Denbrae and to add some further land estate to his fortune.

The connection of all this with the "Haunted Tower" is, that it is practically certain that the mural monument erected thereon was to the memory of John Martine and especially to that of his wife, Katherine Clephane.

This monument and another on the wall some yards farther east are of the same design, materials and date – 1609[liv], the upper terminations only being different.

On the latter the shields (three) are side by side above a level cornice and bear the Arms impaled of well-known east Fife families. On the dexter, Andrew Trail[lv] and his wife, Helen Myrton, in the centre Helen Myrton and her second husband, Sir Robert Dennistoun, and on the sinister, James Trail and his wife, Matilda Melville. The Trails were of Blebo, the Myrtons of Cambo, and the Melvilles of Carnbee. Sir Robert Dennistoun was long Scots Conservator in the low countries, at Camprere, and was of the family of Colgrain, in Dumbartonshire, after whom the Dennistoun district of Glasgow is named. James Trail was a laird in the Parish of Dunino and was the builder of the monument, which is a fine grained freestone with a marble panel – the inscription on which is wholly indecipherable.

The initials of the Squires are at the tops of the shields and those of the Dames at the sides. Menteith's "Theatre of Mortality" has a copy of the inscription with an English translation printed by that industrious antiquary in the first edition of his book published in 1702. The heraldry of the Tower monument has been arranged somewhat differently. There are the same three shields but enclosed within a segmental pediment. The dexter shield is quite defaced, the sinister is so

[liv] Being born in 1635, Martine, Sharpe's Secretary, didn't personally know any entombed in this area, but he did have family in the town and in Fife who would certainly have known some of them.

[lv] This family name can be spelt Traile, Treyl, Trail, or Traill.

far defaced that no charges can be made out, though the outline of the shield itself is fairly traceable.

The centre shield is in fair preservation and bears a lion rampant, the cognizance of the Clephanes, and the initials "K" on one side and "C" on the other and below "1609". It has long been thought that these initials must be "K.G". and that the Arms were either those of Guthrie or Gray, but no member of either of these families can be found within the period in Fife that would in any degree fit into the circumstances. The initial "K" is fatal –

Clephane

no male name beginning with that letter is to be found in any known list of Fife names – at least belonging to any family that bore a lion rampant on its shield. On the other hand the Katherines of the period was spelt with the intital K. Amongst other known examples there is yet to be seen at the old house, of Carslogie one of those triangular panels that used to adorn window heads and on which there were more or less floriated designs with Arms and initials.

In this case two circles are worked into the design in which are "G.C" and "K.O". respectively – George Clephane and Katherine Orme.

If it be objected that the second letter is like a G, it may be successfully maintained that it is just as like a C with a little flourish at the tail, made by the sculptor for his own gratification. That little tag at the end of the C is not sufficient to outweigh all the other evidence that makes for the claim of Katherine Clephane, the Lady of Denbrae, as the person chiefly commemorated on the monument.

When she died is not recorded [she died in 1609] but John Martine married again – a certain Sibilla Wardlaw, [John Martine] died in 1608. All the probabilities, therefore, are that the monument was built in the following year – 1609 – and by George Martine [the Provost who re-acquired Denbrae] to the memory of his mother and father. There is even some small evidence that Sibilla Wardlaw is also commemorated. [He unfortunately doesn't state what this evidence is, so something else may still have been decipherable on the memorial in the early 1900s, which has now been lost.] This George Martine was a

regent, a master, and ultimately Provost of St. Salvator's College, in which office he succeeded his uncle, Dr. James Martine. [James was provost 1577 – 1620, George from 1620 – 1645] The family historian [Sharpe's Secretary] says: "This Catherine Clephane bore Mr. George Martine [the Provost] and three daughters: the eldest, Margaret, married David Carstairs, called Gado, and [who in turn] bore David Carstairs, the famous merchant in Poland. The other two, Christian and Martine after her mother [Henry doesn't give her Christian name, but he does say "after her mother". The third daughter's Christian name is not legible in Macfarlane's records of the time, but it states she was named after her mother, so she too was called Katherine, so Henry was meaning she was given the same name as her mother], died of the great plague at St Andrews, anno 1605.

These Martine's of Denbrae, cherishing a good conceit of themselves, they had appropriated Prior Hepburn's old Summer house and Watch tower as a family mausoleum, and when they were all laid in it, including the girls who died of the plague and perhaps the last laird himself, it was built up...

Why Monteith did not copy the inscription as he did the other of the same date we do not know – perhaps it was already illegible – being by his time nearly a hundred years old; inscriptions on marble do not stand our northern climate very long. It would be interesting to know if any of the present day Martins claim descent from this old St Andrews family.[1]

End of Henry's article

With trees growing within Carslogie House undermining the remnants of the walls, not much now remains of the former five story family seat. It is hard to imagine it was still inhabited until relatively recently. This is where the Clephanes lived, including John and Katherine's daughters

The above photo is Carslogie House today. The drawing below is what it originally looked like in the 1500's

Margaret, Christian and Catherine. What I find interesting about David Henry's chapter is the human element to the mystery. Even though his enquiry was called 'The Haunted Tower' he doesn't go into any speculation as to who the White Lady may be, choosing instead to concentrate solely on the families he believed were connected with the memorial on the tower, and thus who he believed were the occupants of the tower itself.

The following is a very rare photo taken by A. Diston of Cupar. The framed picture hangs in the farmhouse on the present estate complete with corn flies trapped at its base. The castle or rather the baronial

mansion at this time was inhabited by Polish farm workers. When they moved out, the building rapidly deteriorated and began collapsing.

Katherine Clephane is popularly attributed in St Andrews as being the apparition of the White Lady. Carrying Henry's theory forward, to ascertain if this were possible, I went through the family records to see when family members lived and died to see how his theory of the tower being a mausoleum held up.

The task of unravelling the families both Henry and Martine mention wasn't easy. I cross-referenced the sources as much as possible as the lack of recorded births and deaths in the 1500s easily lead to the wrong family line or generation being traced. To make things harder, generations passed on the same forenames. They did this so if a family member died, the complete name would still survive. This way whole families could share the same names yet be generations apart. Given this, I realised what David Henry was up against, so in furthering his explorations, the following is what I have uncovered. Any errors in what you are about to read are my own.

Continuing David Henry's Research

The Reformers do not appear to have destroyed anything structural of the Cathedral in 1559, but they did rip out its heart. This magnificent edifice was now a vacant shell, with its buildings disused, and its overgrown gardens and grounds adorning the landscape. In the late 1500s, when the 200-foot high central bell tower collapsed, and the

ruins became a quarry, it was an ideal opportunity for families of standing to be buried in the oldest quarter of the town. With the fashion of the day for some of the families of Fife to be buried in the ground in front of Hepburn's north Wall, it is easy to see why Henry believed the Clephane's acquired a readymade tomb as a family mausoleum.

The Martine and Clephane families were two ancient and influential families in North East Fife. In particular, they were prominent in St Andrews, where they held many high offices, not over years but over centuries. No matter the turmoil of an age, they were well respected and moved through a period, spanning 600 years of history, relatively unscathed. Given the nature of history, this is a remarkable achievement. They represented an unshakable stone of ancestral wisdom, whatever their formula, they sustained virtues and legacies many a king and queen would have craved.

They had their darker shades of course... I did say relatively unscathed! Despite their conspicuous and influential place in history throughout St Andrews and Fife, if it wasn't for their potential association with preserved bodies and a ghostly figure popularly believed to be one of their own, few would know of their existence today.

Henry believed the mural on the south facing wall of the tower was a description of those interred within. With this idea fixed firmly in his mind he then ventured to find out the details of this family, but all he had to go on were the faint initials KC which he believed stood for Katherine Clephane, along with a partial representation of a shield he believed was the crest of the Clephane family and the date 1609. A name is still legible near the top of a memorial on the tower below the marble memorial. Carved in sandstone, the name is Alexander. He was Katherine's father. As Laird of Carslogie House in the 16th Century he was one of the most powerful members of the family. Henry never picked up on this name on the memorial as he never knew the first name of her father. I only realised this when I went through Martine's 17th Century notes. These were the same notes Henry had gone through, and within these notes, her father's forename is illegible.

Alexander's own father, Thomas Clephane, died in 1547 and his mother Janet Wemyss in 1540. I have found no record of Alexander's birth or death. He had a brother called George whose importance I

shall mention in a moment regarding the family dispute Henry spoke of in his article.

Alexander Clephane married Catherine Carstairs who died in 1583. Their daughter Katherine Clephane married John Martine, Lord or Laird of Denbrae in 1567. He eventually became Bailie of St Andrews and died in 1608. They had one son and three daughters. Their son was another George Clephane, born one year after their marriage in 1568. He amassed a sizeable fortune over the years through his shrewdness as a businessman. His uncle (John Martine's Brother) was Dr James Martine, Provost of St. Salvator's in St Andrews from 1577 to 1620. George succeeded him in becoming Provost of St. Salvator's from 1620 to 1645. George married Catherine Scheves in 1608, the same year his father John Martine died. He himself died in 1649.

Of the daughters to Katherine and John, the first was Margaret Clephane Martine, born in 1570, as Henry stated, she married David Carstairs, nicknamed 'Gado' and they had a son also called David Carstairs who became a famous merchant in Poland. I found an obscure reference stating Margaret died of the plague in 1609.[lvi]

The second daughter was Christian (or Christine) Martine, born in 1572 she died of the plague in St Andrews in July 1605 aged 33 years. She never married and never had children.

The third daughter was also called Katherine Clephane. She also died in July 1605 of the plague, and like her sister Christian, she never married or had children. The year of her birth isn't recorded, but if it were placed between Margaret and Christian, the date would be 1571 meaning she died aged 34.

[lvi] Sharpe's Secretary (George Martine) records her marrying John Anstruther, which I found confusing as she had married David Carstairs. The clarification came when I found the records of the time involve three Margarets. One was Katherine Clephane's great aunt, one her sister, and one her daughter. For her sister there are no recorded details, so Martine recorded the wrong Margaret. The Margaret he refers to was actually the daughter of Katherine's Great Grandparents, George Clephane 1502-1557, and Christian Learmonth Clephane, 1506-1564. They had a number of children, seven it would seem, including Margaret whose details are given as b.1520-d.1574. With them all sharing the same names he went back too many generations, but he does record the right names and identities for Katherine's other two daughters.

Katherine Clephane

The records are elusive when it comes to the date of their mother Katherine Clephane's own birth and death. They are difficult to fathom. The historical line is they are unknown, and Henry says her death wasn't recorded. However, genealogical records have her birth as 1545, making her 22 when she married. Those researching this family tree also repeatedly have her death as being 1609, which is synchronistic, because without knowing the possible connection of her with the Haunted Tower, they have the same date as that on the memorial, which lends credence to Henry's suggestion that this memorial was dedicated to her. However, a number of problems arise when looking to associate Katherine Clephane as being the female corpse in the tower, and thus the White Lady apparition. Firstly, if she was born in 1545 and died in 1609, she would have been 64 years of age. The corpse of the White Lady was young and very beautiful, so aside the possibility of it not being a mausoleum for this family, the corpse was of a younger woman. Secondly, as the family historian Martine, Sharpe's Secretary says following Katherine's death, John Martine was remarried to Sibilla Wardlaw, but this would place Katherine's death before 1609 as John died one year before in 1608. Sharpe's Secretary believed his great grandmother Katherine had died which is why John remarried, but if she were still alive, which the records suggest, something else happened for John to remarry.

Henry talks about a dispute, which was likely to have split the family. It is possible when John paid off the many lawsuits his uncle-in-law (George Clephane, Katherine's uncle) had amassed, and lost his own estate in the process, tensions weakened the relationship between John and Katherine. From this, John and Katherine's son George Martine bought back the Denbrae estate which could partly have been as a way of him trying to bring the family back together, but with John marrying Sibilla, it could mean John and Katherine were divorced. In this post Reformation period one of the only ways this would have been granted was through adultery. Henry says in his Haunted Tower article "I suspect John Hepburn's old summer-house has a more likely and lively history as a haunt of living sinners than as a hiding place of dead saints". In the context of his words, he seems to be referring to a family scandal and although speculative, adultery could have been the one.

Stories passed down through generations often contain elements of truth, and the majority of stories contain the plausibility of truth.

Another local legend about the Haunted Tower is one current Historic Scotland custodians of the Cathedral relay to visitors. It tells how a husband walled up his wife in the tower after adulterating against him. Suffice to say, no one was walled up alive in the tower, but given the location and the above plausibility, the adulteress could have been Katherine.

Katherine's uncle, George Clephane, the one that John bailed out, married Janet Forbes. They had a son also called George Clephane who married Katherine Helen Orme. This last George was Katherine's cousin and they are the initials GC and KO which Henry speaks of on a triangular dormer pediment lying in part of the house.

The dormer pediment from the year 1590

When I visited the farmhouse, the farmer said, "I have something to show you" and took me inside. In the early 1900s, this pediment was incorporated into the hallway wall of the farmhouse on Carslogie estate by the present farmer's grandfather. I was somewhat struck when I saw it. On seeing my reaction, he remarked "you have seen this before". I had indeed. There is a drawing of it from the late 1800s and I was surprised as well as delighted to see it still existed.

The initials "G.C" and "K.O," can clearly be seen along with the date 1590, but there is no record of what this date may signify. It

doesn't signify their marriage, it could be when a portion of the house was built or extended, or it could have been the date when Katherine's father Alexander died, although it is more likely to signify the date Katherine's cousin George became the new laird of Carslogie as he survived until 1612. Katherine Orme is recorded as dying in 1609 and it seems likely she too was a victim of a disease given the term 'plague'. They also had a daughter called Katherine Clephane, which added to the problems in tracing back the family tree. She died in 1662.

The following is a list I put together comprising names from the Clephane and Martine families dying between 1559 and 1609. Given Henry's theory, these are the only candidates from these two families who could have been in the tower. With there being up to 9 males and 1 female in the tower, this exercise would show if it were feasible.

Recorded Deaths of the Clephane and Martine Families between 1559 and 1609

1/ Alexander Clephane of Carslogie
Birth and death unknown. Father of Katherine Clephane Martine and Margaret Clephane Martine. His forename is inscribed and still legible on the lower memorial of the tower

2/ Catherine Carstairs
Alexander's wife and Katherine's mother.
Born (unknown), died 1583

3/ Katherine Clephane Martine of Carslogie House.
This is the Katherine whom Henry believed was the subject of the dedication on the memorial. She was the daughter of Alexander and Catherine Clephane, born 1545 and recorded as dying of the plague in 1609 aged 64

4/ John Martine Lord of Denbrae
Katherine's husband born (unknown), died 1608, age unknown.

5/ Katherine or Catherine Clephane Martine
John Martine and Katherine Clephane's daughter born approx 1571, died 1605, aged 34 from the plague

6/ Christian or Christine Clephane Martine
John Martine and Katherine Clephane's daughter, born 1572, died
1605, aged 33 from the plague

7/ Margaret Clephane
John Martine and Katherine Clephane's daughter
Born 1570, died 1609, aged 39 from the plague

8/ Katherine Helen Orme
Birth unknown, Died 1609
Wife of George Clephane, Katherine's uncle, He caused her husband to
sell his estate to bail him out. George Clephane died in 1615

9/ Helen Clephane
Daughter of George Clephane 1502-1557, and Christian Learmonth
Clephane 1506-1564. , born 1554, died 1605 aged 51. Cause of death
unknown, but being 1605, it is likely she also died of the plague

Conclusions

Henry spent so much time investigating the mural on the tower wall,
which by his own statement was "a long process" he lost sight of the
descriptions of what was actually found within the chamber.

In his interview, Hall says the female body in the tower was four and
a half feet in length. Certainly, the male line of the Clephane family was
an "exceedingly tall, strong race of men". General Clephane died in
1804 as the twenty-first and last of the Clephane male line, he was also
described as being "far above the usual height". It is clear from the
historical records they were of an unusual stature, being described
historically as 'giants'. It is interesting how one report in describing the
occupant's said there was "a man of gigantic stature so dried and hard
as to allow it being lifted and placed on its feet". [2] This would have
easily endorsed his theory, if it were not for the fact the bodies in the
chamber comprised up to 9 males and 1 female, and my list shows the
majority of the Clephane and Martin families dying between 1559 and
1609 were female.

The idea of it being a depository for plague victims is also a major
hurdle to them being the occupants, and only finds its agreement, albeit
a tenuous one with the tower being sealed. It is highly unlikely plague
victims would have been entombed here in 1605. In the unlikely event

~ 150 ~

they were, it wouldn't then have been reopened in 1609 to admit more family members including that of Katherine, as people would worry about its contagious nature. Additionally, and importantly, plague victims wouldn't have been embalmed or preserved.

The records have Katherine and her three daughters dying of the plague, and seven of the nine listed above dying within four years of each other, pointing more towards disease than natural causes. The term "plague" at that time was for any disease killing large numbers of people such as dysentery, which is a likely cause of the 1609 deaths. In 1605, a staggering 503 people lost their lives in St Andrews including two of Katherine's daughters.

The Rev. C. J. Lyon writing in his *History of St Andrews*[3] of 1838, remarks in a footnote referring to before 1826, when the Cathedral ruins became the town's burial ground, "Where the cemetery was formerly situated cannot now be known; but in various parts of the town and suburbs, human bones have been found in great quantities; and in particular, near "the first hole" in the Links, a vast number of human skeletons were recently discovered, when digging the foundations of some houses".

Occasionally, bones have also been exposed through great storms causing landslides along the cliff face of this area by the Step Rock (now the St Andrews Aquarium). Bones were exposed along the shore here from storms in both the 1880s and the 1980s. A myth in the town about the exposed bones attributes them to witches burnt at the stake along this hill, with the remains being tossed into the sea. They were not the bones of heretics that were uncovered here; they were bones of plague victims. Under the Martyrs Monument and surrounding area, there is a quarry pit that was used as a plague pit in 1605. This is where the 503 bodies from a plague sweeping through the town were placed.

In the *Citizen* dated 27 November 1926, William Linskill wrote an article called 'Disappearances and Vanishings'. One of the sections was called 'A Clephane Tomb' and read as follows.

"My friend the late Mr Henry, architect, held the very curious but interesting theory that some of the Clephane family of Carslogie, including a young daughter named Katherine, were laid to rest within the upper Chamber of the Mystic Haunted Tower in Prior Hepburn's old Abbey Wall which he considered would account for the initials "K. G"., or "K. C". in the wall. But the partially embalmed bodies and the coffins placed (not buried) therein were very clearly of a much earlier

date. The beautiful robed White Lady with the long raven black hair, in that Strange Tower is another interesting object that has completely vanished – like the big North Street cellars – although her lovely wraith is said to be occasionally seen flitting about the vicinity still".

The main opponent to Henry's theory of the time was Mr A. Hutcheson who also had agreement from Linskill and others regards the ancient age of the bodies. Hutcheson states, "All of these peculiarities of interment are indicative of ancient modes of burial, which although occasionally represented in rare instances in the 16th Century, render it unlikely that so many instances of these different practices would be brought together in one set of interments".

The bodies were clearly of great importance and antiquity. The styling and embalming appear closer to the coffins originating from different centuries than to family members spanning at most, a 50 year period up until 1609. So having furthered Henry's work and delved into the possibility of the occupants being from a wealthy and influential Fife family, I believe Henry was correct about the mural being placed there as a dedication to the Clephanes. However, as interesting a notion it is for one of Katherine's daughters to have been the White Lady, it is clear the Clephanes were not the occupants of the tower. The mural most likely marks their family plot in front of the tower. Members of the family contracting the plague in 1605 in all probability would have been amongst the 503 victims from the town, who ended up in the plague pit on the Scores.

Although the bodies of the Clephanes were not those in the tower, ironically, it is possible the bones of family members buried in front of the tower ended up in the tower's lower chamber following a levelling of the grounds commencing in 1826. Refer to the foot of p. 177.

Chapter Eleven

The Servants of God

Moving on from Henry's theory, the following is a continuation of Hutcheson's theory for the occupants of the tower being those of saints.

SAINTS AND RELICS
(*To the Editor*)
George Angus 5ᵗʰ March 1894

SIR, - Judging from the interesting correspondence now going on in your columns, there appears to exist some misapprehension and confusion as to what Catholics mean by the words "Saint" and "Relics," and therefore perhaps a few remarks from myself, the first resident priest here [in St Andrews] since the Reformation may not be deemed intrusive. In the widest sense of the word, all the baptised, *i.e.*, all Christians are saints. "Called to be saints," as St Paul says. That does not mean that all baptised live up to their calling or are consistent Christians, for many are called, but few are chosen".

In the very earliest ages of the church, great respect was shown to the relics of the martyrs. As there are heathen and pagan relics so there are Christian relics. After martyrdom, the bones of the martyrs were preserved and reverenced. So the disciples (we read in Scriptures) took the body of John the Baptist and placed it in the Sepulchre; in like manner they rescued the bodies of the other martyrs and gave them decent burial. Altars were erected over these bodies or bones, and Mass said upon these altars. Hence we speak of "altar tombs". And at the present day no Catholic priest can say mass except on a slab, or stone, enclosing certain relics – a tradition of primitive times.

Then, as Christianity spread, there were local saints, holy men and women, martyrs or not, who were venerated in certain districts and localities, and were, outside such localities, unknown. The same thing is still with us in the Catholic Church. Thus in England, all Catholics observe the feasts of English saints. For instance, Chad, Hugh, Bede, Edmund of Canterbury, etc.: while in Scotland these names are not mentioned nor in any way commemorated. On the other hand, certain

saints are commemorated everywhere. That is because the Pope has extended such observance "to the whole church," whereas, as in the cases cited, other feasts are of national and local observance only. But, as time went on, it was necessary that precautions in such matters should be taken, for local testimony (whether as to saints or sinners) is not free from bias, and national prejudices, antipathies, and sympathies might easily cause abuses in holy things. Therefore it became the custom to submit such questions (as of the reputed sanctity of any man or woman) to the central authority of the Holy See, although this was sometimes done as early as the 4th Century. In the early 10th Century we meet with the fully-developed and complete process, which is called canonization, and which provides regularity of proceeding, remedying of defects, and provision for due precautions, and is, accordingly, a very slow process, for "Rome is slow because she is eternal". And in 1170, Pope Alexander III absolutely forbade any public religious honour being paid to anyone, after death, without the consent and approval of the Bishop of Rome – the Vicar of Christ. Mr Lang is quite right in saying that the relics of the saints are preserved in reliquaries of precious metal, which are kept in churches and exposed for veneration on certain feast days. This was seen here on Advent Sunday last, being the Sunday after St Andrews Day, when, after mass, a relic of our National Patron Saint, brought from Amalfi (where his body lies) by Lord Bute, was kissed by all the worshipers. The relic, a piece of bone, is enclosed in a handsome bust of the Apostle made of Scottish silver. I fancy that most of the relics were scattered to the winds at the Reformation here, as in England, where the Anglican Bishops tore down altars and shrines, and abolished the mass, and condemned the worship of the saints and servants of God which had been practiced for 1000 years. No doubt, some relics escaped, and fresh relics were sent to us from Rome and other places, just as they were sent by the Pope to Augustine of Canterbury after he had begun his mission and founded that English Church, which perished in the shifting sands of the Reformation. To go back for a moment to St Andrew. All Scotsmen know that his feast is on November 30. But why on that day? Simply because, in 1295, Pope Boniface VII appointed it to be so observed.

But, it may be asked, may there not be spurious relics? Undoubtedly, and Rome is very particular as regards investigation and authentication of any relics. Two cases are within my own knowledge when certain relics placed in churches in England were removed and

forbidden ever to be shown again, because on examination, it was found that the authentications regarding them were unsatisfactory. As regards miracles worked by relics, it is hardly necessary to go into that question, for we find an instance in the Old Testament, when, as we read, a dead man, on touching the relics, or bones, of the prophet Elisha, "revived and stood upon his feet". What has been, may be. The Lord's arm is not shortened, that it cannot save. Lastly, we by no means contend that there are no Saints or Servants of God, of heroic virtue, beside those publically venerated in the Church. Privately, we may pray to, and venerate, any departed man or woman, and ask their prayers, and say – "Think on me when it shall be well with thee". And they can help us in one way only, and that is by prayer, for we read of "the prayers of the saints," and they certainly in heaven do not require to pray for themselves. Having attained heaven and the Vision of God, what more can they need? And there may be thousands now before the Throne, whose virtues neither tombstone nor calendar record – forgotten by men, but remembered by God. Of these we shall know nothing until the day when the "secrets of all hearts shall be revealed," when, as St Paul says, "The saints shall judge the world," and when our Lord shall come "to be glorified in his saints and admired in them that believe". – I am, &c., George Angus

William Linskill in reply to George Angus's letter in 1894 says,

"SIR, - Kindly allow me space to say a few words more regarding the above Tower. I think I am correct in stating that all the turrets now existing in the old Abbey Wall (several have clearly been removed) excepting two are circular or nearly so. Two only have been square, and of these the one nearest the Cathedral (now known to fame as the Haunted Tower) seems to have been differently constructed from the rest, and to have had *two* chambers, one above the other, not to be found elsewhere.

Genuine intact saints were certainly *very, very rare*. St. Waltheof or Waldeve of Melrose (who was offered the Bishopric of St Andrews, but declined and St Cuthbert at Durham, are the only ones I can, at present, remember in Britain. Abroad I have only seen the *entire* body of one saint – I think, St Charles-Borremeo. If I am wrong, perhaps my friend, Mr Angus, will kindly correct me. Relics, of course, are common; but they are very tiny fragments, often not bigger than a hemp seed..".

His letter continues on p. 172

Saints

Lyon in his *History of St Andrews* published in 1838[1] says, "there were 30 chapels or alterages in the parish church [Cathedral], each of which was endowed, and had at least one chaplain belonging to it, whose duty appears to have been to celebrate *obits*[lvii] for the repose of the souls of deceased persons who had bequeathed money for this purpose". The following is his very rare list of the chapels/altars and their dedications.

Chapels and Alterages in the Cathedral

St Andrew
The Blessed Virgin Mary (In the Lady Chapel)
The Blessed Mary of Piety (Our Lady of Pity)
St Mary Magdalene
St Anne (or Anna)
St Katherine
St Barbara the Martyr
St Michael the Archangel
St Lawrence
St Ferguson
St Ninian
Altar of the Holy Blood
St Nicholas
St John the Baptist
St Bartholomew
St James
St Peter
St Phullan the Abbot (St Fillan)
St Duchatt
The Holy Cross
All Saints

Lyons says his list comes from copies of charters. "They relate to a period of about 150 years immediately previous to the Reformation". This places the records of the dedications to 1409.

He says there were 30 chapels and altarages, but the above list of dedications only extends to 21.

[lvii] Obituaries

William Linskill published many letters to the press about his search for the lost treasure under the Cathedral which he and the town were looking for from 1879 to 1929. His digs were known locally as 'howkings'. His letters took the form of updates in his search for underground passages and chambers in the Cathedral precincts and the surrounding area. In December 1903, he published an interesting letter about this.

""The Howkings". – I think it may be well to say a little about the interior arrangements of our lovely Cathedral, where we have been howking all the summer, and where we hope to recommence howking again very shortly. This same old Cathedral in its prime must have been a wonderful and beautiful sight, and it is a most unfortunate circumstance that there are no means of ascertaining exactly how many chapels and altars it really possessed. We find mentioned – the great high altar, the altar of the holy rood, the altar of the Blessed Virgin Mary in the Lady Chapel, and the altars (and chapels) of St John the Evangelist, St Andrew, St Michael, St Lawrence, St Katherine, St John the Baptist, St Bartholomew, St James, All Saints, St Barbara, Our Lady of Pity, St Ninian, St Nicholas, St Anne or Anna, St Peter, St Phullan, and St Duchatt. Doubtless there must have been many more. The parish altar had a throne and splendid images".

He then went on to speak of some of the treasures, which would have adorned the altars and chapels. These are some of the treasures he was looking for. His list of treasures holds its own fascination, however, not wanting to stray too far from the dedications at hand I have quoted what he says in *Section Four*, commencing at the foot of p. 182.

Linskill's list of dedications is in a different order to Lyon's, and not all the dedications are the same. Linskill never mentions who his source was and I have been unable to find the reference for his list, although similar, it wasn't Lyon.

Cross-referencing the lists shows there are a few dedications unique to each. Lyon's list has St Mary Magdalene and St Ferguson who are not mentioned by Linskill, and Linskill has St John the Evangelist not recorded by Lyon. Linskill also mentions the great high altar being dedicated to Jesus and his 12 disciples. Lyon doesn't mention this, but he does mention St Andrew and the high altar as being the resting place of St Andrew himself. His relics were housed in a large casket. Linskill says on the high altar were "statues of Our Lord in gold, and the twelve Apostles in silver," which must have been a remarkable sight.

Linskill also mentions the Altar of the Holy Rood, which is another name for the Altar of the Holy Cross on Lyon's list. He also has 'Our Lady of Pity', which is the Italian form of 'Our Lady of Sorrows' or 'The Blessed Mary of Piety' mentioned by Lyon. In an article to the *Citizen* dated December 5th 1925, on speaking about the Cathedral he also mentions a few of the saints dedicated in the Cathedral. In his 'short list', he gives 2 more names not on either of the previous lists, a St Fergus and a St Thecla.

By correlating all the saints together, we have the following 24 out of 30 dedications and a further clarification of a few of Lyons 1838 and Linskill's 1903 dedications:

Chapel Dedications in the Cathedral ~ Revised

St Andrew (The Great High Altar – dedicated also to Jesus and his 12 disciples)
The Blessed Virgin Mary (In the Lady Chapel)
The Blessed Mary of Piety (Our Lady of Pity)
St Mary Magdalene
St Anne (or Anna)
St Katherine (of Alexandria)
St Barbara, the Martyr
St Michael the Archangel
St Lawrence
St Ferguson (the Catholic Church have no record of this saint)
St Fergus
St Thecla
St Ninian
Altar of the Holy Blood
St Nicholas
St John the Baptist
St Bartholomew
St James
St Peter
St Phullan the Abbot (St Fillan)
St Duchatt
The Holy Cross (Altar of the Holy Rood)
All Saints
St John the Evangelist

Most of the dedications above are of saints "commemorated everywhere" as George Angus put it, and apart from a few relics of St Andrew, it is highly unlikely any of these were laid to rest here. There is however, one on Lyons list that stands out. Following Hutcheson's suggestion and that put forward by George Angus, where he says, "local saints, holy men and women, martyrs or not, were venerated in certain districts and localities, and were, outside such localities, unknown". It is possible the bodies found within the middle chamber of the tower are those of local saints. As Angus noted, as late as the 10th Century there were little to no records kept in Rome of local saints. After this time there appears a more "fully-developed and complete process, which is called canonization". The Catholic Church has no record of a St Ferguson, so he could be a local saint from a period before the 10th Century.

If the bodies in the tower were local saints, it would fit with the coffins being from different time-periods, even from different centuries. It would also make sense of their preserved state, as the air was far too damp for natural preservation to have occurred in the tower alone. Preserved by the church, they would each have had a chapel or altar in the Cathedral in whose honour they were dedicated to God. Each would have been housed within the sepulchrum of the altars.

The most important of those found within the tower is without doubt the White Lady Saint. She would have been on display, which again makes sense of her being found wearing expensive funerary attire – a silk dress wrapped in waxed linen. Importantly it also explains why she was lying in a coped lidded oak coffin of great antiquity and wore long white leather calfskin gloves.

Between the lists, there are still 6 chapels or altarages where I have been unable to find dedications. With St Ferguson being the only saint out of the list of 24 the church has no record of, this could mean either there were 7 corpses in the chamber rather than 10, including St Ferguson, or not all the corpses were saints. I have not thus far found anything in the archives, and although I am in touch with the Vatican, it is a very slow process. If I do unearth anything further, it will be for a second edition of this book.

Chapter Twelve

Preservation and Incorruption

Preserved Saints

I quoted part of the following short piece at the beginning of this book. It is taken from the end of the *Saturday Review* article of 1893 that first brought the mystery of the tower to the public arena. "Two things were now established. The first was the truth of what they had seen [1826]. For there is a certain soil or a certain atmosphere which preserves dead bodies from decay. It exists in Milan, and it is now known to exist nearer home. And at a certain point from St Regulus Tower all the dead that sleep beneath its shadow are lying now as they lay on their death-bed".

"When a body is described as being incorrupt it means that it does not decay after death. The same cannot be said of a body that is well preserved or mummified, or has undergone an embalming process. Most such corpses become stiff, but incorruptible saints remain completely flexible, as if they are only sleeping".[1]

The bodies found within the tower were a mix of preservation and incorruption. The majority were described as being very stiff and it follows they were physically preserved through an embalming process. Others were preserved through the natural condition of their interment being conducive to incorruption, with one being highlighted by Heddle as being "wholly converted into adipocere".

Linskill corresponding from the University Golf Club at Cambridge in reply to Mr Hutcheson's letter regarding the Haunted Tower in the *Citizen*, 24th February, 1894, says, "It may interest some of your readers to know that I saw in the Crypt of a chapel near Bonn in 1876 (attached to a convent of Servites built in 1627) the bodies of a large number of Capuchin monks in lidless coffins. Although 400 years old, they were in a magnificent state of preservation, the nails on the toes and fingers, and the vestments being *almost intact*. In the same chapel,

behind the high altar, are the sacred stairs, an exact imitation of the ones in Rome leading to Pilate's Judgement Hall. – I am

W.T.Linskill,
48 New Square, Cambridge

"In the Haunted Tower here the toe and finger nails of some of the bodies were also in a perfect state".

John Murray in his book *A Handbook for Travellers on the Continent* published in 1840 has a piece about this crypt near Bonn. He says "A trap-door in the pavement leads into the vaults under the church; they are remarkable for having preserved, in an undecaying state, the bodies of the monks buried in them. They lie in 25 open coffins, with cowl and cassock on; the flesh in some is preserved, though shrivelled up to the consistence of a dried stockfish; they are, in fact, natural mummies. They have been interred here at various times, from 1400 to 1713. The church is annually visited by numerous pilgrims".[2]

The bodies found in the tower were not shrivelled up they were in a far more human state and none were mutilated or disfigured.

A preserved body in the Catacombs of Palermo

A great multitude of cases exist worldwide sharing similar characteristics to the reports of preservation, and for natural preservation, it is true certain locations have been found where the conditions are favourable for the preservation of the dead. Another such instance centres on the catacombs of Palermo in Sicily. The walls of these caves are lined with the mummified corpses of Capuchin monks alongside villagers of both sexes and all ages. They began the practice in 1599 and it soon became a status symbol to be interred in this way. The air within is dust free and very dry, creating a desiccated atmosphere conducive to preservation. They were dehydrated and some were embalmed. The natural process of drying out over so long a period has resulted in them becoming extremely rigid, and with the contraction of the muscles they now display rather gruesome and contorted expressions. There are thousands of preserved bodies here. The last to

be interred in this way was a two year old girl who only died in 1920. To this day they each still hang like rag dolls in their original costumes.

On a website detailing incorrupt bodies of saints, I found the following, "Saint Cecilia - The year of her birth is unknown. She died about 177 C.E. at Rome and her body discovered incorrupt in 1599. Virgin and martyr, Saint Cecilia is the first Saint whose body experienced the phenomenon of incorruption. She is the patroness of church music and the blind".[3] The site also mentions there are over 250 incorrupt bodies of Catholic saints. She was found to be incorrupt a phenomenal 1,422 years following her death. Her body resides in the 5th Century Church, Santa Cecilia in Trastevere Rione, Rome.

Chapter Thirteen

The Reformation

Preparing for a Revolt

In 1516, Prior John Hepburn began building, repairing and extending the 14th Century Abbey Wall. Surmounted along its near mile long length would be 16 towers. This was in keeping with extensive work he was carrying out on the ecclesiastical buildings themselves, which he richly decorated at some considerable expense. His coat of arms can be seen in at least nine different places along its length.

Henry observes in his 1886 article titled '*The Architects of St Andrews*' "That enormous wall was said to have been built between the years 1516-20". Archaeological notes suggest, "the property of the Priory was likely enclosed from at least the 14th Century,"[1] so there had been a wall around the grounds before Hepburn's construction, remodelling and extension, but it may not have been as extensive as the current wall.

In Hutcheson's first article on p. 117 about the Haunted Tower, he makes the remark "The upper part of the tower where the bodies were found was built at a much later date than the lower portion, since there were niches, capitals of pillars, and other fragments of masonry used indiscriminately in its construction".

On the outer side, a line is prominent running midway along various stretches of wall, especially along the north wall. This same line can be traced across the structure of the haunted tower itself.

Thin filler stones were used between the original wall and the extended wall above to keep a straight line in the next layer. This line corresponds with the level of ground within the middle chamber of the tower, which also comprises these rough filler stones. This suggests the ground of the middle chamber was the top of the original wall and the Hepburns built the upper chambers. There may have been flat slabs over this that they reused for the upper third level parapet of the tower and walkway along the top of the north wall.

The ground in the hidden part of the middle chamber in Hepburn's Wall[lviii]

By all accounts, there was also a wooden roof on the tower and perhaps along the walkway of the wall, the remains of which have long since disappeared.

With Hutcheson's suggestion that the lower section is of a much older age, it would appear the original boundary wall defining the Cathedral grounds was 10 feet in height. This lower section is mainly of grey stone, whereas the upper 10 feet comprises mainly sandstone.

A great deal of stone was required to extend and build the wall. This came primarily from older Priory buildings within the Cathedral and Priory grounds. Referring to this, Linskill said, "These stones were from other churches, the two niches [of the Haunted Tower] may have come from the Parish Church when that was demolished". The Parish Church he mentions was the Holy Trinity Church of St Andrews, which stood in the grounds between the Haunted Tower and St Rule's Tower.

Founded in 1141, the last remaining feature of its existence is a stone arch standing to the left of the eastern gable of the Cathedral. This was the original entrance to the Parish Church grounds. Interestingly it is also made of sandstone, suggesting the church was built of the same, thus strengthening the theory that the sandstone of the upper half of Hepburn's Wall came from the church, as well as from other buildings of the same material. Holy Trinity Church was built in its present location in the middle of South Street in 1410 and

[lviii] Photographed by Richard Falconer, published with kind permission of Historic Scotland, Edinburgh

was opened in 1411. Built on the remains of a 13th Century Church and cemetery this then became the burial ground for the town until 1826 when burials switched back to the Cathedral precincts. Refer also to p. 176.

The original entrance to the grounds of Holy Trinity Church

Henry continues, "It must have been a formidable undertaking even to a man with the large resources of the Prior of St Andrews. The work was strong but not fine. The design and execution of the canopied niches on the towers showed plainly the great decline in the architects' art since the time of Arnold and William Wishart... Prior Hepburn's Wall saw the completion of the age of building up, and the approach of the age of pulling down".

Fortification

By the early 1500s, many thousands of pilgrims were coming to St Andrews from across Europe. Despite the Protestant movement causing mounting political and religious tensions, the fact they were spending great sums of money and labouring daily on the Cathedral and Priory is a testimony in itself that they were not looking for an exit plan. Prior John Hepburn who began the work didn't die until 1525 but his nephew Patrick Hepburn became his successor as Prior of the Cathedral in 1522 and immediately set about finishing what his uncle had started. Prior Patrick Hepburn was the 3rd Earl of Bothwell and was the father of James Hepburn. He would become the 4th Earl of Bothwell, famed as being Mary Queen of Scots 3rd husband.

The Hepburns were expanding and improving the precincts to cope with the constantly increasing numbers arriving in St Andrews. They were also developing the University at this time. It was Prior John Hepburn who established St Leonards College in 1512, becoming St Leonards School for girls in 1877, and taking over some of the latter College buildings, this is partly how the school eventually had the exclusivity of the former Priory grounds.

The extensive work the Hepburns were carrying out on the precinct wall was not only a sign of expansion, but of how cautious they were becoming. By raising the height of the original wall by another 10 feet in places, they were improving the security of the precincts, as well as fortifying and expanding them as a simple defence against unrest. On one of the towers in the wall there is the following post 1522 Latin inscription, [P]RECESSORI[S] OP: POR: HIC PAT; HEPBVRN EXCOLIT EGREGIVS ORBE SALVT. 'Here the excellent Patrick Hepburn in his turn embellishes the work of his predecessor with a tower of 'fens'. Fens means defence. The fortification wouldn't have held back any with a concerted desire to gain entry, so it was more as a deterrent to stop undesirables entering the precincts, than as a fortification to stop cannon for example.

It is not known when the wall surrounding the precincts was finally completed, just that it was before 1559. John Hepburn's coat of arms is displayed midway between the old and new construction on the north-facing wall of the tower, pointing to it being a seal between the two and the tower being completed before he stepped down as Prior in 1522.

The Concealment of Saints

The Haunted Tower, as we have seen, is the most unusual of them all in a number of ways. It was clearly built to serve a different purpose to the other towers. With the Lighthouse Tower being so close, the upper section was a watchtower to observe the shipping and the walkway the same, as well as serving to keep an eye on what was happening in the immediate vicinity outside the precincts.

Henry romantically associates the middle chamber as being a summerhouse or garden-house. It is possible this was to be its original purpose. Equally, they could have built it as a retreat but it is possible it was never used for that purpose. Things were becoming difficult for the Catholics. They wouldn't have known when something was going to flare up, but with mounting tensions, the monks knew their

vulnerabilities and how vulnerable the saints were. Not wanting the saints desecrated should anything happen and not knowing when something might happen it is likely they would have moved them to the tower shortly after its completion.

"Dean" of Tyasaoga said "those interred in the Cathedral at St Andrews, had been removed with the intention of being re-interred when the troubles of the times had abated". He believed them to be of "Kingly stock" rather than saints, but I do believe he was on the right track regarding where the bodies came from and why they ended up where they did. I believe he is also on the right track that they were hidden here as a temporary measure. With the Haunted Tower being dedicated to the Virgin Mary, the Mother of Christ, this was an appropriate place to temporarily hide and protect the bodies until such times as the incumbent storm had past. They placed whatever was appropriate within the tower, sealed up the entrance of the lower chamber and the three external keyhole gun loops, blocked up the window on the south facing wall of the middle chamber, and sealed its entrance. Whatever the Catholics thought of what was happening around them, after four centuries of being in power, they believed whatever could occur would be minor in comparison to their own strengths. They had no idea they would be ousted from Scotland and their religious and political control would be permanently overthrown. With the wall of the chamber sealing the entrance only being nine inches thick, this in itself qualifies the theory it was sealed as a temporary measure.

The Build up of Tension

In 1528, the reformer Patrick Hamilton was burnt at the stake in St Andrews as a martyr of the Reformation. He was followed in 1532 by Henry Forrest. Each of these could easily have sparked a revolt but there was none of the time who could spearhead it. Fourteen years later however, there was. The concealing of Saints was a shrewd move by the church, given that around 200 graves within the Cathedral would soon be desecrated. However, they would soon come to realise for a second time, that the fortification of the walls would do nothing to stop the ransacking and overthrowing of the Catholic buildings.

The first time the Catholic defences were breached without the aid of musket or cannon was in May 1546 at the Archbishop's Palace, two month after Cardinal David Beaton burnt George Wishart alive outside

the chamber window of his Palace. His judgement was frowned upon by the prelates in Glasgow who tried talking him out of executing Wishart for fears of personal retribution, and there would be plenty of that to come. Beaton continued regardless and in doing so sealed his own fate. When Wishart was burning, he warned Beaton almost prophetically he would suffer for his crime. Two months later, his words came true. Spurred by what he said, a handful of Fife lairds early one morning, disguised as stonemasons, entered the Palace through the main entrance. Their intention was to kill the Cardinal and take control of the Palace. Whilst making their way up to his chamber, Beaton heard the commotion and barred his door. After pouring hot coals against it to gain entry, he implored with them, "I'm a priest, I'm a priest" he shouted. "We know, we know," they retorted as they stabbed him to death in his nightdress. They stripped him and hung his naked bloody body by an arm and a leg out of his chamber window in the form of the St Andrews cross. The Protestants then had control of the Palace for a year. During that time the preacher and reformer, John Knox, joined them and gave his first sermon within its walls. This was some 12 years before the Reformation itself began.

Mary of Guise, the mother of Mary Queen of Scots stayed in a Royal Palace called the New Inn half way down the Pends Road. Mary was ill with worry and stress through the unfolding of events. She was more than aware of the growing unrest between the religious state and its people. In 1558, Cardinal Beaton's successor Archbishop John Hamilton burnt Walter Milne opposite the Cathedral entrance as a display to Mary of Guise and the church that everything was under control. However, everything was far from under control. Walter Milne or Mill was the last official martyr executed by the Catholics. A cobbled circled cross in front of the courtyard entrance to Dean's Court marks the location of his death. Tensions had never been greater and the townspeople were unwilling to supply the wood and rope required for his execution, not least because he was an 82 year old man. Far from the Catholic Church in Scotland being in control, his execution spelt out the last death knell for a power that had dominated the people and land for over four centuries. Milne was a catalyst, not for the Reformation occurring, but for leaving no doubt in the minds of the people that something had to change. Something had to happen to stop the increasing barbarity and extremities being levied against them. Knox was now making waves upon the shores of St Andrews and the

Catholic seat of Scotland. The tensions between the people and the Church had been tangible for years, and the execution of Walter Milne gave the final legitimacy John Knox needed for a nation to rally behind him.

The Reformation

In July 1559 after preaching a sermon in Perth, Knox arrived with his retinue in the 'Rome of Scotland'. With the smell of Milne's burning corpse still lingering in the memories of those in St Andrews, he preached a rousing sermon over a three day period in the town's parish church of the Holy Trinity in South Street, at the end of which a riot broke out. The 'mob' marched as one down South Street to the Cathedral. The moment they stormed the Cathedral was the moment the Catholic seat of power in Scotland fell. As a statement of retribution for Walter Milne's death, whilst ransacking and smashing whatever they found in the Cathedral, they also took anything combustible out of the main entrance, and burnt it on the spot where Milne himself had died at the stake only months before.

After centuries of Catholic rule in Scotland, the Church completely underestimated the capability and anger of a simple opposition – their congregation, who, without money or help from other powers, completely overthrew them. Mary of Guise fled from her Palace of the New Inn to Holyrood Palace in Edinburgh. With the overthrowing of the Catholic religion, the pilgrims stopped coming and so did the money. With both gone there was now no money, so the merchants also stopped coming.

The Pot of Flowering Lilies

At the end of one of Linskill's short articles headed 'One of the Mysteries of St Andrews' he says, "By the way, the old gateway at the Light-house round tower [Situated just east of the haunted tower] had, it is stated [no reference], a statue of the Holy Mother over its arch, and that the emblematic pot of lilies on the Haunted Tower make me fancy that both gateway and tower may have been dedicated to her, as is also the Church of St Mary on the Kirkhill close by". The small and exclusive sacred Chapel between the high altar and the eastern gable was also dedicated to her and was known as the Lady Chapel.

Linskill was quite correct that the tower was dedicated to the Virgin Mary. The sculpted pot of flowering lilies on the north wall of the tower above Hepburn's coat of arms is an early symbol denoting chastity and with this, it is a symbol for the Virgin Mary. Linskill says in a short article he titled '*The Emblem of our Lady*', that it "represented the beauty and purity of the Blessed Virgin Mary. There is no similar representation of the virgin in the City". He was quite correct. This is one of the rare surviving symbols of the Catholic faith in St Andrews.

The pot of lilies and the arms of Hepburn

Placed on the newer upper section of the tower, her emblem gives a further clue as to the importance of what lay inside. Directly behind this sculpture is the middle chamber itself where the body of the White Lady was entombed. There is a significance here giving us an idea to her provenance, not that the body lying within was the Virgin Mary, but that she carried similar qualities. Again suggesting she was a Saint. Why the Reformers never desecrated this symbol is a mystery in itself. Before the Reformation, the majority of those now adhering to the new Protestant faith were Catholic, so they must have known what it signified. They wouldn't have had any qualms about desecrating statues and the symbolism to her. As an example, in 1547 when the French, following the siege of the Archbishop's Palace in St Andrews, captured John Knox and others, they all became galley slaves. Whilst on the ships "they were threatened with torture if they did not give proper signs of reverence when mass was performed on the ship.

Knox recounted an incident in which one Scot – possibly himself, as he tended to narrate personal anecdotes in the third person – was required to show devotion to a picture of the Virgin Mary. The prisoner was told to give it a kiss of veneration. He refused and when the picture was pushed up to his face, the prisoner seized the picture and threw it into the sea, saying, "Let our Lady now save herself: she is light enough: let her learn to swim". After that, according to Knox, the Scottish prisoners were no longer forced to perform such devotions".[2]

Along with the pot of lilies not being defaced, the statue of the Holy Mother over the arch may not have been defaced, as something still sits in the niche, and being carved of sandstone it appears more weathered than destroyed.

There is also another interesting detail on the tower. A face on the base of the left niche gazing down upon those passing by.

The Sealed Entrance of the Haunted Tower

By the time the Reformation sounded, the middle chamber of the Haunted Tower had its new occupants hidden within, and the entrance was now sealed. Only those involved in their concealment would have known this had been done, and they would have been amongst the most devout and trustworthy in the church. Whilst some stayed and

switched to the Protestant movement, they would have left during the Reformation and along with them, the secret of their concealment also left.

David Henry put forward an argument against the saint idea by saying the Reformers of 1559 would surely have gone through the entrance and destroyed what they found. Linskill proposed a similar argument. Continuing his letter of reply to George Angus in 1894 (from p. 155) concerning saints he says, "I hardly think the so-called Haunted Tower would have made a *satisfactory hiding-place*. The stone-steps leading to a clearly built-up doorway would *at once* attract notice; it was certainly one of the first things that attracted my attention when a small boy. There were holes in the walls of the chamber, and we used to poke in sticks, &c. The air must have had free entrance for a long time, and, no doubt, did much towards destroying the bodies and coffins".

When Linskill was a boy visiting St Andrew, the holes were too small, and the depths too dark for him to see into the chamber, so he never saw any of the corpses. The deterioration as I mention elsewhere was compounded by the elements, but this was not the main cause, it was the Antiquarians poking around on at least five occasions. As we have seen from the reports of what they found within, the bodies were still in a relatively good state of repair.

It is difficult to imagine why the Reformers wouldn't go through the sealed entrance. This is perhaps the only argument against the theory of the occupants being entombed prior to 1559, until we realise the sealed entrance wasn't as out of place or as inviting as Henry and Linskill may have thought. Their argument is based on the same enquiring and curious mind we share today. If we discovered a blocked up entrance we would think it were blocked or sealed to conceal something, but our perspectives have changed over the years. A sealed entrance could also mean the tower was no longer in use. The Cathedral and precincts had undergone so many alterations over the centuries. The blocked entrance to the tower was just one of many doors and windows blocked off or half blocked off around the precincts as sections were partially or completely remodelled, so it wouldn't have warranted any singular or especial attention.

In ransacking the Cathedral, 'the mob' targeted the obvious. Knox didn't want the fabric of the Catholic buildings touched as these remnants of idolatries should be peacefully converted and their

churches used for the true and proper worship of God. Knox spoke of the odiousness of idolatry to God, of God's commandment to destroy all idols, and of the Mass as an abomination to God. The statues, chapels, side altars and treasures detracted from the word of God, so this is what they destroyed. With the Reformers taking the Cathedral and being faced with little evident opposition, they wouldn't have known precautions had already been taken to pre-empt such an eventuality, and wouldn't have suspected that the tower might contain anything of value to the church. Another report from 1868 says the steps led to a blank wall. This typifies the obvious reasoning that probably hadn't changed for centuries. They didn't even consider it may be a doorway and perhaps it was as simple as that.

There appears to be no records of the chamber being opened before 1826, but it was opened in 1609. If we shared Henry's theory for a moment and looked at the tower as being sealed for the first time in 1609, we are still looking at the majority of the bodies surviving intact through a period spanning 259 years up to 1868.

Alternatively, if the bodies were interred before 1559, stonemasons must have entered the chamber in 1609 to secure the memorial plaques to its south wall. In this year, the Witch Trials were in full sway in St Andrews. With the stonemasons not venturing down the "Wee Stair" in 1842 because of evil spirits, (refer to p. 190), or in 1879 when they discovered the tunnel at the Archbishops Palace, in 1609 they certainly wouldn't have lingered in the chamber for any longer than was necessary for the same reasons. If any treasures or further means of identifying the bodies were also hidden alongside the bodies, chances are, this is when they would have been removed.

The Special Collections Unit of St Andrews University has a photo of the Haunted with its entrance still sealed. It sits within one of Linskill's scrapbooks, collated for the St Andrews Antiquarian Society. There was no literature accompanying the photo. In trying to put a date to it, I first noticed the entrance of the lower chamber is not present. From this, I realised the photo dated to before the 1868 opening, as this is the year they opened the lower chamber beneath the stair and never resealed it. I then looked at the graves currently present. One of them has as part of its inscription that the stone was erected in 1860 but the gravestone is not in the photo. Another gravestone not in the photo is one dated June 1860, so the photo dates from before this time. Also, the ground around the tower has been lowered by at least

one foot since the photo was taken, the lower steps leading to the middle chamber are missing and there is ivy along the wall, but not as much as there was in the photos taken between 1905 and the 1920s.

The Missing Stairs of the Haunted Tower – Pre 1860

It is conceivable that before the Reformation occurred they removed the lower four steps of the tower to give an additional feel of abandonment. They were very clever and adept at misdirection. As an example of this, St Salvator's Chapel on North Street houses the tomb of its founder, Bishop Kennedy. A large black slab one foot thick and weighing a few tons sits on top of the tomb. Along its front are many chip marks and scores where grave robbers over the years have tried prizing open the tomb to desecrate the body of the Bishop. None ever managed to lift it. Little did any know he is not in the tomb, but under their feet in front of it. All they had to do was lift up the slab. Underneath they would have found a few steps leading down to a small crypt where his bones remain to this day in a gold casket.

Looking at the tower today, the original top steps are of sandstone, the missing steps have been replaced with a hard grey stone. In Linskill's 1888 article of "*The Howkings*", reproduced earlier, he says, "while the rubble stones were being removed, several richly-moulded stones were being removed which had been employed in building up the door and are being preserved. Eight steps lead up to the door, which is about five feet from the ground, were laid bare". If he hadn't mentioned this in 1888 it would be easy to think these steps were replaced when the iron grating was put in place in 1891. It would have made sense to do it then for the curious to go up and have a look through the bars into the outer chamber, so with them being replaced at an earlier time adds another curious factor to the history of the tower. Why take the trouble and expense of replacing steps leading to a sealed entrance? The Woods and Forests Department were not known for their aesthetics in the Cathedral grounds. It could be that on discovering the middle chamber to be a tomb filled with corpses they could associate more readily with them than the bones in the lower chamber they discarded over the cliffs. With this, it is possible they had the steps of the tower replaced as a mark of respect although we shall probably never know the reason.

As to when they were replaced, it was probably shortly after the 1868 opening. If we go back to Hall's interview regarding 1868, he says, "A few steps led up to what was discovered to be a door built up with thin stones". If the lower steps were still missing in 1868 it would make sense why they used a ladder to get them at least to the sealed entrance. Of course, they could have climbed, but Victorian middle to upper class gentlemen would have held a particular decorum on such matters, and climbing when there were alternatives was one of them. On this, Smith just says they "made an opening in the doorway sufficient to get in".

For the steps to be "laid bare" in 1868, also points to an accumulation of debris in this area after the photo was taken. It would appear a fair amount of debris existed, and was continually shifting around behind the eastern gable towers, along Hepburn's Wall and around the Square Tower. This is why following the 1826 opening, the built up door was not re-discovered until the late 1840s or early 1850s.

The built up door was discovered again in 1868, and for Linskill to say the steps were laid bare in 1888, also suggests debris had once again accumulated in that twenty year span. In 1889, a short article in the press mentions the following about the accumulation. "In 1888 the dirt and rubbish was cleared away from the bottom of the Square Tower, making it a few feet higher than formerly. The same was done with the pillars which extended the whole length of the nave". This work was no doubt carried out around the time of Linskill opening the tower.

The ivy along Hepburn's Wall was present for a great many years. The ivy clad wall in the first photo on p. 24 was taken sometime during the early 1900s. One of the graves in the photo dates to March 1905. The second photo taken in the 1920s shows how prolific the ivy was along the wall. The Lighthouse Turret can also be seen, which at that time was still active.

Chapter Fourteen

The Aftermath

For Sale to Local Builders...
1 Mile of Abbey Wall, Complete with 13 Large Turrets, Archways & Heavy Iron Gates!

The Cathedral was built in the form of the Latin cross. The present east/west gables are 100 feet high and the central Bell Tower, standing at its apex was 200 feet high. In 1561, the lead was stripped off the roof of the Cathedral and the weather soon beat into the fabric of the building. In the late 1500s this bell tower, suffering from the strains of the weather and neglect over the years, collapsed northwards taking with it half the Cathedral and Hepburn's North Wall west of the Lighthouse Turret and Haunted Tower. Soon after, the Scottish government and local council decreed the Cathedral ruins to be a quarry for the town's folk. There then followed a gradual but major construction operation in the town, as the majority of the wooden buildings west of the Cathedral were replaced or built anew with stone harvested from the Cathedral. Everything had a practical use. The damage caused is plain to see, and it is only by a quirk of fate that the ruins we see today still stand defiantly as a fragile relic to a former glory. This is because, due to an extraordinary occurrence, we nearly lost the Haunted Tower and much more besides.

In 1839, the Woods and Forests Department, looking to carry on the tradition of the precincts being a quarry, tried selling off the entire length of Hepburn's near mile long wall surrounding the Cathedral and the old Priory precincts to private individuals and local businesses. Alongside the wall, the sale included the 13 remaining turrets, the arched entranceways and the large gates. The idea was for the successful bidder/s to dismantle and demolish everything to use in construction elsewhere, thus continuing the 'tradition' or legacy of it being a quarry for the stonemasons since the collapse of the bell tower in the 16th

Century. So much for the 'care' component in the Woods and Forests Department remit for the ancient monuments.

The timing of the formation of the St Andrews Literary and Philosophical Society in 1838 couldn't have been better. Part of its remit was to prevent this kind of activity. "In December 1839 they intervened and prevented the Commission of Her Majesty's Woods and Forests from selling everything".[lix] If this society had not been formed, how far would they have gone? It is debatable whether anything to do with the precincts would have remained.

Desecration and Disrespect

Despite there being a respect for the deceased and a fear of the consequences of disturbing them, St Andrews has a long history where altruistic motivations had no bearing. Grave robbers, plying their gruesome trade, would steal bodies shortly after their interment in the Cathedral grounds. During the religious and political turmoil of the Reformation, the bodies of around 200 monks, Canons and Archbishops buried within the grounds were desecrated by 'the mob'.

Following the Reformation, when the grounds became a quarry, it was fashionable for wealthy lairds and families to be buried in the Cathedral ruins.

The memorials of dedication, dating mainly through the 17th and 18th centuries stand embedded in Hepburn's North Wall. In correspondence to the editor of the *Citizen* in 1894, David Henry says, "At the beginning of the 17th Century, people of rank – county lairds and Professors – appear to have been deserting the parish burying-ground in the centre of the town [Holy Trinity – 17th and 18th Century], and choosing for themselves "lairs" along the side of this northern wall, and erecting monuments on which they recorded the names and virtues of their dead".[lx]

It is also debatable whether any of the wealthy families including those of the Clephane's, no doubt interred in the grounds in front of this wall, and the townspeople buried in this area around Holy Trinity church for nearly three centuries are still present.

[lix] St Andrews University Library, MS, Minutes of the Literary and Philosophical Society, December 27, 1839.
[lx] The Haunted Tower, David Henry, *Citizen,* St Andrews, March 20th, 1894

From 1826, the Woods and Forests Department employed workmen to clear away the debris following centuries of neglect. They levelled the ground to make way for a new burial ground, and in so doing, unearthed great quantities of bones. These were the bones of the townspeople and a few well-known Fife families. Rather than rebury them elsewhere, Hall in his 1893 interview said, "About the time that the first entrance into the tower was effected we had been engaged in levelling down the grounds, and had lowered the surface for a couple of feet. At the foot of this tower we found a vault which was filled with bones. It was afterwards found that a sexton, picking up more bones than he could easily get rid of, popped them all through a little hole into the vault". He mentions 'bones' here rather than just skulls.

The ultimate fate of generations of townspeople and a few Fife families was extraordinary. For nearly three centuries, the town had been buried here (12th to 15th centuries). Added to this were burials along the wall from 1600 onwards. A great many of the remains that had survived ended up in the lower chamber of the tower sometime after 1826, and in 1868 they were "finally thrown over the brae into the sea". as Heddle put it. By the time Heddle arrived on the scene these other bones had already been discarded leaving only a few of the more unusual skulls behind. So the bones were moved in two stages, firstly from the burial ground into the lower chamber of the tower, and secondly, over the cliffs into the sea. The workmen of 1868 may not have known where the bones came from, but Hall did. He had been in charge for many years, he was present in 1868 and in commenting on the bones going into the chamber from the burial ground, he says himself "From time to time we had also thus engaged".

Rather than having no respect for the former occupants of the burial grounds they unearthed, they were just doing their job as suited the time, and they were not archaeologists, historians or antiquarians. Aside the bones, when clearing the grounds of the rubble and rubbish there was no sense of historical importance, and the methods they employed were as destructive as the stonemasons originally employed to quarry the precincts of this ancient and grand edifice. In the following years, through the efforts of the Provost, Sir Hugh Lyon Playfair and those in his association, the town once more began feeling the warmth and vibrancy it once enjoyed. This time it was not from the many thousands of pilgrims coming to view the relics of Saint Andrew, but from the tourists. When the railway came to St Andrews in 1852, they were attracted in their droves to the sea air, the golden sands and their newfound passion for the game of "gowf". St Andrews was given a "makeover" before and after this time, and this would always carry its own historical costs. Among the early improvements, town planners levelled the area of undulating land around Holy Trinity Church in South Street concealing the graveyard. The bodies originally six feet under the ground are now only two feet below the paving. Over 200 of the townspeople are still present under the area of Church Square, Logies Lane, the Town Library, and under the taxi rank in South Street in front of the church.

When these photographs were taken in the 1840s, the rubble and debris east of the vast ruins had mostly been removed. As can be seen, the grounds are already starting to fill with a new generation of graves of St Andrews residents. On the far left of the second picture the old Lighthouse Turret can be seen, and between this and the twin spires of the eastern gable, the famed Haunted Tower can just be seen protruding squarely above the wall.

Section Four...

The Treasure

Over the centuries since the Reformation, a great deal of the treasure from Cathedrals, Churches, and Monasteries across Scotland has been uncovered. A lot of which was hidden before the arrival of the Reforming mobs. The Cathedral in Old Aberdeen is one such example. By the time the Reformers arrived the most precious treasure was in the safe hands of the Earl of Huntly.

In 1559, when John Knox was on his way to St Andrews from Perth, a great many pilgrims were still congregating in St Andrews and taking in the daily services at the Cathedral, which housed the largest collection of Medieval Art in Scotland. To date barely even a coin has been found. So what happened to all the treasure?

Like the theory of Saints being hidden by the monks in the middle chamber of the Haunted Tower, is it possible the relics of St Andrew and the precious treasures of the Cathedral were also hidden somewhere within the precincts? If this were the case, the majority of the treasures destroyed were simply the items used for the daily services, including the movable shrines of saints, carried through the town twice weekly.

Chapter Fifteen

Hidden Away

The Howkings

In 1842, whilst clearing away the Cathedral rubble from when the grounds were a town quarry, workmen found a narrow spiral stairway leading straight down underground. The stair was made of white marble and looked as new. Eighteen people saw this stair at the time, yet none would venture down to see where it led as the workmen were scared of evil spirits. The depths of the stair was described as being pitch black and filled with noxious smells. The workmen asked Greig what to do with what they found. When he saw the stair, he said it was "probably just a stair leading to the sea" and told them to fill it in. This they duly did, pilling tons of rubble and rubbish down it. This became known to the Victorians as "The Wee Stair".

Linskill believed under the Cathedral there was a network of underground passages and chambers where they hid treasure in times of uncertainty. He was aware of the Wee Stair and the discovery of a passage at the Archbishop's Palace in 1879 strengthened this belief. He was sure the passage led to the Cathedral and with its discovery, he formed the St Andrews Antiquarian Society. One of their main objectives was to look for the lost treasures of St Andrews. To fund their projects he put on classical concerts and plays at the Town Hall in South Street.

Known as 'The Howkings', the projects involved digging up the old quarters of St Andrews. It was during the digs that he discovered the tombs of Archbishops by the High Altar, and the stone cists in 1904 of 14th Century Priors in the Chapter House. However, none of this is what Linskill or the town were looking for. He did find evidence of chambers and passages, a lot of which had caved in, but the treasure eluded him and the town. There was a problem however. His methods were primitive and from his reports, it would appear he didn't dig deep enough.

Linskill was the driving force and enthusiasm of the project and when he died in 1929, the project died with him.

Since that time, everyone has forgotten how he and the town looked for the lost treasures for 50 years, so in modern times, everyone has resigned themselves to the premise that the Cathedral was ransacked and the treasures were destroyed.

Underground Passages and Chambers

With the Cathedral taking 158 years to build, there was also 158 years to create passages and chambers underground. Linskill certainly believed this, and partly based his initial theory for their existence in St Andrews on the subterranean passages and chambers he was aware of in Cathedrals across Europe.

In Europe, they hid the most valuable treasures underground when trouble was looming, believing whatever occurred would soon pass. Like Linskill, I believe they did the same in St Andrews.

Linskill says, "I am accustomed to seeing crypts below great churches, and shall be very much astonished if I do not see one shortly here at our Cathedral. The altar plate of most churches, abbeys, &c., in Scotland can be accounted for; St Andrews valuables mysteriously vanished into thin air – and where?"

The following short article was written in the press in 1888...

"It is a fact worthy of note that at the time of the Reformation the Cathedral altar plate which was of great value, disappeared entirely, and has never been accounted for. It is improbable that it was melted down, for many reasons, and as its existence at the present day is unknown, it seems just possible that it may be hidden somewhere under the ruined Cathedral. This may, of course, be only an idea, but surely an idea worth following up".

I do not know the author of the above piece. It was an Antiquarian, but it wasn't Linskill as there was a third party mention of him later in the same article. Another article, this time in the press of 1889, also with no cited author has the following...

"The existence of this altar plate has been placed beyond all dispute, and there is no doubt at all that it disappeared in a curious and remarkable manner at the time of the Reformation. It has been said that it is now in the possession of the Pope, but to me it seems much more probable that it is hidden away in the crypt, in all probability beneath where the High Altar stood".

It has been suggested to me that they would surely have taken the most valuable treasures away by sea. Although this is possible, it isn't

something Linskill or the town of St Andrews believed. St Andrews at the time was the greatest seat of power in Europe outside Rome itself. The Catholics had been in power for over four centuries and had no conception of being completely overthrown. Believing whatever would occur would be a temporary measure, it would make sense for them to hide as much as possible underground and perhaps even in Hepburn's Wall, another possibility that can't be ignored.

Following his description of the dedications, Linskill in his series of articles "The Howkings", this time from December 1903, continued with an illuminating report of what some of the treasures from the Cathedral would have comprised. I believe his report is based on what is usually found in other Cathedrals as there are very few surviving records from this period of Catholic rule, but of itself, it makes for quite a comprehensive list. He says, "These altars would all be richly adorned with crosses or crucifixes, numbers of candlesticks and tapers, and handsome reliquaries. Then there would be chalices, patens, cruets, ciboriums, monstrances, lunettes, pyxes, censers, and ships, acolytes, candlesticks, processional crosses, lavabo basins, a paschal candlestick, tabernacle or sacrament house, alms dishes, banners, lecterns, gospel desks, bells, sanctuary lamps, &c., likewise richly jewelled vestments, tapestry, frescoes, carving, sculpture, mural paintings, font pulpit, holy water stoups, and the like – all now cruelly swept away, or more likely hidden away. Doubtless, also, there would be many handsome tombs to bishops and priors, also sacred shrines and jewels. It is sad to see it now, a desecrated, roofless ruin, but with traces still of its past grandeur and stately beauty. Its bells they say, lie sunk in St Andrews Bay, but this fable is told of Aberdeen, Elgin, Aberdovey[lxi], and many other sacred buildings. Future excavations, I am in hope, may lead to the most interesting historic discoveries, and lay bare much that still lies buried beneath the grassy turf of our great Abbey Kirk".

W. T. L.

Linskill records some interesting thoughts on the altar plate and other treasures in the *Citizen* of December 1903, which gives a greater understanding of his long-standing enthusiasm for his "howkings" around the Cathedral.

[lxi] On the west coast of Wales

The Antiquarians are not simply searching for ancient plate, crypts, passages, and the like, they are looking for anything that may throw light on the historic past of this beautiful old city. Many ask and have asked "Where is the alter plate?" Much of it is certainly "somewhere". The priests' first and natural idea would be to conceal it in some capacious hiding-place or strong room, and the [very] short notice which they had of the approach of the mob would necessitate a very speedy removal thither. The clergy and monks [the ecclesiastics] could scarcely have contemplated so immediate and total a destruction of their grand [great metropolitan church] and holy Cathedral, and with it the complete overthrow of their religion; but would merely expect the affair to be a passing tumult. Therefore, the object was to place all the [sacred valuables] jewels, relics, vestments, plate, &c., in a temporary place of safety, cunningly contrived, and well concealed. The [very] short notice would also prevent any attempt to ship even a small portion of them [their valuables] away. Such a process being at all times and more especially in those days a slow and arduous task. The coast also was well guarded by the Protestants in the Castle.[lxii] After the great destruction, St Andrews sunk down from its great past into a mere insignificant fishing hamlet. The stones and rubbish of the Cathedral lay piled high, where they fell until Government took over the ruins in 1826. Is it not most probably that the crypt, strong-room, or call it any name you like, still lies buried awaiting exploration? I, for one, certainly am of that opinion. Besides the Castle and coast were in the hands of the Reformers' I am, sir, &c., W. T. L

The following letter in the *Citizen* is by a Mr S.C.L of Oxfordshire, in reply to Linskill's letter dated December 1903 above. Oddly his reply didn't come until some 16 months after Linskill's letter as it is dated 13th April 1905.

[lxii] Linskill is referring to when the Reformation was actually taking place. Along with ransacking the Cathedral they besieged the Castle and would also have taken control of the port. He is speaking from a stance of the monks having "[very] short notice". Not thinking they may have removed and hidden the most valuable artefacts before the three day run up to the ransacking of the precincts.

ST ANDREWS CATHEDRAL RELICS
(To the Editor.)

SIR, - "W. T. L". Cannot understand how or why the relics (if any existed) were removed from the Cathedral at the Reformation, *How*, of course, we cannot say. *Why*, seems simple enough. Take a case at Dunfermline. St Margaret was buried there. But, in the turmoil of the Reformation period, her relics (or remains) were taken away, to avoid desecration, to Paris. They fell in evil case in Paris, for the Revolution of 1789 the bones were scattered wide, and no one knows exactly where they are. Some, indeed, maintain that they are at the Escurial, near Madrid, the last resting-place of the Spanish Kings. Catholics do not trouble themselves much about it, for "The Lord knoweth them that are His," and "He keepeth all their bones so that not one of them shall be broken," and, somewhere Margaret awaits that day when "He shall come to be glorified in *His Saints*, and to be admired by them that believe". Now it is quite possible that some, at least, of the St Andrews relics were taken to Amalfi[lxiii] for safety sake, and to Amalfi because there rests the body of St Andrew. Moreover, as a Catholic Chaplain (retired) to the Forces told me, the tradition at Amalfi Cathedral is that many relics, or other treasures, came many years ago from Scotland. And there is at Brussels or Bruges, a famous image which once belonged to Aberdeen Cathedral. So, as the Reformed Churches, Presbyterian or

[lxiii] The surviving relics of St Andrew are housed in a number of places across Europe, and smaller relics are scattered throughout the world. St Andrew was crucified in Patras in Greece, and aside the six bones said to have been hidden by St Regulus in Patras and brought to St Andrews, the rest were taken to Constantinople (now Istanbul) in Turkey. In 1208, the remaining relics were taken to Italy and Greece. Amalfi in Italy is where St Andrew was born and Amalfi Cathedral houses some of the relics, as well as some of those of St Peter. Some were also taken back to Patras and are housed in the Basilica of Saint Andrew the Apostle. St Mary's Roman Catholic Cathedral in Edinburgh also houses two relics of the Saint including part of his shoulder donated by the Cathedral in Amalfi in the late 19th Century and another relic given to the Cathedral by the Vatican in 1969. The Church of St Andrews and St Albert at Warsaw in Poland also houses some of his relics of St Andrew. Maybe one day St Andrews will once again host a relic that shook a nation and became its namesake.

Episcopalian, have no use for relics, it seems natural that such should be removed to Catholic countries where they would be valued and venerated. Of course, they may not have been taken away from St Andrews, but I think had such treasures existed they would have been looked for, and discovered, long ago. – I am, Sir, &c.,

S.C.L, Oxon.[lxiv]

Linskill in his letter of reply one week later on 20th April 1905 picks up on a few points made by S.C.L.

ST ANDREWS CATHEDRAL RELICS
(To the Editor.)

SIR, - I notice in last week's Citizen a letter on the above subject signed "S.C.L., Oxon". I think everyone, in a sort of way, venerates old relics, whatever faith they belong to. They may consist of some bit of china, a photo of some long dead relation or friend, or a crucifix and the like. The stuffing of pets, such as dogs, cats, and birds is a sort of love of relics, and they are often enshrined in handsome cases. Personally, I must say I greatly revere relics – of all kinds. Regarding the plate, relics, vestments, and other valuables of this noble Cathedral, I have dealt with the matter in an article called "Underground St Andrews," in Chambers Journal, August 1st, 1904, to which I refer "S.C.L". I do not think a sacred relic of the past is out of place in any Christian building. Crypts, and subterranean strong-rooms were in troublesome times almost matters of absolute necessity, equivalent to the modern bankers safe. In regard to the precious and sacred ornaments at St Andrews Cathedral, the priests' first idea would be to conceal them in a capacious hiding-place or strong room... I am, sir, &c.,

W. T. L

His letter continues, but it is a repetition almost verbatim of his earlier letter of December 1903. I suspect he did this to reinforce his original

[lxiv] "On 5th April 1885 the R. C. Church of St James was formerly opened on the Scores Road, to the east of the Martyrs' Monument. It was erected at the sole expense of the Marquis of Bute, and is seated for 300 – all free. A neat presbytery is adjacent, and is the residence of the Rev. George Angus, M.A. Oxon., the first resident Roman Catholic priest in St Andrews since the Reformation". Citizen, 1885.

argument, as nearly a year and a half had passed since his original letter was published.

ST ANDREWS CATHEDRAL RELICS
(To the Editor.)

SIR, - I think "W.T.L". in writing uses the word "relic" in a sense different from what I mean. Old china, photos, crucifixes, may be valuable and interesting, but are not relics. A crucifix is an image, or a representation, but not a relic. By "relics" we mean, in church language, the bodies of Saints, or fragments of the same, and, as secondary relics, portion of their clothing, &c. Such, no doubt, were venerated in the Cathedral here, and, indeed, mass cannot be said except on an altar stone, or slab, in which relics are enclosed. But all these things were done away with at the Reformation. Other relics, apart from those in altar stones, are placed in frames or settings of more or less precious metal: these are called reliquaries, and some of them may possibly be found in the Cathedral precincts, although I think this is very unlikely. The relics themselves, apart from the frames, might easily have been carried away in small boxes, the size of snuff-boxes or pill-boxes, and the gold or silver frames (reliquaries) might have been left behind. That any *relics* will be found I absolutely disbelieve, and if they were found, how are we to know what relics, or whose relics they are, or if they be relics at all? There is not, now, any possibility of their verification, or authentication, and, whatever other people may do, Catholics are not permitted by Rome to venerate relics which may be spurious, or which lack Episcopal authentication. As to the *reliquaries*, I think that (1) if they were left behind they would soon have been converted into coin and cash, because empty reliquaries are of no use to Christians of any denomination. And (2) if they were buried or hidden, surely it would not have taken 350 odd years to find out where they were. However, they *may* be found – the frames, or reliquaries, which contained relics, but, apart from their pecuniary value, I do not think they will be of much interest, as it seems hardly possible to know what relics they contained unless some legend or inscription be found upon them, which is improbable. – I am, Sir, &c.,

S.C.L., Oxon.

Linskill gives an insight into the perception of the day when he says, "the Antiquarians are not simply searching for ancient plate, crypts, passages, and the like, they are looking for anything that may throw light on the historic past of this beautiful old city".

In S.C.L's last sentence above, he says, "Of course, they may not have been taken away from St Andrews, but I think had such treasures existed they would have been looked for, and discovered, long ago". S.C.L is coming from the angle of Linskill looking for the relics of St Andrew as part of his howkings in and around the Cathedral grounds and not finding any. Indeed, he was looking for the relics, the Cathedral treasures and "anything that may throw light on the historic past," but it appears as I mentioned earlier, he didn't dig deep enough.

The "Wee Stair"

With 18 people having seen the Wee Stair, its existence was not in question. Sometime after 1879, Linskill gathered together those who were still alive that had seen this Wee Stair, to see if they could rediscover its location. Unfortunately, they couldn't decide on its location. With so few landmarks in the ruins, it doesn't seem possible they could have been so disorientated, but back in 1842 the site looked quite different. There was more structure to the ruins then than now. Some of what was still standing was in a precarious state and pulled down. Also despite the Cathedral stone being used throughout the town, a mountain of rubble and stone was still in the grounds. With the grounds cleared, levelled, and landscaped, everything had dramatically changed.

The Scotsman and other papers carried quite a number of articles of correspondence by Linskill and others on this matter. There was far more than is relevant to this present work so I leave that to a future publication, but in concluding his letter in reply to George Angus in 1894 concerning saints, Linskill says, "If anything is concealed in St Andrews, I think it lies in some subterranean, rock-hewn chamber below the east end of the old Cathedral. When I bored there some years ago with a long miner's rod, the rock seemed remarkably *hollow*, giving off a drum-like sound. Dr Lonie, late master at the Madras College, pointed out to me a place at the east end of the Cathedral, where, during some excavations, he had seen steps going down into the ground [the Wee Stair]. Possibly, Mr D. Hay Fleming may have taken notes of the exact information given by Dr Lonie, as I think he told him about

the steps first. A similar staircase is said to have been seen in the neighbourhood of Mr Stirling's house [I believe this may have been a house that stood in the eastern end of the Cathedral grounds near the main entrance]. There can be no doubt that many of those who were associated with the construction of the wonderful subterranean crypts and passages at Hexham, Ripon, &c., were also connected with St Andrews and its ancient buildings. If at Hexham, Ripon, and elsewhere, why not at St Andrews? – I am, &c.,"

W. T. Linskill
48 New Square, Cambridge, 1894

**Dr William
Oughter Lonie**
circa 1857
(1822-1894)

The following is from Linskill to the *Scotsman* newspaper in November 1903. "A pit is now being dug at the extreme east of the building from north to south to find the stairway seen by Mr Lonie and others. I can remember his words perfectly well, when standing at the east end of the Cathedral, he told me of the narrow subterranean steps going down into the ground, which were soon covered up, as the people said it would only be a way to Lady Buchan's cave or the sands". The one who said this was George Greig, head of the Woods and Forestry Department at the time.

Linskill writing at the beginning of 1904 in one of his Howkings letters says "Mr George Greig has given the society a very minute description and measurement of the subterranean corkscrew staircase

near the high altar, which he saw filled up 62 years ago [This places his report to the society as being 1888, the same year Linskill went into the middle chamber for the first time], and which seems to have been found by Dr Gillespie and Dr Buist, and filled up by Scott, the gravedigger, and others. He says the steps were covered with a kind of white tile, and he saw two Gothic arches with scrollwork, and a sort of shaft all below the surface. Dr Lonie and several others have described the same staircase exactly; but as yet we have found no trace of it".

Elsewhere Dr Lonie spoke to Linskill of "the extreme narrowness of the steps, and a nasty deep, dark hole, did not smell pleasant, very close, musty and bad, and they wanted to keep down evil spirits". It was also said, the steps looked fresh and had a ventilation shaft running alongside. The ventilation shaft is very important. Whatever was underground was clearly at a depth where they needed an additional supply of air to that of the stair itself.

In 1904 the search continued, a small team of workmen headed by Linskill dug in and around the Chapter House. He was in the papers on numerous occasions for his discoveries, including his finding of the stone cists of the Priors from the 14th Century we see today in the former Chapter House. Unfortunately, in all his digs, the Wee Stair wasn't one of his discoveries and still remains hidden from us today.

A great deal of material exists about the Wee Stair, about underground passages, chambers and the general howkings of Linskill and his St Andrews Antiquarian Society, which again I leave my research over the years to a future publication, *The Lost Treasures of St Andrews*.

If they hid Cathedral treasures underground, why didn't they also hide the coffins underground? Surely, that would have been the safest place. The only suggestion I can put forward is the access to the stairs leading down to the chambers or crypts were too narrow, steep and awkward to give access to the coffins.

Section Five...

The Ghosts

The young lady in the tower had been embalmed and occupied one of the ancient oak coffins. She wore white calfskin leather gloves, a long white silk dress and preserved as in life, she was as beautiful as accounts of her ghostly spirit suggest.

How widespread her importance was when alive or became following her death currently remains a mystery. It is fair to say she was a young Catholic woman of great importance, who, for her unknown labour in devotion and deed stole the heart of the people, and in all likelihood became a saint. Her body was preserved and may have been displayed in her own chapel or more likely, in an altar dedicated to her in the Cathedral. Nobody knows her name, and nobody knows how or when she died.

Following centuries of devotional prayers by pilgrims and monks, she was removed from her resting place to a tower dedicated to the Virgin Mary. Entombed perhaps with other local saints she lay in silence as a protection against possible desecration. Undisturbed by the Reformation, here she was forgotten for at least six centuries, but our beautiful Lady in white was never at peace...

Chapter Sixteen

The White Lady Ghosts
& Associated Experiences

We now move to an investigation of the White Lady apparitions over the centuries, together with strange incidences occurring in the area of the Haunted Tower, plus details and accounts of other female apparitions in the vicinity of the Cathedral and Priory Precincts. Some of these are also of White Ladies. Alongside their appearances are two Green Ladies, two Black Ladies, a Purple Lady and a Blue Lady, the colour of the dress determining what these apparitions are generically called.

Following the Second World War and a rebuilding of lives, everyone moved on from the legacies of the past. Victorian fears of the White Lady could easily have been lost to new generations, however, Linskill's stories were popular and her ghost was still being seen in the vicinity of the tower. Coupled with this, the continuing warnings to the unwary displayed how real she still was in the minds of those living in the town.

The following is a quote from a lovely elderly woman I met many years ago who saw her after the war. What she says sums up the dichotomy between those who have experienced her and those who have not and consequently hold a sceptical air as to her reality. She said, "oh yes, she is down there, but nobody really believes she exists".

The Phenomenon

As of October 2015, the following list is not only the most current and comprehensive there has thus far been of reported sightings and incidences connected with the White Lady in the vicinity of the tower, and other female ghosts around this old quarter of St Andrews, it is the only list.

There will certainly be many experiences I have not thus far been able to amass and I have not included additional references of her existence from the press of 1894 and beyond.

Apparitions within the Cathedral Grounds

1 White Lady seen by three fishermen (early Linskill, 19th C)

2 White Lady on the cliff side – near Haunted Tower (Linskill) 1911

3 White Lady disappearing into Haunted Tower (Linskill) 1911

4 White Lady on the cliff side – at the Haunted Tower (local woman) 1940s

5 White Lady in the ruins by the Haunted Tower (Grant/Hodges) 1968

6 White Lady in the ruins by the Haunted Tower (Stevenson) No date, but before 1973

7 White Lady walking in the ruins by the Haunted Tower (MacDonald) 1975

8 White Lady by the cloisters (authors account) 1978

9 White Lady by the cloisters (authors account) 1981

Strange Incidences Connected with the Haunted Tower

10 Feeling of arm being pulled into the tower (visitor) 2014

11 Feeling of arm being pulled into the tower (school pupil) 2015

12 Feeling of muscles in arm tightening (Plowright) 2014

13 Camera shutting down (American woman) 2014

14 Camera phone shutting down (Pete Rankin) 2014

15 Photo of skull in lower chamber 2014

16 Millie the dog seeing or sensing something at the Haunted Tower 2015

17 Human shaped shadow by benches across from Haunted Tower 2015 (author & tour party)

Apparitions along the East Scores Path and Castle

18 White Lady walking across path of Gregory Place end into bushes by East Scores path west of the Haunted Tower (visitor) 2015

19 White Lady on the cliff side between the castle and turret (Linskill) 1911

20 White Lady walking along the East Scores path above St Rule's Cave

21 White Lady walking along the shoreline by St Rule's Cave towards Castle

22 White Lady walking 10 feet straight out to sea from Scores path above St Rule's Cave before disappearing

23 White Lady in the courtyard of St Andrews Castle (Historical)

24 White Lady illusion in the Castle (author and 11 others) 2014

25 White Lady illusion in the Castle (author and 14 others) 2014

Two Apparitions along Kirk Hill

26 Apparition walking along the wall from the harbour turret west towards the Haunted Tower (students) 2013

27 Green Lady on Kirkheugh or Kirk Hill (Kilpatrick) 1988

White Lady Apparitions of the Pends

The Colourful Apparitions of Queen Mary's House

Terminology

I use the words ghost, apparition, spirit and impression throughout, and was asked if they all referred to the same thing – a ghost. All of them can be called ghosts or apparitions, which are generic terms for spirits and impressions, but these latter two, are not the same. Spirits are of the deceased and are aware of their surroundings and others, thus it is possible to communicate with them. Conversely, impressions have no awareness. They are energy imprints of incidents making their mark on the fabric of a locality, a recorded image from another time, an impression. They can also be images from another time occurring in present time, as past, present and future are all occurring all of the time, but that leads to its own complexities so I leave it for another time.

Her Ghost

Even after so many years since the first opening, we still have many loose ends about the mysteries of this tower, but through the unravelling of articles, the basic facts were being established and in the words of the *Telegraph* article, "It will be observed that there is a substratum of truth in the *Saturday Review's* story, but the vast and gruesome superstructure, on the first inspection, melts "into air, into thin air," leaving a very matter-of-fact story behind. Although some of the smaller points raised are not altogether clear, [partly because they

took the 1826 opening to be the 1868 opening, and partly because the descriptions were generally quite vague] the main facts, which have been known to several gentlemen for some time, are explained, and the tower finally robbed of its terror".

The facts were indeed there, buried in the minefield of testimony, they just related to different times. The main facts being that preserved bodies were in the tower, including that of the White Lady, interred in coffins dating from different centuries. As to the bold statement made by the newspaper that the tower was "finally robbed of its terror," well, that is a different matter. Despite the *Telegraph* interviews being called '*The Haunted Tower of St Andrews*', it never covered the paranormal side of the mystery. Hall was the only one in the article to mention her, saying as I quoted before, "People had been in the habit of calling the place the Haunted Tower, and when going to the harbour they ran past it". So despite the piece being written with a view to "laying the ghost," it had the opposite effect. Through these articles, she became no less active, and a lot more famous.

Areas of incorruption are frequently associated with paranormal phenomenon through visions, dreams and strange lights appearing around the gravesite. Other characteristics include unusual aromatic smells and the incorruptible person appearing as a ghostly manifestation. The latter being the case here regarding the apparition within the Cathedral precincts.

For reasons currently lost to us, she has startled the town with her sudden appearances for a lot longer than we are aware. It is more than conceivable she has been appearing in this area for many centuries, and quite feasibly for a number of centuries before the Reformation took hold. Early appearances of her would have added a mystique and dramatically increased her importance and devotional veneration.

Her body being secretly removed from the tower sometime between 1868 and 1888 has done nothing to abate her appearances in this quarter. She remains as active as ever.

A Few Facts about the White Lady Apparitions

The White Lady always appears when least expected. In other words, rarely pandering to our expectations this is not appear on demand phenomenon, and warnings to the unwary not to pass by at night only give half the picture, as she can make herself known just as readily during the day. Moreover, contrary to local belief, it doesn't have to be

a full moon or the time we celebrate the dead and call 'All Hallows Eve' or 'Halloween', for her to appear. She appears at any time of the year. Her ghost has been seen more times than any other apparition in the town, which is why she is the most famous apparition in St Andrews.

Many believe there is only one White Lady apparition here, but there are at least 12 locations where they have been sighted, shared between at least five different ladies. There were 11 locations until March 2015, when a woman who came on a ghost tour of St Andrews gave me an account of one she saw standing at the top of the Pends Road as recently as February 2015. I had not heard of her being seen at this location before.[lxv]

The majority of the apparitions haunt areas around the Priory precincts, Cathedral precincts and Castle, and once experienced, it is hard to dismiss their reality.

Animals are especially prone to experiencing the unseen around us. Eddie McGlinchey, an elderly gentleman living not far from the tower, and who I have the privilege of meeting almost every night on my tours takes his wee dog 'Millie' for a walk by day and by night along the East Scores pathway. Sometimes, when they are alone, on nearing the tower Millie will stop, growl and put out her paw as if trying to make friends with someone unseen. Well, we can dismiss her behaviour, but this is the only spot where she does it, and she does not do it very often.

Miss Robertson

I remember when young being told about the White Lady ghost by Miss Robertson, an elderly lady, who, until her death in the early 1980s lived near the bottom of Largo Road.

A heavy boned industrious woman, she had a sharp wit, Victorian ideals and took no nonsense from anyone. She had lived in St Andrews all her life and had never married.

Whenever I visited her, the house would always smell of something boiling on the stove. Once a week when she received her pension, she would visit the local slaughterhouse just up the road (now the Premier Travel Inn) and buy half a sheep's head. It was cheap and she would ensure none of it went to waste over the course of the week. She used it in stews, sandwiches, as a stock for soup and I am sure in a number of other ways I dare not think of.

[lxv] Refer to p. 228

We were talking about ghosts one day when she was once again preparing something in the kitchen. I always remember leaning against the kitchen door as she talked about the ghostly women down the Cathedral. She could become very animated, and on this occasion whisked a wooden spoon she was using to stir something in the pot on the stove and before I knew it, it was in front of my face being waved around as if conducting the start of Beethoven's Fifth. As the spoon dripped a kind of brothy like ooze onto the lino-covered floor, she sternly warned me not to walk over the Kirkheugh after dark". She took reports of the White Lady very seriously and for her, the dead like so many was not a subject to be meddled with. Her mother had also spent all her life here and passed on stories to her of how a ghostly woman haunts the cliffs and "that strange auld tower" as she put it. This was handed down to her mother by her mother when she was young and they lived in the old fisher cottages by the Cathedral. This takes the legend back to at least the late 1700s early 1800s, and a time before the Cathedral grounds were levelled by the Government in 1826.

She told me, "I forgot one night about the ghost. The tower loomed ahead and I soon knew why nobody else was on the path. It filled me with an awfy feeling of dread". She paused for a moment then said with a laugh as she waved the spoon around like a professional fencer, "I soon got past that tower. My heart was fair racing away with me. I was glad to get to the lights of Gregory's [by North Street] and back to the land of the living!" I wasn't so much bothered about avoiding that path after nightfall, as eerie as it could be in the dark, especially when the haar was looming in from the cold North Sea. But her words were influential, and they had an impact on my mind. Admittedly not the impact, nor influence she was intending. If anything, her convictions strengthened my belief of her reality. She gave me an additional enthusiasm for spending more time than I would probably otherwise have done around that old tower after dark. On the other hand, I was certainly one for avoiding her cooking. Even though it generally had a homely smell to it, I knew what her main ingredient was and that stopped me from indulging. She always offered to feed me and I always politely refused, making my apologies that I had either just eaten or was about to when I got home. Sometimes neither was the case, but for all the good heart Miss Robertson had, the fear of the unknown for me wasn't for the White Lady, so much as what I could have been presented with at the table in her dining room!

The Gun Loophole and the White Lady's Hand

In much the same way as a wishing well, people throw money through the middle gun loophole into the lower chamber of the Haunted Tower. When people see money they follow suit hoping the White Lady will grant them a wish, but throwing money into the chamber is a recent phenomenon, not a traditional one. The tower is dedicated to the Virgin Mary so a token could be given for a number of different reasons, but in death, it is very doubtful the White Lady would grant anyone a wish, that is certainly a myth.

That St Andrews legend Miss Robertson used to tell me was if you put your hand in one of the slits of the Haunted Tower, someone might grab it!

Anne Morris a Trustee of the St Andrews Preservation Trust I spoke of earlier in connection with the photo of the hand, told me a slight variation on this. As a child, if a few were walking past the Haunted Tower they would dare each other to place their hand into the gun slit of the Haunted Tower and shake hands with the White Lady. I always invite people on my tours to do the same. Surprisingly, in not knowing what to expect very few take up the offer, but a number have experienced something when they have and it is always the same thing.

The last time was on Easter Saturday 2015. I had 43 people on an evening tour including 30 school pupils aged between 10 and 12. All of them were eager to place their arm through the gun loophole. It only happened to one of them and she experienced something she would

never forget. A young girl burst into tears and it took three teachers to console her. It doesn't shake your hand, it grabs your wrist and tries to pull you into the chamber. Apparitions of the White Lady aside, it could be any number of things that tries to grab the wrist, as this is where nearly three centuries of towns people ended up before being discarded over the cliffs into the sea.

A Delayed Realisation

As so often happens with paranormal phenomenon, the mind doesn't start querying an experience until after something unusual has taken place. It can take a while to digest and think about what has actually occurred. The following is one of those accounts and forms one of a few such occurrences experienced on my tours. This particular experience was in the autumn of 2014.

Hi Richard,

My wife and I took one of your tours on Monday, and thoroughly enjoyed it. I'm afraid the pictures I took through the hole at the side of the Cathedral are bog standard. If you ever want to know the numbering on the pipes there, I'm the man to consult.

There was, however, oddness that we didn't consider until later. When Lynn put her hand through the hole she felt something brushing against it. As you'd said people often felt grabbed, she didn't think about it at the time, but later felt it was strange. My experience was while standing upright by the hole. Even before I bent down to take photographs, I felt a tightness in both of my upper arms. I've not had this feeling before or since, and to start with ascribed it to hanging a rucksack off my shoulders for four straight days. The feeling was as if I was being gripped internally and the arm muscles were being squashed against the bone, rather than any sensation of the arms being gripped around the surface. This wore off fairly rapidly in my right arm, but continued for longer in my left. I remember still feeling it when we were talking outside the house Mary Queen of Scots used.

I appreciate e-mailing you now when neither of us mentioned anything at the time may appear odd. In my case, this was because I attributed it to muscle fatigue. It wasn't until the feeling disappeared and I realised it wasn't due to carrying a bag around that I began to ponder what else it might be.

If you consider this all to be fabricated after the fact nonsense, I quite understand. I'd be suspicious myself under the circumstances, but better to let you know in case others later experience something similar.

All the best,
Frank Plowright

A woman on one of the tours put her arm through, just as a party of people passed and one accidently dropped a coke can. With the fright she got, I thought I was going to have to phone a doctor!

The Gun Loophole and Photography

On some of my tours, people have tried taking photos through the loophole into the chamber. When they do something completely shuts down their camera. It only happens when the camera or camera phone is put through into the chamber itself as if something doesn't want them to take photos.

As an example, an American woman on a tour in 2014 put her digital camera through. She was laughing and joking as most do. We then heard her zoom lens extend and withdraw and her camera completely shut down. Her camera has never done that before. She stopped laughing then.

To give an example with camera phones, Pete Rankin of St Andrews came on a tour with his partner and children. He put his camera phone through to take a picture and something completely shut down his phone. He tried this three times and each time the same thing happened. For the fourth time, he fired up his phone and showed us all it was on. His fingers were not near any buttons and he only put the phone through for less than a second, when he brought it out it had done it again and completely shut down.

A Shadow in the Light – The East Scores Wraith

In the dark, the Scores pathway to the harbour can be eerie enough under electric light, but before its introduction, under the gas lighting it would have attracted its own atmosphere and expectation for something of a supernatural nature to occur.

When the Lighthouse Tower was in operation it had a fixed beacon directed out to sea. This would have lit up this whole area of pathway.

Despite this, the Victorians still never ventured down this way after dark.

I have had tours when the lights along this stretch of pathway running alongside Hepburn's Wall have failed, it can then be so dark the pavement can't even be seen.

On two of my tours, one in July and one in August 2015, whilst walking with parties of people along Gregory Place to the Scores Path and the Haunted Tower, we have seen the black shade of a human standing by the Cliffside Wall between the street light and the bench diagonally opposite the Haunted Tower. After a second or two, it moves toward the streetlight, where diffused by the light it vanishes. Its height is around 5 feet, with a light build and no features to determine if it is male or female.

A Hotspot of Activity by the Lighthouse Tower

The stretch of wide pathway between the fork in the path to the front of the side gate by the Lighthouse Tower has a very unusual feel at times. Covering an area of only around 30 feet, this area of pathway can be likened to walking into a freezer. I have experienced this myself on a few occasions and generally, there will be a very heavy, oppressive feeling

The Scores Path to the harbour with the affected area of pathway in the foreground, followed by the side gate, Lighthouse Tower, and Haunted Tower on the right and the street light and bench on the left

accompanying the cold, one completely different to anywhere else along this stretch.

This phenomenon has been noticed and mentioned by people numerous times on the tours and only then have I mentioned what

myself and others have experienced. Some have a sense of fear when they reach this location, whilst others have a sense of foreboding. This is especially pronounced for some, and a few on reaching this spot have been reluctant to venture any further towards the Haunted Tower.

The wind at this spot can also be very unusual. A gale will blow in this small area when all around is completely still. One evening in July, a few of us experienced this on two back-to-back tours when coming along here. We dwelt for a while at that spot. There was no reasoning as to why it should feel so different.

Thus far, it has always been dark when a change has occurred.

Interestingly, this is just between the stretch of pathway where the White Lady comes out of the gate and where she has been seen on the path by the bushes.

An early photograph of the Lighthouse Tower in operation, with the Haunted Tower on the left

The Experiences of a Young Ghost Hunter

I have always been fascinated with anything associated with the supernatural. From the age of thirteen, I would often go to the Cathedral ruins in the dead of night, and with a deep breath jump over the low western wall and wander the grounds. Many have done the

same over the years and experienced how the expansive blackness of this quarter soon diffuses the glare of the street lighting. The effect gives a defined sense of removal from the rest of the town.

From well within the precincts, sounds of laughter and shouting occasionally filter through the night air, and I would see the odd stray party come over the entrance wall in the distance, no doubt as a dare or bet. They would laugh and joke, but with all their bravado, they would not stay long or stray far from the comfort of the nearby street lighting and the familiarity of their friends.

Whilst wandering the grounds I would think of William Linskill and his ghostly tales and wonder what was hiding in the cold dead of night. My slow pace through the ruins matched those of my wandering thoughts of how the Cathedral must have looked before the Reformation took hold. Attracting up to 30,000 pilgrims a year, this was a great seat of power and a deeply holy and peaceful place for hundreds of years.

As with so many spiritual places there is always something very calming about being within the grounds, one bringing to mind feelings that this was indeed a haven in which to contemplate matters of other realms. I would often go there when I was young with a question in mind and walk out with an answer.

Over the years, I spent a great many nights wandering its precincts, and occasionally others dared to cross the threshold into this quiet sanctuary with me. It was on such a night in 1978, I persuaded six of my classmates to accompany me on a nighttime visit in the hope of catching a glimpse of the Phantom Monk, the White Lady, or some other famed apparition described in the pages of Linskill's famous work. On this occasion, we assembled outside the main entrance to the Cathedral grounds around 9:30pm one cold October evening. For a bunch of thirteen year olds, this was definitely unknown territory.

On this particular night, a cold bitter sea breeze whirled around the graveyard so we were not up for staying there all night. After wandering around for a couple of hours, we sat for a time on the grassy slope just to the right of the main entrance for a rest. By this time, we were so engrossed in swapping ghostly tales it never bothered us the grass was slightly damp. There was nothing quite like a few stories in an idyllic setting to get into the right frame of mind. Not that we needed any encouragement of course, every faint sound created its own air of expectancy.

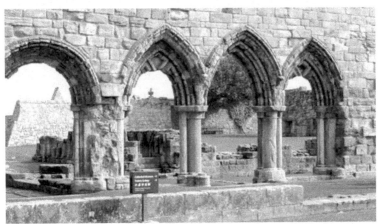

The interlaced arches of the west side of the south transept looking east towards the Chapter House.

Eventually we decided to call it a night, but as we began to get up, one of the party suddenly called out. "What's that over there?" he said. Startled by his tone, we all looked to where he was pointing and standing out distinctly from the fading grey of a pillar was a figure.

It was by the right hand arch of the south transept just behind the cloisters. It was in this area Thomas Platter murdered Robert De Montrose, the Prior haunting St Rule's Tower. The figure was a slim human form, not very tall and adorning what appeared to be a white dress with a white veil obscuring the face. We looked hard and saw it was not a dress and veil but a full-length shroud. It was almost luminescent and appeared to glow very slightly against the black background. It made no gesture and had no movement. In fact, I would say it was unnaturally still. We moved toward it, and I can only describe it as fading into the stone pillar behind as we did so.

We all became scared when we realised what we had seen and as we climbed over the entrance wall, a police car came round the corner from North Street. On seeing us, it stopped. The police officer in the passenger seat wound his window down and asked what we had been doing in the ruins. I must have been as white as a sheet as I leant into the window and told him we had just seen a ghost! He said something to the driver, wound up his window and before we knew it, they were off down South Street.

All of us were left in no doubt that what we had witnessed that night was the famed White Lady.

The White Lady Appears Again

Under similar conditions to the above visit, in September 1981 three of us went there with one aim in mind – to see a ghost. It was a dry still night and as we wandered the precincts, the only sounds came from the occasional passing car and the waves from the sea crashing against the nearby cliffs.

There was something different about this night to pretty much all previous occasions. I can only describe it as having an atmosphere all of its own. After about an hour of aimlessly wandering clockwise around a mix of grass and the occasional stretch of dark gravel path, we walked through the archways and across the old cloisters. When we reached the grassy slope by the main entrance, we turned and standing in exactly the same spot as where myself and a few others had seen her a few years before, was this slim ghostly white figure. Once again, she appeared to shimmer or glow very slightly. We all saw her and after a brief moment, she was gone. The reason for her glowing slightly wouldn't become apparent for another 32 years. Refer to p. 225.

There is nothing obvious to suggest why she would be standing in the archway between the Cloisters and the vestibule of the Chapter House, but there must be a reason. The vestibule by where she stands was the original Chapter House, which eventually became too small, so a larger one was created just to its east. Is it possible there was an altar nearby where she was originally entombed? If this were the case, it is possible she has been appearing here for many more centuries than where she appears by her tomb in the Haunted Tower.

Could the White Lady Apparition be of the Corpse in the Second Chamber?

To add another possibility, the ghost has been observed with long black hair and wearing a white dress. She is observed as she was in life, not as she became in death, as there are no reports of her wearing any gloves. From this, the ghost could easily be of the White Lady entombed in the tower, she could also be the apparition of the White Lady corpse seen in this second chamber. A corpse that is very likely still present. The latter suggestion would then mean only the shrouded figure in the Cathedral grounds is of the White Lady in the tower.

Chapter Seventeen

Linskill's Stories of the White Lady...

Before moving to various other reports of her over the years it is important to begin with two fictional stories by William Linskill that had an impact on the town, and a few subsequent writers unable to make a distinction between the fact and the fiction of what he wrote. The stories, written no doubt by candle light over a glass or two of the finest port appeared in a short book he published in 1911 called *St Andrews Ghost Stories.*[1]

Following the stories is an analysis of the facts and the fiction contained within them and details of where Linskill gathered his inspiration.

His first story is as follows.

The Beautiful White Lady of the Haunted Tower

"How very, very lovely she was to be sure!"

"Of whom are you speaking?" I asked. "Of some of the Orchid or Veronique people, or of some of your own company? I did not know you were hard hit old chap". I was sitting in the smoking-room of the Great Northern Hotel, King's Cross, talking to an old friend, an Oxford man, but now the manager of a big theatrical company, when he suddenly made the above remark.

"No, no! Of none of those people," he replied; "but our talking of St. Andrews reminded me of a ghost, a phantom, or a spectre - call it what you choose - I saw in that ancient city several years ago - no horrid bogie, but a very lovely girl, indeed".

"By Jove," I said, "tell me about it; I want a new ghost tale very badly indeed. I know a lot of them, but perhaps this is something new and spicy".

"I am sure I do not know if it be new," he replied. "I have never seen anything spectral before or since, but I saw that lovely woman three different times. It must be fully ten years ago. I saw her twice on the Scores and once in an old house".

"Well, I must really hear all about it," I said. "Please fire away".

"All right, all right!" he said. "Now for her *first* appearance. I was living in St. Andrews at the time. It must have been the end of January or beginning of February, and I was strolling along to the Kirkhill after dinner and enjoying the fine evening and the keen sea breeze, and thinking about the old, old days of the Castle and Cathedral, of Beaton's ghost, and many other queer tales, when a female figure glided past me. She was in a long, flowing white dress, and had her beautiful dark hair hanging down past her waist. I was very much astonished to see a girl dressed in such a manner wandering about alone at such an hour, and I followed her along for several yards, when lo! just after she had passed the turret light she completely vanished near the square tower, which I was afterwards informed was known as the 'Haunted Tower', I hunted all round the place carefully, but saw nothing more that night. Queer, wasn't it?"

"Certainly it was," I remarked; "but I know dozens of weird stories connected with that old tower. But what more have you to tell me?"

"Well," he continued, "as you may imagine, the whole affair worried and puzzled me considerably, but it was gradually vanishing from my mind when near the same place I saw her again. I had my sister with me this time, and we both can swear to it. It was a lovely night with a faint moon, and as the White Lady swept past quite silently we saw the soft trailing dress and the long, black wavy hair. There was something like a rosary hanging from her waist, and a cross or a locket hanging round her throat. As she passed she turned her head towards us, and we both noticed her beautiful features, especially her brilliant eyes. She vanished, as before, near that old tower. My sister was so awfully frightened that I had to hurry her off home. We were both absolutely convinced we had seen a being not of this world — a face never to be forgotten".

"How strange," I said. "You know, several people saw a girl in that built-up old turret lying in her coffin. A former priest of the Episcopal Church here saw some masons repairing the wall of that tower, and their chisel fell into the turret through a chink. On removing a stone, they came upon a chamber within, and they saw a girl dressed in white, with long hair, lying in a coffin, wanting the lid. The hole was built up again at once. I know, and have often talked to persons who saw her there. One of them was a mason employed at the work. The doorway of the tower is opened up now, and a grill put in, but there is no sign of the girl. Queer stories arose. Some said it was the remains of Princess

Muren, daughter of Constantine. Others said it was the embalmed body of some sweet girl Saint concealed there in times of trouble, and so on; but finish your story".

"I have little more to tell," he answered. "Some months afterwards I was a guest in an old house in Fifeshire, and was given the turret room. On the second night I went to bed early, as I had been at golf all day and felt awfully dead beat. I must have fallen asleep suddenly, as I left my candle burning on the table. All of a sudden I woke up with a start to find the now familiar figure of the "White Lady" at the foot of my bed. She was gazing at me intently. When I sat up she glided away behind the screen at the door. I jumped up, put on my dressing-gown, seized the candle, and made for the door. The lady was gone, and the door was as I left it when I went to bed — locked. I unlocked it, flung it open, and looked into the passage. There she was. I saw the white dress, the splendid hair, the rosary, and the gold locket quite plainly. She turned her lovely face to me and smiled a sweet, pathetic smile; gently raised her hand, and floated away towards the picture gallery. Now for the end. Next day my kind hostess took me through the old gallery. I saw pictures of all ages, sorts, and sizes; but imagine my amazement when I saw 'The White Lady' - the same white dress, the lovely sweet face and splendid eyes, the rosary, and a locket, which I now saw had on it the arms of Queen Mary and Lord Darnley. 'Who on earth is that?' I asked.

"'You seem interested in that painting', said Mrs ------.

"Well, that is a portrait of one of the lovely Mary Stuart's Maries. She was madly in love with Castelar, the French minstrel, and after he was beheaded at St Andrews she became a nun, and it is said died of grief in her nunnery".

"That is all, old boy," he said, "and it is late. I think it seems right; *that* girl I and my sister saw *must* have been the spirit of Marie --- ; and perhaps it was she who was the occupant of that Haunted Tower - who knows? but I shall never, never see such a divinely beautiful face on this earth again".

The following is his second story.

Concerning More Appearances of the White Lady

I HAD been invited, and was sitting at tea with a very dear old lady friend of mine not long ago. It may seem strange, but tea is, I consider, an extra and an unnecessary meal. It does not appeal to me in the least, and only spoils one's dinner and digestion. The reason I went to tea was because in her note to me the lady mentioned that she had read my book of ghost tales, and that she was interested in ghosts in general and St. Andrews ghosts in particular, and that she knew lots of such stories in the days of her girlhood in St Andrews, now about 85 years ago. That is why I went to eat cakes with sugar, hot buttered toast, and drink tea as black as senna or a black draught. She had also informed me in the note that she could tell me a lot about the Haunted Tower and the Beautiful White Lady.

It took some time to get her to that point. She would talk about Archbishop Sharpe and his haunted house in the Pends Road, of the ghost seen by Archbishop Ross, of my friend the Veiled Nun, of the Cathedral and Mr John Knox, of Hungus, King of the Picts, of Constantine, Thomas Plater, and various others. She told me a long tale of the Rainham Ghost in Norfolk, known as "The Brown Lady of Rainham," whom her father Captain Marryat both saw, and so on.

At last we got near the subject I wished information on.

"In my young days," she said, "St Andrews was quite a wee bit place with grass-grown streets, red-tiled houses, outside stairs, queer narrow wynds, not over clean, only a few lights at night - here and there, an old bowet or oil lamp hanging at street corners. Everyone believed in Sharpe's Phantom Coach in those good old days".

"Did you ever see it?" I queried.

"No," she said, "but I have heard it rumble past, and I know those who have seen it, and many other things too".

"But tell me about the White Lady, please," I said.

"I will. Few people in those days cared to pass that Haunted Tower after nightfall. If they did they ran past it and also the Castle. Those new-fangled incandescent gas lamps have spoiled it all now.[lxvi] The

[lxvi] This is quite a humorous in-joke of Linskill's. It was Linskill that had them installed when he was Dean of Guild for the town.

White Lady was one of the *Maries*, one of the maids of honour to poor martyred Mary of Scotland, they said then. She was madly in love with the French poet and minstrel, 'Castelar', and he was hopelessly in love, like many others, with Marie's lovely mistress, 'the Queen of Scots'".

"Was she supposed to be the girl seen in the built-up Haunted Tower?" I asked.

"That I really can't say," she said. "There was a story often told in the old days that a beautiful embalmed girl in white lay in that tower, and it was there and near the Castle that she used to appear to the people.[lxvii] You know poor Castelar, the handsome minstrel, said and did some stupid things, and was beheaded[lxviii] at the Castle, and was probably buried near there. Get me from that shelf Whyte Melville's novel, 'The Queen's Maries'".[lxix]

I did as she bade me.

"Well, you will see there that the night before Castelar was to be beheaded kind Queen Mary sent one of her Maries, the one who loved Castelar, at her own special request to the Castle with her ring to offer him a pardon if he left this country for ever.[lxx] This Marie did see Castelar, showed him the Queen's ring, and pleaded with him to comply, but he refused - he preferred death to banishment from his beloved Queen's Court, and the fair messenger left him obstinate in his dungeon.

This faithful Marie paced up and down all that night before the Castle; then at dawn came the sound of a gun or culverin, a wreath of smoke floated out to sea, and Castelar was gone. Whyte Melville says she did not start, she did not shriek, nor faint, nor quiver, but she threw her hood back and looked wildly upward, gasping for air. Then as the rising sun shone on her bare head, Marie's raven hair was all streaked and patched with grey. When Mary Stuart fled to England, this faithful Marie, now no more needed, became a nun in St Andrews.

[lxvii] Refer to p. 217 & p. 239

[lxviii] He was hanged in Market Square (now Market Street) in St. Andrews on the 20th February 1563.

[lxix] The book was a work of fiction published in 1862 by Major George John Whyte Melville, a novelist, poet and a golfing friend of Linskill's. Refer to p. 251

Look at page 371 of Whyte Melville's book," she said. So I read –
"It was an early harvest that year in Scotland, but e'er the barley was
white, Marie had done with nuns and nunneries, vows and ceremonies,
withered hopes and mortal sorrows, and had gone to that place where
the weary heart can alone find the rest it had so longed for at last".

The pathetic and the comic often go together. Just at this interesting
point a cat sprang suddenly up and upset a cup of tea in the lap of my
genial hostess. This created a diversion. Old ladies are apt to wander,
which is annoying. She got clean away from her subject for a bit. She
asked me if I knew Captain Robert Marshall, who wrote plays and "The
Haunted Major". [lxxi] I said I knew Bob well, and that he was an old
Madras College boy.

She then wanted to know if I knew how to pronounce the name of
Mr Travis's American putter, and if Mr Low or I had ever tried it. She
also wanted to know if I knew anything of the new patent clock worked
on gramophone principles which shouted the homes instead of striking
them.

Having answered all these queries to her satisfaction, and taken
another cup of senna — I mean tea — I got her back to the White
Lady.

"Oh, yes, my dear," she said, "I saw her, I and some friends. *A lot of
us* had been out at Kinkell Braes one afternoon and stayed there long
past the time allowed us. It was almost dark, and we scuttled up the
brae from the Harbour rather frightened. Just near the turret light we
saw the lady gliding along the top of the old Abbey Wall. She was robed
in a grey white dress with a veil over her head. She had raven black hair,

[lxxi] Captain Robert Marshall was indeed from St. Andrews and like myself went
to Madras, and Linksill knew him. He was a Captain in the 71st Highland
Light Infantry. He was a Scottish author and playwright and his story *The
Haunted Major* was a ghostly golfing yarn he published in 1902. It features a
game of golf played at St. Magnus (St. Andrews) and the prize was the hand in
marriage to a woman. The hero of the story is one Major John Gore who is
playing very badly until the ghost of the Scottish Prelate Cardinal Smeaton
comes to his aid against Gore's opponent called Lindsay. This is a play on St
Andrews history. Smeaton is Beaton who was killed at the Castle by Lindsay
(Norman Leslie), Lesley is described by the ghost in the book as one of his
most determined foes and bewitches Gore's clubs to win the game against his
archenemy!

and a string of beads hanging from her waist. We all huddled together, with our eyes and mouths wide open, and watched the figure. 'It's a girl sleep-walking', I murmured.

'It's a bride', whispered another. 'Oh! she'll fall', said a little boy, grasping my arm. But she did not. She went inside the parapet wall at the Haunted Tower and vanished completely.

'It's a ghost; it's the White Lady', we all shrieked, and ran off trembling home. My sister also saw her on one of the turrets in the Abbey Wall, where she was seen by several people. Some months after, as I was doing my hair before my looking-glass, the same face looked over my shoulder, and I fainted. I have always felt an eerie feeling about a looking- glass ever since, even now, old woman as I am. Her lovely face is one never, never to be forgotten, having once seen it, but your new fashioned lamps have altered everything".

"And what do you think about it now" I asked her.

"I have told you all I know. The Lady used to be seen oftenest between the Castle and that old turret. Perhaps she came to look at the last resting-place of her much loved and wayward minstrel, Castelar. Maybe she came to revisit the favourite haunts of her beloved girl Queen - truly called the Queen of the Roses; but to my dying day I shall never forget that face, that lovely, pathetic face I saw years ago, and which may still be seen by some. What! must you really go now; won't you have another cup of tea? Very well, good bye".

As I wended my way Clubwards I could not but think of the strange tale I had just heard and of Castelar's sad end, and I could not help wondering if I should ever be favoured with a sight of this beautiful White Lady.

Chapter Eighteen

An Analysis of Linskill's White Lady Stories and his Mysterious Marie of the Haunted Tower

Linskill's Inspiration

Linskill had a fascination for the White Lady and the focus of his stories is one of Mary Queen of Scots' Marie's. To find the truth from the fiction of what he wrote it is necessary to unravel his stories and find his sources.

In his story '*The Beautiful White Lady of the Haunted Tower*' Linskill finds himself chatting with an old Oxford friend at Kings Cross Station. His friend sparks up and says "I saw 'The White Lady' – the same white dress, the lovely sweet face and splendid eyes, the rosary, and a locket, which I now saw had on it the arms of Queen Mary and Lord Darnley.

'Who on earth is that?' I asked...

'You seem interested in that painting', said Mrs ------.

"Well, that is a portrait of one of the lovely Mary Stuart's Maries. She was madly in love with Castelar, the French minstrel, and after he was beheaded at St Andrews she became a nun, and it is said died of grief in her nunnery.

....perhaps it was she who was the occupant of that Haunted Tower – who knows?"

This is the first intimation Linskill gives for the apparition being one of the Queens Maries and how the sightings are in some way connected with the occupancy of the Haunted Tower. He also associates her as being a nun. This is a far cry from his more sober report about the White Lady and the occupancy of the tower in his *St Andrews Citizen* articles.

His tale was in part inspired by the white leather gloves found on the hands of the female body within the tower during the 1868 opening of the tower, one of which he is said to have seen, and apparently taken by the stonemason John Grieve.

White leather gloves were worn by royalty and also denote wealth or someone of great importance. Certainly in Fife it was fairly common for

white leather gloves to be put on the hands of the deceased body of a wealthy individual that the living might then kiss the hand, and be granted good fortune by the deceased's spirit. This is the same as that of saints. Mr A. Hutcheson said in his letter, "Gloves were usually put on that the faithful might kiss the hands of canonised persons," which strengthens his idea that she and the other occupants were saints. It also fits that the body of the White Lady was in a coped lidded coffin. She had been on display.

Linskill dismissed the idea of the bodies being saints because for him the gloves denoted royalty and strengthened his belief in the White Lady as being one of Mary's Maries. He then constructed his stories accordingly.

In Linskill's story 'Concerning more appearances of the White Lady' he gives reference to Whyte Melville's novel, 'The Queen's Maries' and the page number 371 where the relevant passages can be found. It would be easy to think this book was a fictional inclusion, but the book does exist. The novel was Whyte Melville's The Queen's Maries, written in 1862.[lxxii] This is where Linskill further developed the ideas for his stories about the White Lady and his most famous ghost story 'The Veiled Nun of St Leonards'.

Linskill boldly says "The White Lady was one of the Maries, one of the maids of honour to poor martyred Mary of Scotland… She was madly in love with the French poet and minstrel, 'Castelar', and he was hopelessly in love, like many others, with Marie's lovely mistress, 'the Queen of Scots'".

Linskill's stories revolve around this Marie and the French poet and minstrel and as they unravel, they release the seeds of who he believed the apparition and the occupant of the tower to be. In his story, Castelar's infatuation with the Queen causes her to send him to be executed in St Andrews. The love lorne Marie goes to the Castle with a ring from the Queen pardoning him if he agrees to leave Scotland. The Queens Marie implores him to do so and when he refuses..".the fair messenger left him obstinate in his dungeon.

This faithful Marie paced up and down all that night before the Castle; then at dawn came the sound of a gun or culverin, a wreath of smoke floated out to sea, and Castelar was gone".

[lxxii] Refer also to p. 250 and more about Melville and his influence on Linskill and his White Lady and Veiled Nun stories.

In Linskill's story, Castelar was beheaded in the castle for his trouble. His description of the White Lady in his early correspondence to the press as having 'raven' hair came directly from Melville's 1862 story. Linskill then adopted the word raven for his 1911 stories. Quoting directly from Melville's fictional story he writes, "as the rising sun shone on her bare head, Marie's raven hair was all streaked and patched with grey".

Later Linskill says, "The Lady used to be seen oftenest between the Castle and that old turret. Perhaps she came to look at the last resting-place of her much loved and wayward minstrel, Castelar. Maybe she came to revisit the favourite haunts of her beloved girl Queen – truly called the Queen of the Roses". Earlier in the story, the elderly woman in Linskill's company and in answer to his question "Was she supposed to be the girl seen in the built-up Haunted Tower?" replied "That I really can't say, there was a story often told in the old days that a beautiful embalmed girl in white lay in that tower, and it was there and near the Castle that she used to appear to the people".

Again as with his previous story, Linskill is laying the seeds of her apparition in this quarter, reinforcing her appearance between the castle and the Haunted Tower as being that of one of the Queen's Marie's. The apparition is actually that of Lady Buchan, refer to p. 239. Interestingly, he does not give the name of his Marie at any point in his stories about the White Lady. There is however, one mention of her name in his book. It sits in another of his stories called *The Spectre of the Castle,* Linskill through his fictional Dickensian character Jeremiah Anklebone says, "I often used to climb over the Castle Wall after dusk, and smoke my pipe and meditate on all the grand folk that must have been there in bygone days before the smash-up. I thought of lovely young Queen Mary, of Mary Hamilton, and her other Maries, of Lord Darnley, of the poet Castelar…"[lxxiii]

Linskill introduces us to many fictional and fanciful characters in his stories and Mary Hamilton is one of them. The four Maries were Mary Seton, Mary Beaton, Mary Fleming and Mary Livingston. Mary Hamilton is a fictitious Marie from a Scottish ballad called *The Fower Marys* (The Four Maries). Some versions of the ballad have her name as Mary Carmichael, another fictitious Marie. The ballad is well known in

[lxxiii] W. T. Linskill, *St Andrews Ghost Stories*, The Spectre of the Castle. Reproduced in *Ghosts of St Andrews,* by the present author

folk circles and was made famous by the singer Joan Baez who recorded and sung this famous and ancient folk song about her. A website about Mary Queen of Scots has the following "this popular song was believed to be relating to Mary, Queen of Scots until it was traced back to the court of the Tsar. The ballad dates between 1719 and 1764 and narrates the story of Mary Hamilton, a Scottish maid of Peter the Great's wife Catherine, who was executed for the murder of her illegitimate child, product of an affair with the Tsar Peter".[1]

Linskill mentions one of his Oxford friends recognising one of the Maries from a portrait. We don't have to look too far for an answer to dispel this part of his story. Antonia Fraser in her book *Mary Queen of Scots* in 1969 points out, "There are no contemporary portraits of the four maries to be seen. One picture once thought to be that of Mary Beaton showing her with fair hair and dark eyes are now thought to date from the late 17th or early 18th centuries".[2]

Additionally, the four Maries and Mary herself are all documented as being buried or entombed elsewhere. If it were not for this, his suggestion would indeed have opened a very interesting line of enquiry. Moreover, even with this, his seeds of association stuck in the minds of many of his readers of the day. With the preserved corpse fitting the description of the ghost, none of them can lay claim to being the White Lady roaming the quarter of the Haunted Tower. However, at least one of the apparitions of the White Lady in St Andrews is believed to be that of Mary Queen of Scots and quite possibly two others also. She haunts Queen Mary's House in South Street by the Cathedral. The building, now the library for St Leonards School, retains Mary's bedchamber, preserved as it was when she stayed here around September each year between 1562 and 1566. Her ghost roams her former chamber and has also been seen seated at her tapestry here. Both appearances have her wearing a white dress. Andrew Lang said of her, "Mary Stuart is the fairest and most fascinating of all the historical shadows which haunt St Andrews".

Mary and her Maries visited St Andrews on six occasions and there are documented associations of Mary and her Maries wearing white dresses. Despite white being the official colour of mourning in France at the time, this was her favourite colour, so she wore white to the wedding of her first husband Francis II, at the Cathedral of Notre Dame in Paris in 1558.

Today being married in white is an accepted tradition, but back in the 16th Century she was one of the first, and set a precedent that was later picked up by Queen Victoria who also wore white for her wedding. It was Victoria's wedding that started the tradition of the white wedding dress we now have today.

The portrait of Mary has her wearing white in mourning for the deaths of her mother Mary of Guise and her father-in-law Henri II of France. They both died within a short time of each other and

Mary Queen of Scots
in 'White Mourning' Circa 1560

she became known as the 'White Queen'. A few months later in December 1560, her first husband, King Francis II, died and shortly after this, she came to Scotland and to St Andrews as Queen in 1561. This was post Reformation St Andrews. The Catholic Queen now ruled a Protestant country and with the Cathedral no longer ringing the bells of her Catholic faith, all was quite different to the France she had left behind. The Cathedral was a direct reminder of the stormy climate she had entered into. On her first visit to St Andrews in 1561, the lead was stripped off the roof of the Cathedral. To see the largest building in Scotland and the former seat of her church lying abandoned would have added to her sense of grief and sorrow.

Mary and her Maries enjoyed roaming the town, which was considerably smaller than it is now. It is possible the figure of a woman wearing a white dress standing by the 'Eye of the Needle' (refer to p. 228) and the same figure walking along the high wall beyond the Pends entrance (refer also to p. 228), both sighted just near her dwelling, are also those of Mary.

As a respite from the politics of Holyrood Palace in Edinburgh, the Priory precincts and Cathedral gardens would have given her time to reflect on her many tragic losses and the recent loss to Scotland of its Catholic faith. It gave her a perspective on how she should handle the

troublesome Protestant Mr Knox as she looked to secure at least some of her religious dignity – even if the Cathedral was now stripped of its own.

It is interesting investigating the origins of Linskill's ghost stories, to hopefully glean those nuggets of fact. We know Mary Hamilton is a fictitious figure, but who was the poet Castelar he introduces us to? In life Castelar was Chatelard, an enthusiastic, if not foolhardy, French poet in the Court of Mary Queen of Scots and the story in part is based around his sad and unfortunately true tale. He was in love with Mary and wrote poems for her, which she responded to in kind. With this, rumours spread they were having an affair. This was not the case and certainly not to Mary's liking, but in his mind there was more to their relationship than she was obviously aware. She was very charismatic and he mistook her flirting to be something more substantial. Rumours spread that his antics were also a deliberate ploy by her enemies to destroy her reputation. Rather than being calculated and clever, Chatelard willingly placed himself so close to death because of his infatuation with her. His mistaken belief that she shared the same feelings for him was to be his undoing. When the Queen was at Rossend Castle in Burntisland on her way to St Andrews in February 1563 – Lyon in his *History of St Andrews*, 1838, writes "a singular incident occurred. Chatelard obtruded himself into her bedroom and presented himself to her! [While she was disrobing] It was the second time he had been guilty of this treasonable offence, [the first time a few days earlier he hid under her bed in Holyrood Palace and was banished by Mary from Scotland, it was only two days later that he found himself again in her chamber, this time in Burntisland] and Mary now determined to make a public example of him. Accordingly, he was seized and conveyed to St Andrews; [He was kept captive in the Bottle Dungeon of the Castle] to which place the chancellor, justice-clerk, and other counsellors, were brought from Edinburgh to sit upon his trial. He was condemned to lose his life, and was executed in this city". Chatelard had no fancier from one of the Queen's Maries, and wasn't beheaded at the Castle as Linskill had written, but he was executed in St Andrews. He was taken from the Bottle Dungeon of the Castle and hung at the Tolbooth in Market Street.

Chapter Nineteen

Further Accounts and Fictional Components

The Bible or Prayer Book

In his stories, Linskill has the apparition of the White Lady holding a prayer book. He also mentions a rosary, which he uses to reinforce the idea of her being one of the Maries. I believe she was of the Catholic faith but these are fictionalisations. He obtained the idea for the book from a *Scotsman* article, which he wrote about in an article in the 1920s...

ANOTHER "WHITE LADY"

Dean of Guild Linskill writes:- "My mind was carried back to long ago when I read an interesting article in the *Scotsman* on 'A French Pompeii'. It is a place called Les Baux on top of a mountain about 15 miles from Arles. I know well the Italian Pompeii, and I also know Arles, but I never managed to pay a visit to Les Baux. I wish I had. The article says:- 'Unlike Pompeii, this dead city has never suffered burial. City? Three cities lie here'. A very interesting and minute account is then given of the history of Les Baux, which I will not repeat here, but one item strikes me forcibly as it in many ways reminds me of 'The White Lady' of the Haunted Tower here, so I will jot it down – 'A romantic find was made about forty years ago. In one of the vaults (below the old church) a stone coffin accidently came to light, wherein lay a young and lovely girl, with a "Book of Hours" in her folded hands. She was pillowed around and beneath in her own golden hair. Everything fell to dust except those glorious tresses, the pride of the Court in the days of the Troubadours, which you may see for yourself in the Museum at Arles laid on a velvet cushion under glass". Is this not a twin story, in a manner to our own Lady of the Haunted Tower? The difference is that this girl had golden hair, and our fair lady had raven black tresses; and that the girl at Les Baux crumbled away to dust, whereas our beautiful lady was secretly removed somewhere by someone unknown. The one was down in a vault, the other up in a tower".

He gives no indication when the *Scotsman* article was published, but it was prior to his own publication as he does say, "My mind was carried back to long ago when I read an interesting article in the *Scotsman*".

Conflicting Descriptions

It is easy for fictional elements to filter into factual reports, especially where the paranormal is concerned, and there are many examples of this. Over time, fictional 'props' such as those Linskill used in his stories, the rosary, book, and veil etc, have easily found their way into accounts and commentaries by authors having read his stories, or heard tell of them perhaps without knowing he was the source. However, with no distinction, once in the public domain these additions are easily engrained as fact. Additionally, Linskill's stories themselves have been retold, rehashed and embellished so many times, but rarely does he get a mention or even a reference. He had quite an impact on the town and because of this, it is naive to tell a story clearly coming from Linskill and not quote him as the original source of the material.

Unfortunately, this is a common occurrence amongst those dipping their toes precariously into the world of the paranormal in St Andrews. It is so rife it is almost standard practice, but adding in fictional elements does nothing for the integrity of the subject. The reality of which hangs precariously enough in the minds of many.

Peter Underwood in his *Scottish Ghosts*, 1973, writes, "It is an unidentified lady in a long white dress with a veil, holding a book in her clasped hands. In May 1968, she was reported to have been seen near the Round Tower by an arts student, Miss Alison Grant, and by a medical student Mark Hodges, and when she was fourteen years of age Mrs Stevenson of Elgin saw the 'White Lady'. She was standing in the ruined abbey with her brother on a bright moonlit night when they both saw the figure, all in white, with a veil hiding the features".[1]

His brief description of her at the start of his article holding a book is a fictional addition lifted from Linskill. He doesn't directly attribute the book to what any saw, but the inference is enough for us to make this association. The above account by Mrs Stevenson and her brother is the same as what a few of us saw on two occasions, but there is no mention of a specific locality, other than she was seen "in the ruined abbey".

There is a report of the White Lady being seen during the day by two people in 1975 wearing a light grey dress... Andrew Green wrote, "One often hears stories of hauntings without much evidence to support them. Having been told on numerous occasions of the ghost that frequents the Round or Abbey Tower of St Andrews it was with considerable interest and pleasure that I met Ian MacDonald and his wife in June 1979, for they had both actually seen the apparition. They were on a visit to the golfing centre in 1975 and decided to spend some time looking round the ruins of the Cathedral. On nearing the tower in the Abbey Wall they noticed the figure of a woman in 'a light grey dress' moving towards them. But what puzzled them was not the fact that she was carrying something that 'looked like a prayer-book' but the fact that she was wearing a light veil. "You don't see that these days" Ian said to his wife. At that moment the ghost vanished leaving the couple open-mouthed with astonishment".[2]

Both Green and Underwood mention the Round Tower. This is the Lighthouse Tower. The Abbey Tower they refer to is the Haunted Tower. She walks between the two, which is only in keeping with other reports if they were on the Scores path by the Haunted Tower when they saw her. None of the other accounts have her moving through the Cathedral precincts, she is always stationary, and while it cannot be disputed they saw her with a book, it is out of sorts with all other reports. The suggestion it looked like a prayer book is also too close to Linskill's own fictional addition.

At the end of a piece about her, Geoff Holder in his booklet *Haunted St Andrews* in muddling the fact with the fiction just points out the discrepancies. "The White Lady is described as: veiled, or unveiled; carrying a book, or not; possessing a rosary or a string of beads, or not; having long black hair, or not; walking, or motionless, passing through solid objects, or vanishing; moving through the grounds of the Cathedral, or outside the precinct wall, or along the top of the wall itself; and seen by moonlight, or at twilight, or in the evening, or in daylight. The only constant features are that the phantom is female, clothed in a long white or grey-white dress, and silent."

Her Two Ghostly Forms

After having conducted a great deal of research into the sightings of her over the years and having seen her twice in the Cathedral grounds, my

line of enquiry led to some interesting conclusions no one has realised. I mentioned near the beginning of the book there are two distinct forms of her. In taking away the fictional elements of the sightings, and by correlating all the accounts, a pattern emerged that clearly defines them. I found no discrepancies in what people have observed. One is within the Cathedral precincts the other is along the Scores path out with the precincts. Both forms comply with the description of the body found within the middle chamber. It would be easy for some to say they have seen the apparition inside the precincts with beautiful features and long black hair, or outside the wall standing motionless with a veil, but to date no one has.

The White Lady – Cathedral Precincts

In the Cathedral grounds, she is very slim and not very tall. She stands motionless and is covered head to toe in a white shroud. She is as luminous as the full moon, is the only way I can describe her, and she has a curious glow surrounding her being. She has been seen both by day and by night, although most of the sightings of her within the precincts are by day. Some describe her as being completely shrouded in white, while others as wearing a white or grey dress and a white veil. Both are the same. It is the way we describe what we see. None of those who have seen her describe her as wearing a wedding dress, although this would be the first conclusion the mind would come to. The mind will do everything it can to rationalise what it is experiencing, but the reality lends itself more to the appearance of a full-length shroud. Linskill never saw her and through his fictional stories, he is the only one who refers to her as being a bride. In his first story, he says, "she was dressed as a bride for a wedding". In his second, "It's a bride".

The image is an impression of her entombment in the tower shrouded in white wax cloth. The wax cloth under the moonlight is the reason she is as bright as a light or as luminous as the moon and appears to glow very slightly. She is only seen in this burial shroud on hallowed ground, which is very reminiscent of the depiction of a deceased spirit from an early engraving of Dee and Kelly.

The depiction of her can easily be likened to something out of a horror film or an old grimoire of magic. In the following picture, the magician and his scryer are standing in a graveyard with the spirit they have just summoned to appear before them. Although not completely

shrouded the depiction of the spirit is reminiscent of what a few of us have seen. She had a particular rigidity about her in the graveyard and has been described as looking as if she were carved out of sandstone. I would certainly agree with this, as her stance is unnaturally motionless.

The White Lady - Scores Path

In contrast, on the Scores pathway she always appears at night. She is animated and was last seen crossing the pathway along Gregory Place in April 2015. She also glides from the narrow side gateway by the Lighthouse Tower to the Haunted Tower, where she turns and with piercing eyes acknowledges those who see her. Traditionally she is believed to disappear through the wall into the tower itself, but I have found not one report of any observing her doing this. It is thought provoking that this is the only direct link between the apparition of her on the path outside the precinct and the Haunted Tower. So the White Lady on the outside could well be the apparition of the corpse in a second hidden chamber. When she does appear on the path side she is very slim and not very tall. She wears a long white dress contrasting against her long straight black hair. She is young and very attractive and aside being animated, she appears to be aware of those who see her, so this is her spirit.

Holder continues, "There would appear to be no further recorded sighting of the White Lady since 1975, despite the fact that, thanks to popular journalism and the internet, she now has celebrity status".[3]

Regarding the last piece of his article, there isn't a great deal on the internet about her at all, other than a passing reference. As I mentioned, anything more tends to involve Linskill's stories, with either a rare reference to him as the source, or as a rehashing of his stories having been purportedly passed down through the years like a family heirloom. For the sightings, there have been at least nine locations where a White Lady has been seen since 1975. Three can be directly attributed to her, two could be of her, and four are of other White Ladies in the area.

With the descriptions being similar, it is easy to attribute them all to her.

A New Fable about the White Lady Apparition

One of the more unusual and misinformed commentaries of the White Lady comes to us from Helen M. Howell in her article Britain's Haunted Churches as recently as July 30th 2013. It is a good example of how fiction can be presented with its own factual legitimacy. "One of the most famous ghosts is the White Lady. This apparition has been seen regularly over the last few hundred years. Some theories suggest that this was a young woman who was executed during the Protestant Reformation in the 16th Century. It is believed that she was only 21 years of age and was burned to death at the stake. Witnesses also report the smell of burning embers and hear the crackling of flames near the site where her execution took place".

This is definitely a new one, even with the best of intentions she displays how corrupt reports can become. There are no theories about what she writes, so her saying, "some theories suggest" gives credence to a tale otherwise written with no foundation in fact. The only aspect compliant with reports is her saying the "White Lady apparition has been seen regularly over the last few hundred years". The rest of what she writes is a fabrication of the apparition of a woman who has no association to the White Lady of the Tower and to a local myth, which also has no basis. The apparition in question is believed to be a woman burnt at the stake along the Scores by what is now the Aquarium. Most think this is the area known as Witch Hill and is where the heretics were burnt, it isn't, that is further along the Scores between the Catholic Church and the Castle. While there are apparitions here, and there is one of a woman, she is not a "witch". The other part of the tale comes from a myth about the cobbled area just in front of the arched entrance to St Salvator's. This is where 24 year old Patrick Hamilton, was martyred. Burnt at the stake here in 1528, a local myth tells how people have experienced the smell of burning and have heard the crackling wood. To date there are no reports or any recorded documentation of any coming forward with experiences of such phenomenon. The fable is a hotchpotch of these two tales.

Chapter Twenty

More White Ladies of St Andrews

St Rule's Tower

In the early 1990s, a light was seen one night in the lowest window of the tower by Pete Marini and a few others. It then disappeared and reappeared in the next window up and then up to the next. The light then disappeared once more and a figure in white appeared peering over the top of the tower. The figure then disappeared and the lights were again seen lighting up each window in succession down the tower. The heavy wooden door is locked at night so no one could have gained entry and certainly, nobody ever appeared at ground level.

The White Ladies of the Pends Road

The Apparition on Hepburn's Wall

In reference to the apparition on the wall, Linskill mentions "we saw the lady gliding along the top of the old Abbey Wall. She was robed in a grey white dress with a veil over her head. She had raven black hair, and a string of beads hanging from her waist".[lxxiv] This is Linskill pulling out all the bells and whistles for this one. Certainly, by mixing in the veil, the black hair, and adding the string of beads it makes for an entertaining story and is a good example of how he blends his fiction.

He also wrote in one of his stories a 'report' of the White Lady being seen on the wall to the eastern side of the Haunted Tower... It may seem strange the ghost should be seen on top of a wall, motionless or gliding and this piece about her could easily be dismissed as fiction. For a long time I thought it was as he is the only one to mention her being seen on the wall by the Haunted Tower. Then I spoke with a woman who saw a figure walking along Hepburn's Wall from the Harbour Tower in 2013. Refer to p. 234.

[lxxiv] Refer to Linskill's story, *Concerning More Appearances of the White Lady*, p. 211

A White Lady has also been seen on top of a wall near the top of the Pends Road. Two men saw her a few years ago.

Neil Dobson a marine archaeologist in St Andrews said it was the figure of a woman. She was very bright like a light moving slowly along the high Cathedral precinct wall. The account is in-keeping with Linskill when he says she glides "along the top of the old Abbey Wall".

I believe Linskill was aware of a White Lady roaming this stretch and switched her location to the Haunted Tower along the north wall, reinforcing her associations there and making for better copy.

The wall at the eastern stretch, unlike that of the southern or western wall has a parapet built by the Hepburn's designed for walking along its top. This would serve to reinforce his idea of her roaming this northern quarter. It is some 20 feet high and 4 feet thick along the seaward side. In recent times, the internal walkway has partly collapsed. There are those who remember it still being intact as late as the 1970s. When they were young, they used to scale the wall and walk along the top. It is still possible to walk along a lot of the southern wall. St Leonards staff did so for years to spray the weeds, until health and safety stopped them.

The White Lady and the Eye of the Needle

A White Lady was seen in March 2015 at the top of the Pends Road by a woman who came on one of my tours. She saw her only a couple of weeks before when walking up the Pends toward South Street from the harbour. When she entered the Pends gateway she saw a woman

standing by the South Street arch on the pavement, next to the narrow arched pedestrian entranceway locally called the 'Eye of the needle'. The woman was wearing a white dress and as she drew near, the woman walked through the arched entrance to South Street. Her observer was only a couple of seconds behind her and when she went through the archway, the White Lady had completely vanished.

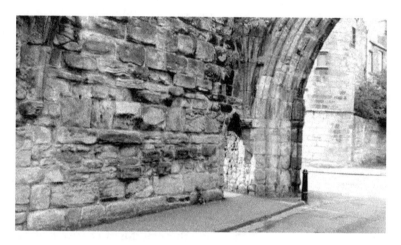

Being so close to Queen Mary's House, it is quite possible this apparition is an impression of Mary Queen of Scots. She did not die here, but there was an emotional and historical intensity associated with her that has had a marked impression on many places she visited across Scotland.

The White Lady of the Mill Port

Just to the right of the Mill Port at the harbour end of the Pends, a woman in a white dress stands looking out to sea. Legend tells how she is waiting for the fishing boat of her husband to come into the Harbour, but his boat never arrives. It was lost at sea in a great storm and his body never found. She remains by the port to this day longing for his return.

At one time, the small building here was a mortuary. Interestingly the area of grass next to this, at the foot of the Eastern Cemetery is full of the unmarked graves of those who in times past were lost at sea and were washed ashore here with no identities.

The White Shade of a Figure

In the 1970s William McIntosh, when walking through the Mill Port of the Pends at around 11:30am, saw the shape of a white figure. It was moving up the Pends on the path to the left. He only saw it for a brief moment before it disappeared through the wall.

Through the Port a blocked off entrance can be seen in the photo that led to the Tiend Barns. The ghost of a monk has been seen walking along the Pends then disappearing through this stretch of wall and a policeman in Victorian times saw a woman on horseback wearing green, ride down the Pends and through this same stretch of wall.

The Grey Woman

A local man walking down the Pends saw a woman walking up the Pends towards him. As they were approaching each other, she just disappeared. There were no entrances in the wall that she could have gone into. He described her as wearing something like a grey plastic mackintosh, the kind worn in the 1950s, but it was more to the colour and texture of the material than the styling he was referring too.

Kirkheugh (Kirk Hill) to the Palace

The Kirkheugh

This reference to the Kirkheugh or Kirk Hill as it was formerly known, is to the large promontory of rock at the northeasterly edge of the town just beyond the Cathedral precincts overlooking the harbour. It is the site of St Mary on the Rock, the first Catholic Church in St Andrews, which was originally a Celtic Culdean settlement. All that remains is part of the foundational ruins and some portions of the walls near the

flagstaff. David Hay Fleming says, "These are the remains of where the Celtic Church had an early settlement. Yet, the interest attached to these insignificant looking ruins is of no ordinary kind. According to an old tradition, the Church was at first built on a rock beyond the end of the pier; but when the sea encroached another was erected here to replace it. The rock, which can still be seen at low-water, bears the name of the Lady Craig...this is undoubtedly one of the earliest Culdee churches. In all probability, this is the site of the Monastery erected by Cainnech in the latter part of the sixth century; and there can be little doubt that it was of this Monastery that Tuathalain was Abbot, who died in 747. Here, too, came Constantine the Third, when, wearied with the troubles of a public life, resigned the crown, in 942, and became a canon of the Church of St Mary on the Rock. He was afterwards made Abbot, and lived here five years before he died".[1]

Constantine the Third was the father of Princess Muren or Mirren, and is attributed as being one of the identities of the White Lady, and as the occupant of the Haunted Tower. Refer to *Other Theories for the Identity of the Occupants* on p. 127.

An Account of the Kirkheugh Green Lady

The following short poem from 1910 is well suited for the next ghostly apparition.

It is an awesome thing,
To meet a-wandering,
In the dark night,
The dark and rainy night,
A phantom greenish-grey,
Ghost of some wight,[lxxv]
Poor mortal wight,
Wandering,
Lonesomely,
Through
The black
Night![2]

This is the account of the Kirkheugh ghost given to me during my researches for this book by a young woman by the name of Jane

[lxxv] Girl or reanimated corpse

Kilpatrick. A student at St Andrews in 1988, who for the first time in print, further confirms the tales having caused the fear to build over many years in the hearts of so many locals in the town venturing past this area after nightfall.

On the 24th October 1988, having finished her studies at St Andrews College in North Street, Jane Kilpatrick, a student at the University of St Andrews started on her way back to her University residences at the Gatty by the East Sands. It was dark by now, being about 6pm. Her usual route home gave her a tour around part of the oldest quarter of St Andrews, taking her along North Street, Gregory Place and along the path of the Scores and past the Haunted Tower to the harbour. The path runs alongside the 20 foot high Cathedral precinct wall on the right and the steep cliffs overlooking the North Sea on the left. She would then walk over the Kirkheugh or Kirk Hill following the right hand path sweeping alongside the Cathedral Wall, down the steps by the ruins of St. Mary's Church as it veers away from the wall to the harbour front, where she would then continue to her residence.

Nothing unusual had ever happened to her before this day other than the occasional antics of the stray student! But on this particular occasion when just past the Haunted Tower, she noticed what appeared to be a female figure standing on the grass in front of her. The figure was standing quite still and silent between a bench and the high Cathedral Wall. Her arms were stretched out as if leaning on the back of the bench. Drawing closer more features became apparent. Certainly what she was looking at was a woman, quite tall, young, slim, with long dark hair and wearing a long pale green dress, quite plain in design with sleeves puffing out at the wrists. Around her waist hung what she thought to be a belt, the same colour as the dress and tied at the middle. As she drew closer a strange feeling crept over her, an impression that the figure didn't belong in our own time at all. It was a very eerie feeling she couldn't quite explain.

The woman seemed solid enough at first but when about ten feet away, she seemed to fade as if merging a little with the wall behind, but not becoming transparent. As already mentioned, it was dark by this time but the moon was shining clearly in the star clad sky and the street lamps lighting the way were enough to see by.

The figure was gazing at her with "a fixed intensity," as she put it, almost menacingly, which coupled with a looming fear made her feel

cold and uneasy. No actual expression was to be found, but the right side of her face had been badly disfigured, distorting the eye somewhat. This startled her. It didn't appear to be a natural disfigurement but something that had occurred to her whilst alive.

Jane and her apparition were the only ones on this stretch of the path at the time.

View over Kirkheugh. The path runs along the side of the north wall past the Haunted Tower which can be seen just to the right of the twin Cathedral towers and continues pas the bench just to the left of the foreground foundation stones down to the harbour

She carried on walking, and made no attempt to communicate with this figure but found it hard to take her gaze off whatever it was she was now seeing. On passing this curious woman, she then became aware of it seeming to follow her. The Cathedral Wall at this point on the Kirkheugh veers away more to the right at an angle to the pathway. Rather than follow her on the path, the woman followed pace but kept on the grass by the course of the Cathedral Wall. On reaching the steps leading down to the harbour by the old Kirk ruins she noticed the apparition out the corner of her eye and turned to look. The Green Lady as it were, was now standing by the wall some thirty feet away from where she was. Her hands were clasped in front of her and she was

still staring at her as menacingly as before. Feeling very unnerved Jane ran the rest of the way to her residences.

Upon arrival, she was quite out of breath and by all accounts was looking very pale. Her friends held a certain amount of disbelief to start with when she relayed her experience to them, and whatever they made of her account they had no doubt at all that whatever it was she saw that evening had disturbed her greatly, and had frightened her.

Jane is a girl of sober and balanced temperament, studious, very down to earth and had no motive for making up such a story, not least in knowing the kind of ridicule she was going to get from her friends. When I met her in 1988, it was the first time she had spoken of that night other than to her friends in her residence after it had happened. From then on, when her studies took her into the hours of darkness she took a different route home. She chose to walk the less isolated but longer route down Abbey Walk, where she felt safer than she did along the Kirkheugh or the Pends Road.

The apparition of the Green Lady, like the apparition of the White Lady on the pathway is also a spirit, as she was not only aware of Jane, she followed her at her own pace. What we have in this area outside the wall are the apparitions of two separate individuals. The faces of both have clearly been seen. They both have long flowing dark hair and the face of the Green Lady has been disfigured by an incident occurring while she was alive. She is confined to the area of Kirkheugh along the wall between the tower and the eastern tower overlooking the harbour, and in some ways, her identity is more of a mystery than the White Lady of the tower. As there is no evidence to suggest why she would roam this quarter.

The Harbour Turret Ghost

There is also another ghost along here sharing a similar pattern to the Green Lady. It walks along Hepburn's Wall from the Harbour Tower westwards towards the next Round Tower. Interestingly it covers the same ground as the Green Lady and it is possibly the same ghost. This figure has been seen at night by different groups of people. It was last witnessed by students in 2013.

On each occasion, it has been when they have reached Kirkheugh from the steep pathway by the sea leading up from the north end of the harbour. It is also slim and appears silhouetted against the skyline. It

too keeps pace with those walking along the cliff side path, following along the wall for a few seconds before disappearing.

The White Lady of Abbey Walk

Moving slightly off the beaten track for a moment, the Abbey Walk also has a couple of ghosts that Jane fortunately never saw, nor I imagine knew about! Both are referenced by Linskill. One is the phantom coach the other a White Lady. In his story *The Veiled Nun of St. Leonards*, p. 246, he only gives the briefest mention to her in a list of occurrences he recorded around the town and says, "There is also a white lady that used to haunt the Abbey Road".

The White Lady of the Abbey Walk has been seen at least three times in recent years. Each time she stands in the same place, opposite the old Cottage Hospital demolished in February 2014 to make way for new residences. Once was by a man cycling up Abbey Walk. He saw a figure in white standing beside the arched entranceway of the Teinds Yett beyond which is the grounds of St Leonards School. Taking him by surprise, he fell off his bike. Two others have also seen her when walking along the pavement. She is always motionless and on both occasions as they approach her, she vanishes.

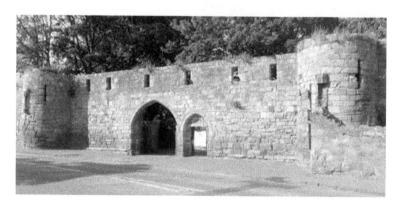

The Tiends Yett was an entrance port to the former Priory precinct grounds. This one lead to the back of what was then the Palace of the New Inn, and the Teind Barns holding the food produce for the Priory and pilgrims. The turret on the left of the photo was believed to have been part of a building that stood inside the archway. This was one of the trade entrances to the precincts.

The Scores Path Faces

Many people take photos on my tours, being one of the most beautiful locations one could imagine it isn't surprising, but occasionally something odd pops up when they do. One was of people by the Castle Sands and looked like seafarers coming ashore.

Faces are the commonest to appear, including one of a skull like face in the lower chamber of the Haunted Tower taken by Derek H. J. Eddie of St Andrews. On that particular tour, I didn't have time to mention that up to 1868 the chamber was full of bones and skulls.

We could easily say there is nothing there and it is just the way the mind works as we look to find familiarity in everything we observe. Especially faces, which we are prone to pick out more readily than anything else, faces in the clouds etc.

I don't present the photos here as any form of 'proof', only individual experience will move that particular mountain, as no amount of photography or video will sway the sceptical mind that trickery wasn't involved. I include them here for the oddities they appear to be. The photos are genuine, and they may well be illusions, but of all the thousands of photos taken on the tours, it is very rare for something to show up in them, especially from the same vicinity. Genuine photos generally have a relevancy to the location of where they were taken that is in keeping with its history, often without those taking the photos being aware of what that history is. Two of the photos taken independently by different people have what appears to be a face in them. They were taken in the same vicinity six months apart. I have included two photos of each.

This is the original image, which I have cropped to just include
the section of the photo with what appears to be a face on the right.

This is the same photo but I have added a lot of contrast
to bring out more definition in the face.

The photo was taken mid afternoon in the autumn of 2014, whilst we
were walking up the brae of the East Scores path from the Haunted
Tower to the Palace. It was a warm clear afternoon. The woman who
took this photo stopped at one of the photographic hotspots to get a
shot of the Cathedral facing south. I was standing just to her right.

There was nothing noticeable at the time. The head is to the right of the photo, within what looks to be a haze or glare on the camera lens from the sun.

This location is where a gentleman on one of my tours saw the apparition of the White Lady, April 2015.

Six months later, another visitor took a photo when we were starting to walk away from the Haunted Tower moving again towards the Palace.

In the photo, there is what looks to be a face. Oddly, this one is on the back of my head! It was taken early in 2015, and the photographer was unaware of another photo of a face having been taken only yards from where he took this one. Again, I have included a cropped version of the original, and one focusing in on the detail. Unfortunately the printed

images don't do the photos justice, so they are harder to see, but the Kindle version is in colour and shows them up more clearly.

The White Lady on the East Scores Path

Linskill mentions on a couple of occasions "the lady used to be seen between the Castle and that old turret,"[lxxvi] which in his book he directly associates with the embalmed girl in the tower. He has a way of merging stories and accounts and his reference in this instance simply to a 'lady' is not to the White Lady of the tower, who he also associates in his fictional stories as being one of Mary Stuart's Maries, it is to Lady Buchan who lived in St Andrews from 1760 to 1765. Linskill was more than aware of her and her ghost. Wearing a white summer dress, she wanders the area of the cliff tops and the shoreline between the Castle and the Haunted Tower.

Her apparition was seen from the Castle Sands a number of years ago standing on the pathway above the cave entrance. Leaving the path, she walks in midair about 10 feet seaward before vanishing. There have been many landslides in this area over the years, and in the 18th Century the land at that part extended further out than it does now.

For centuries, the cave has been known as St Rule's Cave or St Rule's Cell, and from the 18th Century, it shared its name with its more recent occupant, becoming known as Lady Buchan's Cave. There is a legend of singing and a sweet smelling scent of perfume drifting through the air around the Castle Sands and along at this cave. A Filipino woman I had on a tour in August 2015 has smelt the scent of the perfume when sitting down at the beach reading a book. She said it had a very distinctive and unusual smell. Not unpleasant, but unmistakable and not like anything she has smelt before. The scents of old had their own distinctive aromas and this appears to be what she was picking up. If she could replicate that scent, she may well make her fortune in the perfume industry.

The legend of St Rule or St Regulus, has him staying within this cave or cell following his arrival with the 6 relics or bones of St Andrew.

St Rule lived in the village of Muckross as it was then known. It then became Kilrymont, and eventually St Andrews, so named after the

[lxxvi] Refer also to Linskill, *Concerning More Appearances of the White Lady*, p. 211

relics he brought to these shores. He lived here for 30 years and was buried in the church of the time on Kirkheugh.

In complete contrast to this, around 1000 years after the purported occupancy by St Rule, and with a fairly eccentric reputation, Lady Buchan used the cave as a romantic retreat for tea parties and picnics in the summer months. Steps carved out of the rock lead up to the cave. It isn't known who carved them. Lady Buchan could have commissioned them, but they are far more likely to have been carved by the early Catholics here. Along with St Rule's Church housing the relics, the cave through the legend of St Rule attracted equal numbers of pilgrims. At its height, St Andrews attracted up to 30,000 pilgrims a year through the summer months. Inside the cave, there is a stone altar, a stone seat and a small recess for a statue.

"Both cave and church [St Rule's standing some 60 feet above and south east of the cave] were long much resorted to by pilgrims, as sung by Scott [Sir Walter Scott] in Marmion [1806]:

> But I have solemn vows to pay.
> And may not linger by the way,
> To fair St Andrews bound,
> within the ocean-cave to pray,
> where good Saint Rule his holy lay,
> From midnight to the dawn of day
> Sung to the billows' sound".[3]

At low tide, the pilgrims would gather around the rocky shoreline and celebrate mass. This must have been an impressive site to behold from the cliff top, as well as a dangerous one to experience if the tide were coming in.

There is plenty of scope for injury on the rocks and steps would have been an invaluable aid for many. So they were probably carved for the ease of the pilgrims passage to the cave entrance around the time the church standing above was constructed, placing them to around the 11th or 12th Century.

At the top of these steps, the cave itself comprised two chambers. Becoming too dangerous due to erosion the cave has unfortunately been blocked off, however a rare and detailed description of the interior of the cave exists. It was written by James Grierson in 1807 and gives an illuminating account of what the cave was like in the early 1800s, as

well as what Lady Buchan had done to it around forty years earlier. "In the rock overhanging the sea-beach, and forming the high shore betwixt the harbour and the Castle of St Andrews. Is a curious cave, commonly called Lady Buchan's Cave. This lady, while residing with her family in St Andrews, about forty years ago, [1760's] had it elegantly fitted up and adorned with devices of shell work, and used occasionally to resort to it for the purpose of enjoying the sublime prospect of the adjacent ocean, or as a romantic retreat for a tea-party in a fine summer's evening. The cave consists of two apartments. The first, or outermost, is circular, and the entrance is under an arch nine feet high. The excavation is itself nearly of the same height, and as much in diameter. The east side is evidently artificial, and is cut into the form of a table or alter; so that it is probable the cave was once the retreat of some monk or hermit; for this part of it was so formed prior to the decorations and repairs bestowed upon the cave by the above mentioned lady. In the south-west side of this excavation, is an aperture in the rock of the size of an ordinary door, leading to the other apartment of the cave. To this the first serves as a kind of anti-chamber. The inner apartment is nearly in the form of a cube, of which the side is about eight feet. The opening betwixt the two apartments had a neat folding door upon it at the time when the cave was wont to be the occasional retreat of the lady whose name it bears. Its mouth opens directly into the bay. The sea at high-water washes the bottom of the cliff perpendicularly below it, and its floor is then about twelve feet above the level of water. The access to it is by a narrow track running obliquely along the rock".[4]

The White Lady - Archbishop's Palace (St Andrews Castle)

The ghost of a White Lady seen here is thought to be Cardinal Beaton's mistress, Marion Ogilvy. Wearing a white dress, she walks across the courtyard and down three steps that lead to nowhere now, but once led to the banqueting hall, known as the Great Hall. The rock face it was standing on collapsed into the sea one night during a great storm in 1801, taking the hall with it. That area would eventually become known to us as the Castle Sands. On the anniversary of Beaton's death, she also appears at Claypotts Castle in Broughty Ferry by Dundee.

A brief story about the ghost of the White Lady here was recounted by James Wilkie in 1931. "A sojourner sat within the courtyard watching to the eastward the great breakers roll in and dash in spray upon the cliffs. The tide was nearing the fall and the nor easter [wind]

~ 241 ~

blew strong and salt. It was the hour between one and two in the afternoon when the Castle and Cathedral alike are left to a stray visitor. No footfall sounded on turf or gravel, but the mortal became aware he was not alone. Over the grass in a diagonal line from the gatehouse and past the draw-well came a lady of old years "gazing straight on with calm eternal eyes. "She pressed steadily forward to the boundary rail where there is no exit. "The unspoken question formed itself "whither?" and the unspoken answer was flashed back, "it matters not to you". She passed on through the rail to where the sea broke in foam below, and turning to her left where no foot can now tread disappeared beyond the masonry".[5]

The White Lady Illusion in the Archbishop's Palace!

In October 2014, a party of 12 I had on a tour all saw a motionless figure standing in the courtyard of the Castle grounds. It was very bright and motionless. It was dark, the time being around 8pm, and the moon was rising over the horizon of the sea. We all looked at the figure in disbelief, trying to make sense of what it was. One of the party went down the track of Castle Cliff to have a look from the side into the castle. When he came back he said it looked like a reflection in a window from either the moon rising or perhaps students in the castle with a light. The latter didn't fit with what we were looking at and the next day I went to the Castle to see the staff. On explaining what we had seen, a curator of the Castle and myself went to the spot where we believed we had seen the figure. There are no windows in the castle towers so it wasn't a reflection. The figure was standing by the vaults of the Kitchen Tower, not far from the location of where other reports state Marion Ogilvy – Cardinal Beaton's mistress has been seen.

A few days later, I was also in the Castle talking to members of staff about it. One of them had been on duty the day we saw it. She said that evening they had accidentally left some of the lights on in the Castle over night. A few days later, a party of us saw the same thing, in the same position. We all took photos. The next day I went to the Castle and found the lights had again been on. This explained the mystery. The bright light we had seen which looked like a figure in white was actually the back of the stone arched entranceway to a vault of the Kitchen Tower. Lit by the light within it shows how easy it is to mistake a physical explanation for a supernatural one.

Chapter Twenty One

The Bride of Heaven
& the Veiled Nun of St Leonards

The St Leonards Chapel Ghosts...

The Veiled Nun of St Leonards isn't one of the White Ladies roaming the area, on the contrary, she is dressed in a black nun's habit. I give mention to her here as Linskill's association of a nun and the White Lady led him to establishing the most famous ghost story in St Andrews *The Veiled Nun of St Leonards*.

In the excerpt from his *The Beautiful White Lady of the Haunted Tower* he says, "She [Mary Hamilton] was madly in love with Castelar, the French minstrel, and after he was beheaded at St Andrews she became a nun, and it is said died of grief in her nunnery... perhaps it was she who was the occupant of that Haunted Tower –who knows?"

Before delving into Linskill's ghostly and ghastly legend of the Veiled Nun, we need to spend a few moments with a few other ghosts roaming the area of St Leonards Chapel.

The small figure of a woman in black clothes has been seen either wandering into the chapel through the south door or seated within the chapel itself, and is believed to be the ghost of a nun.

The ghost of a nun has also been seen walking out of Queen Mary's House into the garden, just behind St Leonards Chapel and the Nuns Walk.

A small girl has been seen standing motionless outside the chapel by the southwest corner of the chapel.

A Convent Chapel

David Henry the architect who penned a chapter in his book called *The Haunted Tower of the Cathedral Precincts*, was commissioned to make architectural alterations to St Leonards Chapel in 1899. In 1910, although he wasn't involved in this particular project, a new roof was put on the Chapel. In another part of his book he says, "The conclusion is not unwarranted that the church of 1413, then recently built, was for

the old ladies who succeeded the pilgrims – a church or convent chapel being for them a necessity. Other meetings are mentioned as being held in the church, but the Canons who built it, and who administered the affairs of the sisterhood, may very well have had the use of it when they required".[1]

St Leonards Chapel looking east towards the 'Half Moon' Gates. The ghost of a little girl stands on this south west corner of the chapel and a nun walks into the chapel through the south door

He also says, "It is thought that the old ladies had a curatus or chaplain to perform the divine offices in their Church, and the whole arrangement points to the separateness which had to be maintained between them and him. There is the combined vestry and sacristy to which there was access by a door in the western gable – probably outside of the wall enclosing their precincts. From this there is a "priest's door" for him into the Church when ministering at the altar, but probably he read the daily services from the so-called passage in the wall behind the altar where there is a sufficiently large opening – in which some grate or screen concealed him, but did not obstruct his voice.

This "passage" could be entered only from the vestry, and the remains of a stone bench at its southern end with a narrow slit in the wall beside it indicates another, and perhaps its chief function of a Confessional. There the priest sat and heard confession from his female penitents in the church – separated from them by a thin stone wall".[2] He later continues "When the fullness of the time came that their place was wanted for something else the women were displaced, and their

little Church and vestry incorporated into a larger scheme for a College of priests, in which was needed no distinction between sexes or between clergy and laity, and where a "priest's door" was not a necessity, when all were priests or in training for the priesthood".[3]

The Veiled Nun of St Leonards

Introduction

Linskill's story *The Veiled Nun of St. Leonards* is the most famous ghost story in St Andrews. It is not however the most famous ghost. That honour is still reserved for the White Lady of the Haunted Tower and Cathedral precincts. Since the publication of his story in 1911, the avenue has been known as the Nun's Walk. Its official title, which few will know or perhaps remember unless they have read Linskill's story of the nun is the St Leonards Church Avenue.

View along the Nuns Walk from the east, looking toward the 'Half Moon' Gates and St Leonards

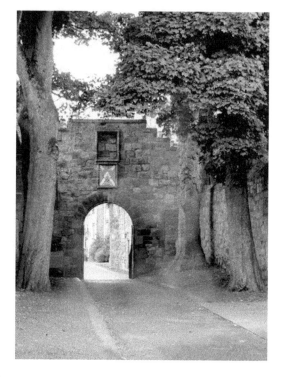

The Nuns Walk is located just off the upper part of the Pends and leads to St Leonards Chapel, St Leonards School and Queen Mary's House. It is along this quiet unassuming avenue that the apparition of another Nun appears.

The following is Linskill's story concerning her sad tale. It is these short dark tales that capture the imagination, and this one didn't disappoint.

The Most Famous Ghost Story in St Andrews...

"Curiously enough, although I have been in many old haunted Castles and churches (at the exact correct hour, viz., midnight) in Scotland, England, Wales, and the Rhine country, yet I have never been able to either see or hear a ghost of any sort. The only experience of the kind I ever had was an accidental meeting with the far-famed "Spring-heeled Jack" in a dark lane at Helensburgh. It was many years ago, and as I was then very small and he was of immense proportions, the meeting was distinctly unpleasant for me.

Now, from legends we learn that St. Andrews is possessed of a prodigious number of supernatural appearances of different kinds, sizes, and shapes – most of them of an awe-inspiring and blood curdling type. In fact, so numerous are they – 80 in number they seem to be – that there is really no room for any modem aspirants who may want a quiet place to appear and turn people's hair white. [As of 2015, I have recorded at least 400] It might be well to mention a few of them before telling the tale of "The Veiled Nun of St Leonards Church Avenue".

We will put aside ordinary banshees and things that can only be heard. Well, there is the celebrated Phantom Coach that Willie Carson told us of. It has been heard and seen by many. There is also a white lady that used to haunt the Abbey Road, the ghost of St Rule's Tower, the Haunted Tower ghost, the Blackfriars ghost, the wraith of Hackston of Rathillet, the spectre of the old Castle, the Dancing Skeletons, the Smothered Piper Lad, the Phantom Bloodhound, the Priory Ghost, and many, many more. The Nun of St Leonards is as curious and interesting as any of them, though a bit weird and gruesome. In the time of charming Mary Stuart, our white Queen, there lived in the old South Street a very lovely lady belonging to a very old Scottish family, and her beauty and wit brought many admirers to claim her hand, but with little or no success. She waved them all away. At last she became affianced to a fine and brave young fellow who came from the East Lothian country, and for some months all went merrily as a marriage bell, but at last clouds overspread the rosy horizon. She resolved that she would never become an earthly bride, but would take the veil and become a bride of Holy Church – a nun, in point of fact. When her lover heard that she had left home and entered a house of Holy Sisters, he at once announced his intention of hastening to St. Andrews, seizing her, and marrying her at once. In this project it would seem the young lady's parents were in perfect agreement with the

devoted youth. He did hasten to St. Andrews almost immediately, and there received a terrible shock. On meeting this once lovely and loved maiden, he discovered that she had actually done what she had threatened to do. Sooner than be an earthly bride she had mutilated her face by slitting her nostrils and cutting off her eyelids and both her top and bottom lips, and had branded her fair cheeks with cruel hot irons.

The poor youth, on seeing her famous beauty thus destroyed, fled to Edinburgh, where he committed suicide, and she, after becoming a nun, died from grief and remorse. That all happened nearly 400 years ago; but her spirit with the terribly marred and mutilated face still wanders o' nights in the peaceful little avenue to old St Leonards iron kirk gate down the Pends Road. She is all dressed in black, with a long black veil over the once lovely face, and carries a lantern in her hand. Should any bold visitor in that avenue meet her, she slowly sweeps her face veil aside, raises the lantern to her scarred face, and discloses those awful features to his horrified gaze.

Here is a curious thing that I know happened there a few years ago. I knew a young fellow here who was reading up theology and Church canon law. I also knew a great friend of his, an old Cambridge man. The former I will call Wilson, and the latter Talbot, as I do not want to give the exact names. Well, Wilson had invited Talbot up to St. Andrews for a month of golf, and he arrived here on a Christmas day. He came to my rooms for about ten minutes, and I never saw anyone merrier and brighter and full of old days at Cambridge. Then he hurried off to see the Links and the Club. Late that evening Wilson rushed in. "Come along quick and see Talbot; he's awfully ill, and I don't know what's up a bit". I went off and found Talbot in his lodgings with a doctor in attendance, and he certainly looked dangerously ill, and seemed perfectly dazed. Wilson told me that he had to go to see some people on business that evening down by the harbour, and that he took Talbot with him down the Pends Road. It was a fine night, and Talbot said he would walk about the road and enjoy a cigar till his friend's return. In about half-an-hour Wilson returned up the Pends Road, but could see Talbot nowhere in sight. After hunting about for a long time, he found him leaning against the third or fourth tree up the little avenue to St Leonards kirk gate.

He went up to him, when Talbot turned a horrified face towards him, saying, "Oh, my God, have you come to me again?" and fell down in a fit or a swoon. He got some passers-by to help to take poor Talbot

to his rooms. Then he came round to me. We sat up with him in wonder and amazement; and, briefly, this is what he told us. After walking up and down the Pends Road, he thought he would take a survey of the little avenue, when at the end he saw a light approaching him, and turned back to meet it. Thinking it was a policeman, he wished him "Good evening," but got no reply. On approaching nearer he saw it to be a veiled female with a lantern. Getting quite close, she stopped in front of him, drew aside her long veil, and held up the lantern towards him. "My God," said Talbot, "I can never forget or describe that terrible, fearful face. I felt choked, and I fell like a log at her feet. I remember no more till I found myself in these rooms, and you two fellows sitting beside me. I leave this place tomorrow" – and he did by the first train. His state of panic was terrible to see. Neither Wilson nor Talbot had ever heard the tale of the awful apparition of the St Leonards nun, and I had almost forgotten the existence of the strange story till so curiously reminded of it. I never saw Talbot again, but I had a letter from him a year after written from Rhienfells, telling me that on Christmas day he had had another vision, dream, or whatever it was, of the same awful spectre. About a year later I read in a paper that poor old Talbot had died on Christmas night at Rosario of heart failure. I often wonder if the dear old chap had had another visit from the terrible Veiled Nun of St Leonards Avenue".

The Facts - The Not So Veiled Nun of St Leonards

A few days before Christmas 2014, I had 18 St Leonards pupils on a tour together with some of the teachers. After speaking of Linskill's story, one of the pupils who was 17 at the time said she saw the nun two years before in 2012 when she was 15.

She was walking along the avenue one evening when she saw a woman all in black standing next to a tree. She was near what they call the 'Half Moon' Gates leading into the complex from the Pends Road. The mind will always try to work out the logic of what it is experiencing, so to start with she thought she was in fancy dress, but when she drew near, the woman started merging with the tree. She realised this was the ghostly nun. Terrified, she ran through the gates to the school's reception.

In April 2015, one of the party on a tour I had was a girl also from St Leonards School. She was 16 and told me about an experience she also had 2 years previously in 2013 when she was 14. She hadn't

thought anything of what she experienced until I spoke of the other pupils experience the year before. That was when she realised she had seen something very similar and was almost in shock at the thought. She said she was walking along the avenue and saw a woman. She was all in black and was standing in front of the same tree. She thought she was in costume and when nearing her, she seemed to move round the back of the tree. I asked if she could see her face, she said, yes. I then asked if her face was mutilated. She said no. This is exactly what the 17 year old had also seen one year earlier. On this occasion, she didn't appear to merge with the tree, but it is probable half of her disappeared into the tree rather than half of her disappearing round the back of it.

The tree where the nun stands beside the 'Half Moon' Gates
at the end of the Nuns Walk

The avenue can be a very eerie place at the best of times. Even in daylight when the sun is shining through the trees, there is a sense of something very unusual here. From these reports, the ghost of a woman wearing black exists, but the rest of Linskill's famous story is very much that – a story.

The Inspiration Behind Linskill's Veiled Nun Story

Linskill's 1911 story has gathered a particular pace and popularity over the years. Peter Underwood's brief accounts of a few St Andrews ghosts in his book *Gazetteer of Scottish Ghosts* in 1973 is a good example of this. Linskill's book served to reinforce aspects other authors would dearly love to be true.

His story was certainly based on the apparition of the nun in the avenue, which in his day was a very picturesque tree lined avenue. He got the basis of his story and the involvement of the nun from Whyte Melville's fictional story '*The Bride of Heaven*'. In his story '*Concerning More Appearances of the White Lady*', one of the Four Maries (the fictitious one) becomes a nun. The following from that story says, ""Look at page 371 of Whyte Melville's book," she said [the elderly woman speaking with Linskill in the White Lady story]. So I read [this is another direct quote from Melville] – "It was an early harvest that year in Scotland, but e'er the barley was white, Marie had done with nuns and nunneries, vows and ceremonies, withered hopes and mortal sorrows, and had gone to that place where the weary heart can alone find the rest it had so longed for at last".'

Linskill builds this into his story intimating that having been a nun she had then died. Melville in his book however continues… "tomorrow she would become the Bride of Heaven, and *the veil she would then put on must never be taken off again this side of the grave*.' This is crucial to Linskill's Veiled Nun ghost story. "*Never taken off this side of the grave*". The location was easy as there was already the ghost of a nun. He borrowed the veil from Melville, which was reinforced by reports of the shrouded White Lady in the Cathedral grounds. The mutilated features he got from the facial disfigurement of the Green Lady on the Kirkheugh. So add the veil to the disfigured apparition of the Kirkheugh and Melville's reaction of Marie to the death of Castelar "she threw her hood back and looked wildly…" add in one lantern and St Leonards Chapel Avenue and both the ghost, location and the background story were born.

As a point of interest, on reading a little further down the page in Melville's book we find his fictitious Marie (his White Lady) never became a nun in St Andrews. He says, "There is little doubt she would have fulfilled her intention had the occasion ever arrived". In Melville's story the occasion never arose because she died before she had a chance, which is why he says "Marie had done with nuns and nunneries… and had gone to that place where the weary heart can alone find the rest it had so longed for at last". Linskill had switched round Melville's story.

Major George John Whyte Melville

Linskill's stories of the White Lady and the Veiled Nun were initially based on existing ghosts, but who was Whyte Melville that gave him further inspiration to write his stories surrounding them? Well, his name was Major George John Whyte Melville, a novelist, poet and in his later years, a golfing friend of Linskill's in St Andrews. He was a senior Freemason and a prominent member of the R & A.

It was he who laid the foundation stone of the R & A Club House in 1854. He struck the foundation stone with a mallet and in true Masonic fashion called for "the Great Architect of the Universe to shower down his blessing upon the work". He was well respected in the town and very influential in his deeds.

I am sure you have seen and passed the fountain in Market Street often enough, but have you ever wondered why it is there? This is a memorial fountain built in his honour in 1880. As an aside, the fountain is made of the same Dumfriesshire red sandstone as the former Hamilton Hotel built in 1894, and now called Hamilton Grand overlooking the Old Course.

When the fountain was completed, it only flowed with water a few times, as fresh water in the town was often scarce. Following many repairs the water was switched on again in 2015, the first time since between the two world wars.

George John Whyte Melville
1821-1878[lxxvii]

[lxxvii] From the National Portrait Gallery in London

The Pends Wraith

In Linskill's story *Concerning more appearances of the White Lady* I mentioned his quote from Melville's novel regarding Mary Hamilton's reaction to Castelar's death "she threw her hood back and looked wildly upward, gasping for air".

This is very reminiscent of another ghost seen on the Pends Road. The last time was early in 2015 by boarding pupils of St Leonards School. On looking out of the windows of St Rule's dormitory, they have seen on more than one occasion a fairly tall slim figure standing at the entrance gate on the cobbles by the Pends Road. Facing the dormitory, the figure is wearing a black cowled robe, with the large black hood covering the head and hiding any features. The wraith like figure then tilts its head back and looks up at them in the window. To their horror, the black hood is completely empty.

They believe the figure to be a woman. It could well be, but it could also be one of the frequently sighted monks witnessed on the Pends Road over the years, as it easily fits the description of a Benedictine monk. We tend to think of monks as being big characters, but this is through stereotypical caricatures such as Friar Tuck. The majority would have been thin, as food was modest and fasting was frequent.

Chapter Twenty Two

The Fair Woman
A St Andrews Ghost Story

A few days after meeting with Jane Kilpatrick and her relating to me her account of the Green Lady, I came across a book in the University Library in St Andrews that had within its pages a ghostly tale about Mary Queen of Scots. Reproduced in full from a book edited by Charles Brown in 1911 entitled *Seekers after a City*.

Written in a style reminiscent of Linkill, it would, in fact, fit quite snugly in his volume of *St Andrews Ghost Stories*. In fact, his book came out at the same time as *The Fair Woman* which is attributed to one Robert L. Mackie, an undergraduate of the time in St Andrews and relates to the year 1587. One day after Mary Queen of Scots was beheaded at Fotheringhay Castle in England.

"We sat over the fire, my friend Crawford and I one cold October evening. Crawford had spent the last month in Paris, and could talk of nothing else, nor was I eager to check him. "Another thing they have in Paris which they don't have here," he was saying, "the quays by the river, with their rows and rows of bookstalls. Edinburgh can't hold a candle to it there. And that reminds me......"

Here he drew from his pocket a little copy of St. Augustine's Confessions, bound in dark leather, beautifully tooled on the back and sides. He handed it to me and said: "No, even in France they can't turn out things like that nowadays. I picked it up on one of the bookstalls I was talking about. But the binding isn't the most interesting thing about it; look at that paper inside".

I opened the book, and discovered that two large sheets of paper had been folded and placed between the fly-leaf and the title-page. I took them out and examined them. They were yellow with age and covered everywhere with a fine close writing, which was still legible, although the ink had faded to a dull brown. I looked more closely, and saw that the words were French, and that on the second sheet the handwriting were not alike, for half-way down the last page the thin tremulous script

of the first writer seemed to grow more shaken and uncertain, and the manuscript was completed a little further down in a bolder and a firmer hand.

"What is it?" I asked. "My French is somewhat rusty, and you can never tell an *f* from an *s* in these old manuscripts".

"Shall I translate it for you?" said Crawford taking the papers. "It is a strange production. I do not know what you will think of it".

"You wet my curiosity; please translate".

This is what Crawford read to me on that cold autumn evening:-

The snow beats hard on the Priory Walls on this the ninth date of February in the year 1587. From my little window I can hardly see the orchard wall, so thick come the flakes, and along the corridors doors are creaking and banging in the wind. I should smile now if one were to call this "fair France," only I am in no smiling mood to-day. Something impels me to write of these far-off days, when I was a student at St Andrews and an officer of the Arch Guard at Holyrood House. I had thought that these times were forgotten, that Brother Eustice and Laurence Fotheringham were as two different men, but I deceived myself, for to-day the past is more with me than the present. At times, too, I fancy that I hear the sound of a bell. It must be fancy, for our chapel bell would not ring so faintly, and the bells of the neighbouring village would not have so deep a sound; yet the noise has been echoing in my ears all morning.

How well I remember that wild evening in January, twenty-nine years ago! Christmas had passed, the "daft days" were, and with my two friends, Scrymgeour and Wedderburn, I was returning to St Andrews. The gale had delayed us as we crossed from Dundee to Ferry-port, and after that the sodden roads made difficult walking, so that it was almost dark when we halted at the little inn at Leuchars. Nevertheless we resolved to push on, for we knew the road well, and the gale had abated. But before we had reached Bishop Wardlaw's Bridge[lxxviii] the snow came down thicker than ever, the last glimmer of light faded from the west, and the east wind buffeted us hither and thither. We were not a little afraid, but we talked confidently, joined hands, and walked straight forward. Suddenly Wedderburn knocked against something that gave out a hollow noise. We felt about carefully, and discovered that we were at the door of a little cottage. We knocked, and heard a

[lxxviii] At Guardbridge

stir within, but still the door was shut, though now a light glimmered at the window. Losing my patience, I shouted: "Open to us, good people; we are neither ghosts nor robbers, but three poor travellers lost in the storm". It was enough; the door was slowly opened by a white-faced old fisherman, and we were allowed to enter. Once we were in, he and his wife strove to make up for their show of inhospitality. Food and drink were set before us, fresh wood was thrown on the fire, and we were invited to warm ourselves before it.

"I am sorry I did not let you in before," said the old fisherman in his quaint Fife tongue; "it was foolish of me, but I was afraid".

"Afraid of what?" I asked.

"Then you do not know – you do not know about the fair woman?"

"No," I replied; "tell me about her".

"Well, I have never seen her, but my brother did once. People say that on a wild night like this a knocking is sometimes heard by those who live in lonely houses. If anyone opens, a beautiful woman comes in and – was that anyone knocking?"

We all listened, but we could hear nothing. I looked at my host, and saw that his face showed white even in the glow of the firelight.

"It was the wind," I said; go on. What is the woman's name?"

"Her name is – but I cannot tell you; are you sure you heard no noise?"

"Nothing, except the wind and the falling embers. But who or what is the woman?"

The old man's voice sank, and we all grew white as he whispered, "Her name is Death". Then he started up with a cry: "The knocking, do you hear it? Do you hear it? Mary have mercy upon us, she is coming!"

We listened intently, nor dare I say that none of us trembled. Sure enough, we could hear a low measured tapping on the door of the hut. We sat for three minutes or more, but the tapping still continued. I began to grow ashamed of my fears. Was I to send a stranger wandering to his death because of some words spoken by a doting old man? So before the others could think, I stepped to the door and unloosened the pin. For a few moments we could see nothing, for the snow drove into the room, and the whole house was full of eddying smoke. After the door had shut to with a clash, we were aware of an exceedingly fair woman standing before us. She was robed in a long shimmering garment of green, which glittered with amethysts and rubies. Her hair

was long and golden, with a reddish light in the depths of it, and her face – but who shall describe it? I have read of Helen, for whom the Greeks warred through ten weary years, and of Isoud, whose loveliness drove men mad, l, but even now I cannot think that they were fairer than that glittering woman. She glided to the door which led to the inner room, no one hindering her. A moment she paused on the threshold and beckoned me to follow; then she entered. I sprang forward, but Wedderburn sought to detain me, and it was some time before I could persuade him to let me go. I entered the other room. To my astonishment it seemed quite empty. I called for a light, and we searched in every recess; but no, our visitor had disappeared.

We returned to the fire, and gazed at each other blankly enough. The old fisherman and his wife were down on their knees among the ashes, clattering away vigorously at their beads, and we knew that for ourselves there would be no sleep tonight.

The long night passed, and we resumed our journey. Often we would talk of the strange visitor of the night before, for with the light our courage had returned, but we could come to no satisfactory conclusion. We reached St Andrews where the old friends and the old tasks speedily banished all thought of what had passed in the fisherman's hut.

The weeks and months passed rapidly, and before two years had ended I was done with St Andrews. It was no longer a place for us of the old faith; the Colleges were ruled by Knox's friends, and the great Cathedral, once the glory of our country, was now a roofless ruin. My blood boils yet as I think of that day of rapine. Our Church has faults enough, I well know, but a faith which makes war on everything beautiful can never be a faith for me. I was sick at heart for the condition of my country, but I could not mend it, for I was only a youth, the younger son of an obscure country laird; so I girded my sword about me and went into the French service. Four years I spent in France, and gained, they say, some distinction, but I was weary for the sight of our leaden skies and the bleak little tower of Fotheringham. In the autumn of 1563 I returned to Scotland, and a few months afterwards joined the archer guard as lieutenant. Our duties were to watch over the Palace of Holyrood and guard the six great gates of the city.

It was then that I first saw our Queen (will the bell never stop tolling?). I was on guard at the Netherbow Port when she swept up on

her white horse with her four Maries behind her and my lord of Arran at her bridle-rein. The gates were opened, and I saluted as she galloped past, but my hand could hardly hold the sword, so shaken and bewildered was I by the vision of her loveliness. From that day forward I was her liege worshipper. There is no other word for it. I did not desire to possess her; I felt that she was not of my world, and that a lifetime of striving could not make me worthy of her. It was enough to see her face and have a word from her occasionally, and the next three years were spent in a dream of happiness.

Only once was it broken. I had been sitting in the lodging of my friend Charteris, and our talk turned to the Queen. I poured out my praises of her – how every man, woman, and child in Scotland loved her, and how under her guidance our country would once again be counted among the nations. "Of her would I say, as the poet said of another fair woman of old – 'Surely in her all beauty is gathered up as in a flower', and for us the only praise to be rendered is worship and silence". Thus ended my rhapsody, but Charteris shook his head.

"I once thought as you do, Laurence, but strange doubts assail me. It seems that no one can prosper in her shadow. Think, King Francis died before he reached his nineteenth year; the Queen's friend, Rizzio – you know what has become of him. I was in St Andrews when Chastelard was burned[lxxix] – poor infatuated fool, but he met his death bravely. Arran, who used to follow the Queen with his looks wherever she went – he is mad now; yet she does not smile any the less. Who will follow next...".

I could contain myself no longer and broke in: "Look here, Frank, you were my friend, else I should run my sword through your body; as it is, you can be my friend no longer. Little did I think that you had so base of mind, that you could slander one so fair and innocent. Farewell until you acknowledge that your words are false". With these words I closed the door haughtily behind me and rushed from the house.

This happened in January of the year 1567. On Saturday, the eighth day of February, the Queen called for me. She was in the little supper-room where Rizzio had been murdered, with only one attendant. I bowed to her and she began...

[lxxix] As noted earlier, Chastelard was hung at the Tollbooth in Market Street for his over exuberance with the Queen.

"Are you not on duty to-morrow night at the gate-house of the Palace?"

I said that I was.

"You know that there is a masque[lxxx] at the Palace then. You have been looking pale of late – nay, do not protest – pale and troubled. We are careful of our subjects' welfare. Leave your watch for one night, no one will suffer, and come to the masque. Do not hesitate now; remember that I, your sovereign, command you".

I could not resist her entreaty, and the next evening saw me at the masque. Would I, could I forget that terrible night, when my lord of Albany, the Queen's husband, was foully murdered in the house of the Kirk-of-field! Had I only been on guard the murderers would have not escaped, for one of my men challenged Lord Bothwell at the gate-house, but foolishly let him pass. I was blaming myself, when a wild, a horrible suspicion flashed over my brain and made all my blood stop. It was the Queen who had asked me to leave my post for one night – had she anything to do with Darnley's death? I strove to fight down the thought, but it came before me in all sorts of fearful shapes, and the words of Charteris echoed in my brain. I must be satisfied at once; if it were true – I could not tell. I hurried up the Canongate to the Castle, whither the Queen had betaken herself after the murder, and after some little delay I was admitted. My trouble now was to gain access to the Queen, and it was only after I had told the guards that my business was one of life and death that I was allowed to see her. I was ushered into a little room, draped all in black, and with half-shuttered windows. Someone rose as I entered. It was the Queen.

I gazed upon her. No one so fair and gracious could ever be guilty of such a crime. But my thoughts were broken up.

"What is your errand, good sir? Have you come to spy upon our grief?"

"No, your Majesty, but you told me to leave the Palace gate-house on Sunday night".

"I always thought that in you I had a loyal and dutiful subject, but now my very kindness you throw back in my face. Has any slanderer gained your ear?"

[lxxx] A Masque was a costume performance or ball where everyone dressed in elaborate costume, much in the same way as fancy dress today.

"There are whisperers who say that wherever you go, Death follows".

"And why should it not, tell me that – why should I not? Look at my hair; see, was ever gold more lovely? And my hands that loose it – poets have called them lilies; but well you know that never was a lily so fair. My face, you would gaze upon it; but you dare not, for you would tremble and fall down before its beauty. And you ask if death is to outweigh all this. Is death to be weighed in the balance beside love, or the music of violins, or the scent of roses, or this one perfect face before which all the world bows in worship? Forgive me, for I am weary and alone, and I know what I say. But I forgot, you are my enemy, you cannot trust me…"

"Nay, madam. I shall trust you till my death".

"Whether you trust me or not. I have faith in you. See, I am writing a letter. Take it to my lord Bothwell – believe not what slanderers say of him, for he has been deeply wronged – take it, and the rash words you have spoken to me are pardoned".

I bowed down and kissed her hand, the fairest hand in all the world; then I took my leave. I went to my lodging to prepare for the journey and snatch a bite of food. The Queen's face, that face "before which all the world bows in worship" – where had I seen it before? I pondered the question, then gave a sudden start of horror. Yes, I remembered now; her face was the face of the strange woman I had seen in the fisherman's hut nine years before. My limbs trembled under me, and something seemed to rise in my throat as if to choke me. With an effort I fought down my weakness – perhaps my memory had failed me; but no. I remembered too well. If so, what of the letter? I looked at it, the dainty seal and the wavy, graceful handwriting. Surely this could not be a message of death. But now it seemed that I was on the brink of a fearful precipice, and that if I did not act at once I should be lost; so I broke the seal of the letter and read its contents. They were brief indeed: "The fellow that bears this grows troublesome. See that he is removed. - MARIE R".

Truly she, the fairest of all women, was Death.

Of what happened in the next few weeks I but dimly remember, for they passed like a fevered dream, I left Scotland, and became a Franciscan brother in this little monastery here (the bell has not ceased ringing). The twenty years have passed peacefully enough, a little monotonously perhaps; but if no great joys enter here, no great sorrows

come either. The Queen is now in an English prison, but even there her presence throws a shadow. Bothwell is a homeless exile now, and the Duke of Norfolk, the greatest nobleman in all England, had to yield up his life because of her. The bell grows louder now, louder and deeper....

"Here the handwriting changes," said Crawford; "someone else must have written what follows".

Strange is the tale which I relate, strange and hard of belief. On the evening of the eighth day of February, 1587, as I was walking along the corridor which leads by Brother Eustice's cell, I saw a strange shape gliding towards me. She passed quite close to me, and I could mark her well. Her hair was like spun gold, and it fell over garments of green, which glittered with rubies and amethysts. Her face made me lower my head – it was so beautiful – and on her white throat she wore no ornament save what seemed to be a slender thread of crimson silk. She went to Brother Eustice's door, pushed it gently aside, and entered. I was affrighted, but when half-an-hour had passed and no one appeared I called Brother Leonard, and together we entered Eustice's cell. There was no one there save Eustice, and he lay quite still with a look of victory on his face. It was quite plain that he was dead.

Four weeks have passed since then, and strange news has come to us. On the eighth day of February, Mary Stuart, once Queen of France and Scotland, was beheaded in Fotheringay Castle. Was the bell which Eustice heard, the passing bell at Fotheringay? Was the shape which I saw – but God alone can tell.

I had listened spellbound while Crawford read to me. Now he had finished, and with an uneasy laugh he said: "Makes one creep, doesn't it?"

"What do you make of it?" I asked. "Will you send it to Hume Brown?[lxxxi] It ought to make a stir among the historians".

"Oh no, my dear fellow. Such things can have no place in history – even though they are true"."

<div align="right">Robert L. Mackie [1]</div>

[lxxxi] Peter Hume Brown was a notable Scottish historian. Born in 1849 he was the first Professor of Scottish History at Edinburgh University in 1901. He died in 1918.

References

Chapter Four

[1] Millar, A. H: *Fife – Pictorial and Historical Vol. 1*, 1895, pp. 321-322
[2] Edinburgh Architectural Association 1907 Exhibition Catalogue
[3] Ibid.
[4] Henry, David, F.S.A. Scot: *Knights of St. John with other Mediaeval Institutions and their Buildings in St Andrews*. W. C. Henderson. K. Son, University Press, 1912, p. 42
[5] Mr A. Hutcheson: *Scottish Antiquity*, April 1894

Chapter Five

[1] Cook: *Excursionists Guide to St Andrews*, J. Cook & Son, 80 Market Street, St Andrews, 1896, p. 18

Chapter Six

[1] Gorman, Martyn:
http://www.abdn.ac.uk/bodysnatchers/background.php
[2] Ibid
[3] Linskill, William: *St Andrews Wonderful Old Haunted Tower*, October 5th 1918
[4] Ibid
[5] Ibid

Chapter Seven

[1] Maurier, George du: *Trilby*, New York International Book and Publishing Company, 1899
[2] Cooke, George Alexander: *A Topographical Description of the Middle Division of Scotland*, G. Brimmer, London, 1805, p. 212
[3] Grierson, James: *Delineations of St Andrews*, R. Tullis, Cupar, 1807, pp. 190-1
[4] B. Faujas de Saint Fond, *A Journey through England and Scotland to the Hebrides in 1784*, trans. Sir Archibald Geikie, Vol. II, Glasgow, 1907, p. 196
[5] Biography of the Literary and Philosophical Society of St Andrews, at the National Archives of Scotland, 1838-1916
[6] Ibid.

Chapter Seven (continued)

[7] *St Andrews Howkings.* The Saturday Review, November 18, 1893.
[8] Ibid.

Chapter Ten

[1] Henry, David, F.S.A. Scot: *Knights of St. John with other Mediaeval Institutions and their Buildings in St Andrews.* W. C. Henderson. K. Son, University Press, 1912, pp. 41-47
[2] Cook: *Excursionists Guide to St Andrews,* J. Cook & Son, 80 Market Street, St Andrews, 1896, p. 18
[3] Lyon, Rev, Charles Jobson: *History of St Andrews: ancient and modern,* The Edinburgh Printing and Publishing Co., 1838, p. 194

Chapter Eleven

[1] Lyon, Rev, Charles Jobson: *History of St Andrews: ancient and modern,* The Edinburgh Printing and Publishing Co., 1838, pp. 63-64

Chapter Twelve

[1] Dunning, Jim: Ireland's Own Magazine, *The Incorruptability of Saints*
[2] Murray, John: *A handbook for travellers on the continent,* A Spottiswoode, London, 1840, p. 254
[3] http://www.marypages.com/IncorruptBodies.htm

Chapter Thirteen

[1] http://canmore.org.uk/site/94500/st-andrews-cathedral-precinct-Wall
[2] Reid, W. Stanford: *Trumpeter of God,* New York: Charles Scribner's Sons, 1974, p. 57, & MacGregor, Geddes: *The Thundering Scot,* Philadelphia: The Westminster Press, 1957, pp. 49-50

Chapter Seventeen

[1] Linskill, William: *St Andrews Ghost Stories,* J & G Innes, 1911. Republished by Richard Falconer, *Ghosts of St Andrews,* Obsidian Publishing, 2013

Chapter Eighteen

[1] http://www.marie-stuart.co.uk/Music/Lyrics/FourMarys.htm

[2] Fraser, Antonia: *Mary Queen of Scots,* Weidenfeld & Nicolson, London, 1969, p. 190

Chapter Nineteen

[1] Underwood, Peter: *Gazetteer of Scottish Ghosts,* Fontana/Collin, 1973, p. 169

[2] Green, Andrew, M.: *Ghosts of Today,* Kaye & Ward, 1980

[3] Holder, Geoff: *Haunted St Andrews,* The History Press, 2012, p. 20

Chapter Twenty

[1] Fleming, Dr. Hay, LL.D: *Handbook to St Andrews and Neighbourhood,* St Andrews Citizen Office, 1897, pp. 65-66

[2] Walsh, Clara A.: Master-Singers of Japan. *Wisdom of the East Series.* Murray, 1910

[3] Jack, Thomas C: *Ordnance Gazetteer of Scotland: A Survey of Scottish Topography, Statistical, Biographical and Historical.* Grange Publishing Works, Edinburgh. 1880s

[4] Grierson, James: *Delineations of St Andrews,* R. Tullis, Cupar, 1807, pp. 220-221

[5] Wilkie, James: *Bygone Fife: From Culross to St. Andrews,* William Blackwood, 1931. pp. 366-367

Chapter Twenty One

[1] Henry, David, F.S.A. Scot: *Knights of St. John with other Mediaeval Institutions and their Buildings in St Andrews.* W. C. Henderson. K. Son, University Press, 1912, p. 183

[2] Ibid, pp. 181-182

[3] Ibid p. 183

Chapter Twelve Two

[1] Brown, Charles (ed): *Seekers after a City. The Fair Woman,* Robert. L Mackie. Ballantyne, Hanson & co., Edinburgh, 1911, p. 83

Lightning Source UK Ltd.
Milton Keynes UK
UKHW011546270921
391258UK00003B/68

9 780992 753825